NN

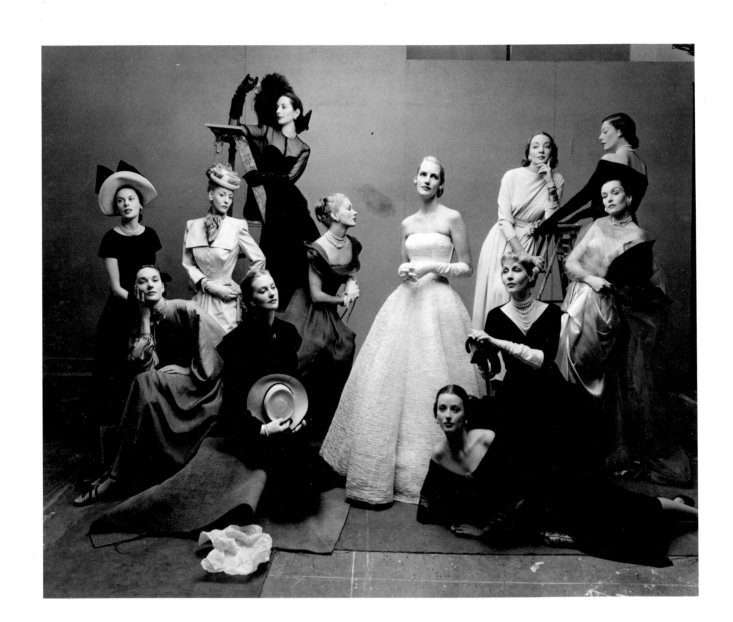

Irving**PENN**

Master Images

The Collections of the National Museum of American Art

and the National Portrait Gallery

Merry A. Foresta • William F. Stapp

Published by the Smithsonian Institution Press

Washington, D.C.

An exhibition at the National Museum of American Art and the National Portrait Gallery,
March 30–August 19, 1990

© 1990 by Smithsonian Institution. All rights reserved.
Library of Congress Cataloging-in-Publication Data
Foresta, Merry A.
 Irving Penn master images : the collections of the National Museum of American Art
and the National Portrait Gallery / Merry A. Foresta, William F. Stapp.
 p. cm.
 "An exhibition of the National Museum of American Art and the National Portrait Gallery,
March 30–August 19, 1990"—Verso of t.p.
 Includes bibliographical references.
 ISBN 0-87474-849-6 (pbk.)
 1. Photography, Artistic—Exhibitions. 2. Fashion photography—Exhibitions. 3. Pho-
tography—Portraits—Exhibitions. 4. Penn, Irving—Exhibitions. I. Penn, Irving.
II. Stapp, William F., 1945– . III. National Museum of American Art (U.S.) IV. National
Portrait Gallery (Smithsonian Institution) V. Title.
TR647.P46F67 1990
779'.092—dc20 89-43466
 CIP

Cover illustration
Barnett Newman, New York, 1966
National Portrait Gallery, Smithsonian Institution

Back cover
Three Dahomey Girls, One Reclining, 1967
National Museum of American Art, Smithsonian Institution

Frontispiece
Twelve Most Photographed Models, New York, 1947
National Portrait Gallery, Smithsonian Institution

This catalogue and the exhibition have been made possible by a generous grant from USAir, Inc.

68. W. H. Auden, New York. © 1984 Irving Penn, courtesy of *Vogue*.

69. Janet Flanner, New York. © 1948 (renewed 1976) The Condé Nast Publications Inc.

70. Georgia O'Keeffe, New York. © 1984 Irving Penn, courtesy of *Vogue*.

71. Charles Sheeler, New York. © 1984 Irving Penn, courtesy of *Vogue*.

72. Joe Louis, New York. © 1948 (renewed 1976) The Condé Nast Publications Inc.

73. E. B. White, New York. © 1948 (renewed 1976) The Condé Nast Publications Inc.

74. George Grosz, New York. © 1983 Irving Penn, courtesy of *Vogue*.

75. Artur Rubinstein, New York. © 1984 Irving Penn, courtesy of *Vogue*.

76. John O'Hara, New York. © 1984 Irving Penn, courtesy of *Vogue*.

77. Marcel Duchamp, New York. © 1984 Irving Penn, courtesy of *Vogue*.

78. Mrs. William Rhinelander Stewart, New York. © 1948 (renewed 1976) The Condé Nast Publications Inc.

79. Duchess of Windsor, New York. © 1960 (renewed 1988) Irving Penn, courtesy of *Vogue*.

80. Igor Stravinsky, New York. © 1948 (renewed 1976) The Condé Nast Publications Inc.

81. Marlene Dietrich, New York. © 1950 (renewed 1978) The Condé Nast Publications Inc.

82. Carson McCullers, New York. © 1951 (renewed 1979) The Condé Nast Publications Inc.

83. T. S. Eliot, London. © 1960 (renewed 1988) Irving Penn, courtesy of *Vogue*.

84. Sir Jacob Epstein, London. © 1950 (renewed 1978) The Condé Nast Publications Inc.

85. Senator Tom Connally, Washington. © 1951 (renewed 1979) The Condé Nast Publications Inc.

86. Philip Johnson and Ludwig Mies Van Der Rohe, New York. © 1984 Irving Penn, courtesy of *Vogue*.

87. Frederick Kiesler and Willem de Kooning, New York. © 1960 (renewed 1988) Irving Penn.

88. Saul Bellow, New York. © 1964 The Condé Nast Publications Inc.

89. David Smith, Bolton's Landing, N.Y. © 1965 The Condé Nast Publications Inc.

90. Hans Hofmann, New York. © 1965 The Condé Nast Publications Inc.

91. Rudolf Nureyev, New York. © 1965 The Condé Nast Publications Inc.

92. Truman Capote, New York. © 1965 The Condé Nast Publications Inc.

93. Barnett Newman, New York. © 1966 The Condé Nast Publications Inc.

94. Isaac Bashevis Singer, New York. © 1966 The Condé Nast Publications Inc.

95. Saul Steinberg in Nose Mask, New York. © 1966 The Condé Nast Publications Inc.

96. Tom Wolfe, New York. © 1966 The Condé Nast Publications Inc.

97. Hell's Angels, San Francisco. © 1967 Irving Penn.

98. Hippie Family (F), San Francisco. © 1967 Irving Penn.

99. Hippie Family (K), San Francisco. © 1967 Irving Penn and Cowles Publications Inc.

100. Hippie Group, San Francisco. © 1967 Irving Penn.

101. Rock Groups (Big Brother and the Holding Company and The Grateful Dead), San Francisco. © 1974 Irving Penn.

102. John Updike, New York. © 1971 The Condé Nast Publications Inc.

103. Duke Ellington, New York. © 1971 The Condé Nast Publications Inc.

104. Tony Smith, South Orange, N.J. © 1971 Irving Penn, courtesy of *Vogue*.

105. George Balanchine, New York. © 1972 The Condé Nast Publications Inc.

106. Anaïs Nin, New York. © 1971 The Condé Nast Publications Inc.

107. Woody Allen as Chaplin, New York. © 1972 The Condé Nast Publications Inc.

108. Elliott Carter, New York. © 1984 Irving Penn, courtesy of *Vogue*.

109. Merce Cunningham, New York. © 1978 Irving Penn.

110. Aaron Copland, New York. © 1979 CBS Inc.

111. Joseph Brodsky, New York. © 1980 The Condé Nast Publications Inc.

112. John Huston, New York. © 1983 The Condé Nast Publications Inc.

113. Henry Geldzahler, New York. © 1981 Irving Penn.

114. Virgil Thomson, New York. © 1983 The Condé Nast Publications Inc.

115. James Van Der Zee, New York. © 1983 The Condé Nast Publications Inc.

116. Suzanne Farrell, New York. © 1983 The Condé Nast Publications Inc.

117. Jessye Norman, New York. © 1983 The Condé Nast Publications Inc.

118. Willem de Kooning, Long Island, N.Y. © 1984 The Condé Nast Publications Inc.

119. Jasper Johns, New York. © 1984 The Condé Nast Publications Inc.

120. Isamu Noguchi, New York. © 1984 Irving Penn, courtesy of *Vanity Fair*.

Contents

x **FOREWORD** by Alan Fern and Elizabeth Broun

xii **ACKNOWLEDGMENTS**

xiii **IRVING PENN: A WORK CHRONOLOGY**

1 **IRVING PENN: THE PASSION OF CERTAINTIES** by Merry A. Foresta

14 **CATALOGUE: NATIONAL MUSEUM OF AMERICAN ART COLLECTION**

85 **PENN AS PORTRAITIST** by William F. Stapp

97 **CATALOGUE: NATIONAL PORTRAIT GALLERY COLLECTION**

171 **SELECTED BIBLIOGRAPHY**

173 **INDEX**

Foreword

The photographic work of Irving Penn constitutes an achievement of exceptional range and quality. He has made portraits, illustrated fashion for magazines, and explored surprising (and often humble) objects in his private work, but despite the diverse demands of these different areas of his craft, everything he has produced has been invested with his special vision. Those who know Penn's work only from reproductions in books and magazines will have little idea of the impact of his work in the original; his prints have a monumentality, clarity, and sensitivity to tonality that are uniquely his. Penn seems always to be in control of his subjects, of light, and of the very photographic emulsions that are his tools, but his work never seems a mere technical exercise or a labored attempt at individuality. He is manifestly one of the significant figures in American photography today.

Therefore, it is particularly fortunate that our two Smithsonian museums—the National Museum of American Art and the National Portrait Gallery—have acquired a unique Irving Penn collection: the photographer's own selection from four decades of work. We are deeply grateful to Mr. Penn for his gift of these extraordinary prints, which will be available for generations to come in our two neighboring museum collections, and we appreciate the care and attention Mr. Penn has given to the inaugural exhibition of this collection and to the publication that accompanies it.

The curators of photography in our two museums, Merry A. Foresta and William F. Stapp, have worked closely with Mr. Penn in bringing this collection to the public, and the photographer has been generous in sharing his own views of the aesthetics and technical side of his work. The essays by Ms. Foresta and Mr. Stapp in this book will help to guide viewers to a deeper appreciation of

Penn's achievement and to gain some understanding of how the artist views his own accomplishments. We are appreciative of the efforts of our many colleagues in the two museums who have devoted their professional skills to the mounting of this exhibition and publication of the book, and to Amy Pastan, Acquisitions Editor at the Smithsonian Institution Press, for overseeing this publication.

It gives us special pleasure to acknowledge the assistance of USAir, Inc., in supporting this book and exhibition. USAir has distinguished itself as a sponsor of the performing arts in many of the communities it serves, but to our knowledge this is the first time it has ventured into the visual arts. Without the imaginative and sympathetic attention of USAir's Chairman of the Board and President, Edwin I. Colodny, and Vice President—Corporate Communications, Patricia A. Goldman, this happy collaboration would never have come about. We are grateful for their assistance and delighted to work together to bring the work of a remarkable photographer to a larger audience.

Elizabeth Broun
Director
National Museum of American Art

Alan Fern
Director
National Portrait Gallery

Acknowledgments

This exhibition and catalogue grew out of the important gift of 120 master photographs, which Irving Penn made to the Smithsonian Institution in 1987. It is to him that we owe our first and major acknowledgment, not only for the images themselves, but also for his generous contribution of time and dedication to the entire project. To his assistant, Patricia McCabe, goes our gratitude for her command of information about Penn's career.

We would also like to thank Jack Mognaz of the Marlborough Gallery, who first introduced Mr. Penn to the collections of the Smithsonian Institution, and who in conversations with Carolyn Carr, Assistant Director for Collections at the National Portrait Gallery, suggested that the National Portrait Gallery and the National Museum of American Art might be an appropriate place for a major collection of the photographer's work. Several individuals at both museums who helped make this book and exhibition possible deserve special thanks: at the National Museum of American Art, Abigail Terrones, Lynn Putney, and Charles Booth of the Graphic Arts Department; research volunteer Sandra Berler; Conservators Catherine Maynor and Fern Bleckner; and Exhibition Designer Allan Kaneshiro; and at the National Portrait Gallery, Ann Shumard of the Department of Photographs; research volunteer Maria Marks; Paper Conservator Linda Stiber; Mat Cutter Edmund Myers; Curator of Exhibitions Beverly Cox; Exhibition Designers Nello Marconi and Albert Elkins; and above all, Frances Stevenson and Dru Dowdy, Publications Officer and Editor, assisted by Judith Kloss. Finally, we would like to acknowledge Acquisitions Editor Amy Pastan and catalogue designer Janice Wheeler at the Smithsonian Institution Press for their work on behalf of this catalogue.

Merry A. Foresta and William F. Stapp

Irving Penn: A Work Chronology

1917	Born in Plainfield, New Jersey.
1934–1938	Studied at Philadelphia Museum School of Industrial Art; attended design classes with Alexey Brodovitch.
1937–1938	During school vacations, was an assistant at *Harper's Bazaar*, where Brodovitch was art director.
	Made drawings of shoes and other minor illustrations. With earnings, bought first camera, a Rolleiflex.
	Worked evenings and weekends at Brodovitch's personal studio on Brodovitch's design projects.
1938–1940	Was freelance designer in New York. Made photographs in the streets. Made sketches for projected paintings.
1940–1941	Did advertising design for a New York department store.
Late 1941	En route to Mexico, traveled slowly through southern United States, making camera notes.
1942	Painted in Mexico. Made photographs in the streets.
	Dissatisfied with the painting results, destroyed the year's work before returning to New York.
1943	Hired by Alexander Liberman, art director of *Vogue*, as his assistant, primarily to make suggestions for covers to be photographed by others.
	At Liberman's direction became a photographer. First cover (October 1943) was a still life. Eventually photographed 163 *Vogue* covers.
1944	First, tentative, photographs of fashions for *Vogue*.
1944–1945	Photographed war activities in Italy and India; also made a private documentation of political wall inscriptions in Italy, Yugoslavia, and Austria.
1946–1948	In New York, made an extended series of photographs of dance and dancers for *Vogue* and for the use of the dance companies: Ballet Society and Ballet Theatre.

1947	For *Vogue* in New York, photographed a number of still lifes, and began a major series of portraits of figures in the arts. Subjects included: W. H. Auden, Marc Chagall, Le Corbusier, Alfred Hitchcock, John Marin, H. L. Mencken, George Jean Nathan, and Salvador Dali.
1948	Photographs for *Vogue* of postwar Italian architects and designers in Milan. Elsewhere in Italy, portraits of figures in the arts: Massimo Campigli, Marino Marini, Renato Guttuso, Giacomo Manzú, Roberto Rossellini and Anna Magnani, Luchino Visconti. In Naples photographed street people and popular entertainers.
	First trip to Paris for *Vogue*. Portraits of Jean Cocteau, Balthus (Baltusz Klossowski de Rola), Père Couturier, André Derain.
	Photographic essay for *Vogue*: "Picasso's Barcelona."
	Portraits of Joan Miró in Tarragona, Spain.
	In New York, portraits for *Vogue*, including Georges Enesco, Georgia O'Keeffe, Truman Capote, Noel Coward, Marlene Dietrich, Marcel Duchamp.
	Photographic essay in Peru, for *Vogue*: "Christmas in Cuzco."
1949–1950	Major personal project photographing nudes. Technical experimentation in printmaking, with silver paper, bleaching, and redevelopment. These prints were first shown at Marlborough Gallery, New York, in 1980, as "Earthly Bodies."
1949	Sent by Liberman to Paris for *Vogue* to see and study the couture collections, but not yet to photograph.
1950	A program of work for *Vogue* in Europe. Photographed the Paris couture collections—the first of eventually twenty-six.
	On the suggestion of Liberman, made a comprehensive series of pictures of the small trades, first in Paris, then in London, and the following year (1951) in New York.
	Portrait subjects in Paris included: Blaise Cendrars, Alberto Giacometti. In London: Cecil Beaton, Evelyn Waugh, Richard Burton, Ralph Richardson, T. S. Eliot, Jacob Epstein, Henry Moore.
1951	In *Vogue*'s New York studio, constructed a point source horizontal enlarger based on the zirconium arc lamp. With eventual use of this apparatus in mind, photographed in France and Morocco, the results of which were published as essays "Fishing on the Seine" and "Morocco."
	In France, made portraits of Colette, Maurice de Vlaminck, and Jean Gabin.
	In a studio arranged by *Vogue* at the Corcoran Gallery, photographed about eighty of Washington, D.C.'s government, military, and social figures.
1952–present	Advertising photographs for American and international clients.
	Continuing photographs of fashion and beauty subjects for *Vogue*.
1957–1958; 1961	For *Vogue*, portraits in France: Pablo Picasso, Simone de Beauvoir, Yves St. Laurent, Eugène Ionesco, Jean Giono. In London: John Osborne, Ivy Compton Burnett, Cyril Connolly.
1960	Published *Moments Preserved*, eight essays in photographs and words.
1961	Began a series of yearly photographic essays for *Look* magazine: 1961 Provence 1962 Provincial Foods of France

	1963 Portugal
	1964 Sweden
	1965 Paris
	1966 London
	1967 San Francisco

1962 A group of photographic people-essays for the short-lived *Show* magazine:
 Somerset Maugham (France)
 Sophia Loren (Italy)
 Robert Graves (Majorca)
 Henry Moore (England)

1963 The Museum of Modern Art circulated (in the United States but not in New York) a small exhibition of work.

1963–1965 Travel essays for *Vogue*:
 1963 Japan and Scotland
 1964 Crete
 1965 Gypsies of Extremadura

1964 Began printing in platinum metals. This continues to the present time.

1965 Built a portable traveling photographic studio for a series of ethnographic essays for *Vogue*:
 1967 Dahomey
 1967 Nepal
 1969 Cameroon
 1970 New Guinea
 1971 Morocco

 Much of this material was included in a book, *Worlds in a Small Room*, published in 1974.

1967–1973 Photographed seven flower essays for *Vogue*, one a year. These were later assembled and published as a book in 1980.

1969 Experimental color printing of photographs on porcelainized steel; pigments were suspended in gelatin.

1975 Exhibition at the Museum of Modern Art, New York: "Irving Penn: Recent Works," photographs of cigarettes—platinum prints of photographs made in 1972.

 Exhibition in Turin, Italy, at the Galleria Civica d'Arte Moderna: "I Platini di Irving Penn: 25 Anni di Fotografia."

1977 Exhibition at the Metropolitan Museum of Art, New York: "Irving Penn: Street Material," photographs in platinum metals.

 Published *Inventive Paris Clothes 1909–1939: A Photographic Essay by Irving Penn*, with text by Diana Vreeland.

1979–1980 Photographed a series of forty-two still lifes using an altered 12 × 20-inch camera. Platinum prints of this material were exhibited at Marlborough Gallery, New York, in 1982.

1982–1984 A series of portraits for the new *Vanity Fair*, including: Italo Calvino, Willem de Kooning, Eugène Ionesco, Jasper Johns, Arthur Miller, Isamu Noguchi, Philip Roth.

1984 Exhibition at the Museum of Modern Art, New York: "Irving Penn," a retrospective of 160 photographs. This was circulated to museums in America, and abroad: Tokyo, Osaka, Paris, London, Madrid, Barcelona, Essen, Stockholm, Humlebæk (Denmark), Oslo, Helsinki, Lausanne, Tel Aviv, and Milan.

A book to accompany the exhibition was published by the Museum of Modern Art: *Irving Penn*, with text by John Szarkowski.

1986 Photographed a number of animal skulls at the Narodni Museum in Prague, Czechoslovakia.

1987–1988 Exhibition at the Pace/MacGill Gallery, New York: "Cranium Architecture."

Merry A. Foresta

Irving Penn: The Passion of Certainties

Assembled at the National Museum of American Art as part of a master set of Irving Penn images at the Smithsonian, early portraits, fashion photographs, nudes, small-trade workers, and ethnographic portraits, photographs of found street refuse, still lifes, and recent photographs of animal skulls from the collection of the Narodni Museum in Prague together form a retrospective of the artist's career. As a group the photographs also represent a wide range of photography's occupations and concerns. Today, with interest running high in popular culture, the ways in which art, advertising, and fashion intersect are being examined with increased interest by both critics and artists. The conjunction between art and commerce that winds through Penn's career challenges our usual definitions of both these areas. Issues of art—the pursuit of a particular aesthetic standard—and advertising—the creation of desire—are topics usually considered antithetical. Concerned with both, for almost half a century Penn has fashioned his career along complex and occasionally mysterious lines.

Penn's photography is best known through magazines; his first photographs were for the printed page, not the photographic print. Through the influence and resources of his sponsors—after 1943 predominantly Condé Nast—he has made portraits of some of this century's most important artists and has photographed the most beautiful women dressed by the most distinctive couturiers. They have also made possible photographic excursions to places such as Morocco, Peru, and New Guinea, remote from fashion capitals. His still-life arrangements of geometric purity or reclaimed trash were posed in a studio furnished with lights and backdrops that might also have accommodated the demands of a well-organized advertisement for perfume or cosmetics. The in-

terconnections between art and advertising in Penn's work are understandable. How he manages to simultaneously accomplish so much is remarkable; that he weaves with grace and confidence the private thread of personal vision through such enormous range is his rare talent.

By his own account, he drifted into the New York commercial art world almost by accident after his design studies at the Philadelphia Museum School of Industrial Art, doing graphic work for his former teacher, an ex-Imperial Russian cavalryman, Alexey Brodovitch, at *Harper's Bazaar* during the late 1930s. After a short stint as the advertising designer for Saks Fifth Avenue in 1940, a job he inherited from Brodovitch, he retired to Mexico for a year of painting.[1]

In 1943 art director Alexander Liberman lured him to *Vogue* as his assistant. There he learned to use an 8 × 10-inch camera and published his first color image on the magazine cover.[2] Penn demonstrated an ability to create pictorial images that could also communicate an appropriate sense of the product being sold. During his connection with *Vogue* and Liberman, who would become employer, patron, and collaborator, Penn coaxed a photographic style as strong and personal as a painting style from a medium whose natural tendency is to obscure and dilute the imprint of the photographer.

From the outset Penn displayed a remarkable responsiveness to new developments in American as well as European art. The surrealist drawings by Jean Cocteau, Pavel Tchelitchew, Salvador Dali, Rufino Tamayo, and others, which apprentice Penn had opened in the mail at Brodovitch's *Harper's Bazaar* office during his student summers, were of great influence. Though museums had introduced this work in exhibitions such as the Museum of Modern Art's 1936 "Fantastic Art, Dada, Surrealism," for the most part it was greeted in America with puzzlement and ridicule. More generous was the welcome offered by the American magazines that provided a forum for a new species of art and fashion. In the late 1930s, artists, including Dali, Giorgio de Chirico, and Tchelichew, contributed painted cover designs to *Vogue*, and the accoutrements of surrealist imagery were used throughout the magazine to provide a kind of cultural uniformity. Columns, mannequins, and masks appeared in shallow surrealist wastelands assembled with great care. Jewelry and accessories were photographed on dismembered hands and wrists, and amorphous sections of models were highlighted in dark, shadowy sets.[3]

Through Brodovitch, and then through Liberman, both of whom had immigrated to America via Paris, Penn was perhaps especially aware of the effect of avant-garde European artists as they sent first their art, and then brought themselves, to America during the Second World War. Based on the drawings that survive Penn's 1942 painting expedition to Mexico, his own models were de Chirico and Matta.[4] Though he ultimately destroyed his oils before returning to New York, notably scraping the paint from the surface in order to preserve and carry home the more expressive texture of the canvas—a reversed Max Ernst

frottage? or the prescient taste of an artist soon to be involved with the expressive line of fabric folds?—Penn, the student designer, had announced more artistic affiliations.

The earliest Penn photograph represented in the National Museum of American Art collection is a 1944 portrait of Giorgio de Chirico. In the chronology of his career, which Penn prepared for this catalogue, it is telling that he singled out the experience. In Rome, as a volunteer member of the American Field Service, Penn encountered the aging surrealist at the foot of the Spanish Steps. Thrilled to see one of his artistic heroes, Penn remembers that he immediately and enthusiastically accosted the old artist, who responded graciously—and perhaps gratefully, considering his somewhat forgotten and war-interrupted career—to this unexpected youthful adulation. Penn was invited back to the studio, and during two days of visits and conversations, he made de Chirico's portrait [Cat. no. 1].[5]

Compared to the many portraits of artists, writers, and celebrities that would follow during his career, the de Chirico likeness is more revealing of Penn's interest in defining his thematic subject than of any future stylistic patent. Publicly, Penn rarely describes the process of a portrait sitting or reveals his personal reaction. However, published in the February 15, 1946, issue of *Vogue*, in an article that the magazine devoted to Penn's "Overseas Album," the portrait was accompanied by the photographer's own commentary: *This picture was taken in the dining room, but the same day we had gone for a walk in the old Roman Forum and took some others. Once he hurried over to a bush, broke off a few sprigs, and put them in his hair. "This is laurel, the classical symbol of fame and achievement," he said as he posed again.*

Penn determined upon a different set of props for his likeness of artistic fame, however. In part the enthusiastic wish of the young photographer to doubly honor his hero, Penn's portrait in the dining room includes a de Chirico nude self-portrait on an easel behind the sitter—one, Penn related, "on which even the hair on his chest was painted with great love." More than simple description, however, Penn's double portrait is a comparison between the painted representation and the photographed—the artist's narcissistic depiction of himself and the imposition of an outsider. In response to Penn and his camera, the seated de Chirico must twist himself around—the resulting image of this awkward pose suggesting not only the sitter's disquiet with the event of being photographed, but the startling authority of Penn's early control in arranging a situation that produces the picture that *he* wants. Beyond confirming Penn's interest in a subject from the art world, it is an image that sets in motion many questions of representation and preservation that have dominated Penn's career as an artist.

Penn's earliest still lifes and his fashion photographs for *Vogue* covers also read like a lexicon of themes that would be repeated in his later work. Though it

would be inaccurate to claim for him the invention of the genre of editorial still life—Leslie Gill in the 1930s at *Harper's Bazaar* and, earlier, Edward Steichen are more likely contenders—Penn was a powerful practitioner of a photographic tradition that has proven to be one of America's most significant contributions to the medium. Controlled arrangements of disjunctive objects for metaphoric purpose, his images announce the way he wanted us to look at the world. Some of his photograph layouts for 1946—such as a page broken into a checkerboard format, with each little box containing a different image—seem to show the influence of Joseph Cornell's surrealist boxes.[6] Penn's surrealist-style cover for the May 1, 1946, *Vogue* "Summer Beauty" issue included still-life arrangements of pills and lamb chops, images of beetles crawling on flowers and fruits, a woman's extended legs photographed as a detached abstract object, and a masked face.

More contrived than later Penn photographs for fashion layouts, *The Tarot Reader* [Cat. no. 15] from 1949 combines the association of chic surreal mysticism and graphic black-and-white design to illustrate the intriguing flair of the new season's coats and hats. But Penn adds elements of seventeenth-century Dutch genre to his layout, with fashion models replacing the ubiquitous card players and fortune tellers, giving us a small scenario in which women wait for their future—fashionable or otherwise—to be told. The predilection for settings that evoked Dutch painting traditions, which fascinated him at the time, was also apparent in the series of black-and-white still lifes that Penn produced in 1947, such as *Still Life with Food, New York* [Cat. no. 2]. Here the formal perfection of the composition is intruded upon by an element of disorder, evoking human action, which is otherwise absent from the picture. Composed of the elements of good food and wine—a sack of corn and a bunch of fresh grapes—there are also the requisite signs of decay in the half-drunk glass of apéritif and the almost too-obvious bug that makes his way toward spoiling the grain. Along with the discarded stems of just-eaten cherries, the dark, textured ham, hulking in shadow, makes an ominous image. Suggestive without being specific, the image sketches out the realm of studio arrangement—used for fashion portrait or still life—that Penn would later perfect.

As if some perfect blend of portrait and still life, Penn's fashion photographs proved to be his earliest success. Penn gave his models a kind of character that seemed bound to ideal form, and directed their arrangement with a minimum of ostentation in metaphoric designs. Without doubt, Penn's interpretations of the couturier's art were different from earlier representations of fashion. The revolutionary series of photographs that Penn made of the 1950 Paris collections for *Vogue* simply but emphatically revised the terms on which future fashion photographs would be considered. The previous generation of photographers for *Vogue* and *Harper's Bazaar*, such as Man Ray, Cecil Beaton, Erwin Blumenfeld, and Maurice Tabard, had applied the surrealist technique of using women's bodies as an arena for psychological excavation and had made the

alterable object of the mannequin-woman stylishly acceptable. With an exaggerated, elongated torso and an expressionless face and meaningless gesture that mimicked the fragmentary plaster statues that were favored as props, she was a convenient vehicle to show how clothing looked. Penn, however, was more concerned with how clothing looked when it was photographed.

Dior's postwar dream of a "New Look," which emphasized rounded shoulders, cinched waists, and voluminous fabrics and which returned fashion from the "parsimonious era" of the war to an "art of pleasing," had by 1950 entered every designer's vocabulary.[7] Whereas, earlier, Penn might have provided a setting for his fashion model such as the one he suggested for his card players, or more extensively in an entire fashion-photographic essay titled "Flying Down to Lima" that he created for the February 15, 1949, issue of *Vogue*, now Penn realized that gesture was everything.[8] In response to the powerful line and volume of the clothes, Penn's photographs show off tall, large-boned American women with long, thin arms and elongated hands that bend impossibly at the wrist and slant up on a hip canted out from a tiny waist; cigarettes are smoked in long, elegant holders; heads push back; noses and chins thrust into the air. No mannequins, these models have character to look you in the eye. They give to the new postwar attitude of "hand-on-the-hip defiance" its most thorough development [Cat. no. 27].

Rejecting elaborate settings for fashion, Penn instead placed his models against plain backdrops, destroying any sense of space or scale, leaving the subject of fashion to speak for itself. Penn, now in tune with the new American abstract painters—by 1950 *Vogue* had illustrated work by both Jackson Pollock and Mark Rothko—sought to isolate his subjects from cultural associations of the prewar years. In his photographs the effect of natural light gave a reality to spare and artificial situations; light delineated every seam of a dress, and the texture of the cloth and the outline of the garments became paramount. A gesture with a long black glove might choreograph and define the space across a page.

Penn's fashion photographs make us aware of how style operates. The final image submitted by Penn to be published is likely to include a reference to the seamless backdrop in front of which the model stands.[9] Perhaps, as in his photograph of a Rochas dress modeled by Lisa Fonssagrives-Penn, Penn even allows a provocative—because restricted—glimpse of the studio, its starkness suggested by bare floorboards and empty walls [Cat. no. 28]. Confined to the impractical beauty of her dress, so Penn controls his model's awkward place, visually pinning her—in the legless mermaid dress, could she possibly stand alone?—onto the shallow ground of the canvas backdrop. Such artistic dominance jars us out of our usual immersion in the fashion pitch.

Always remarkable in a Penn photograph is the care with which he poses and arranges his subjects within the rectangle at his disposal. It is far from the appearance of accident. Yet—almost magically—it is the way in which his models

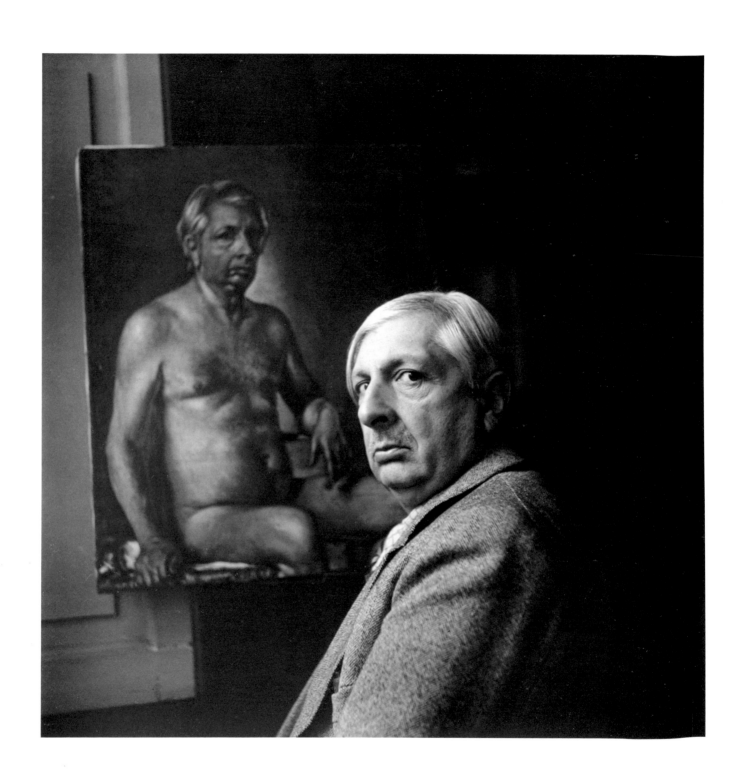

1. Giorgio de Chirico, *Rome, 1944*

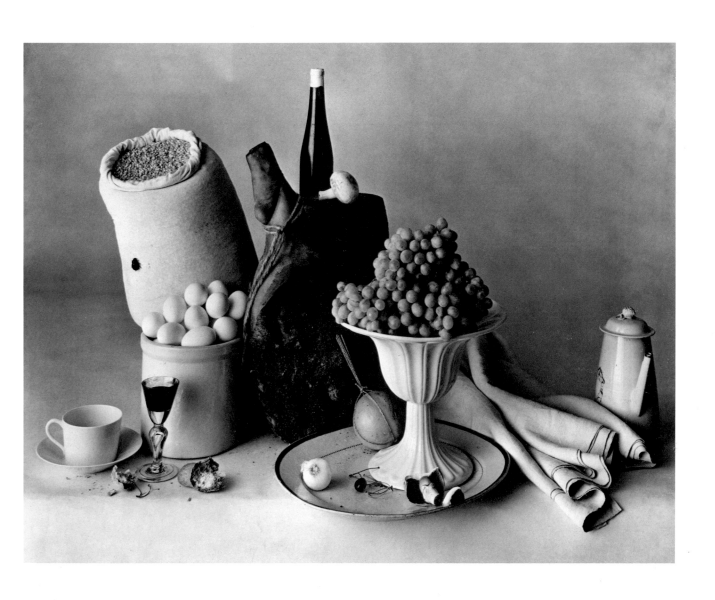

2. Still Life with Food, *New York, 1947*

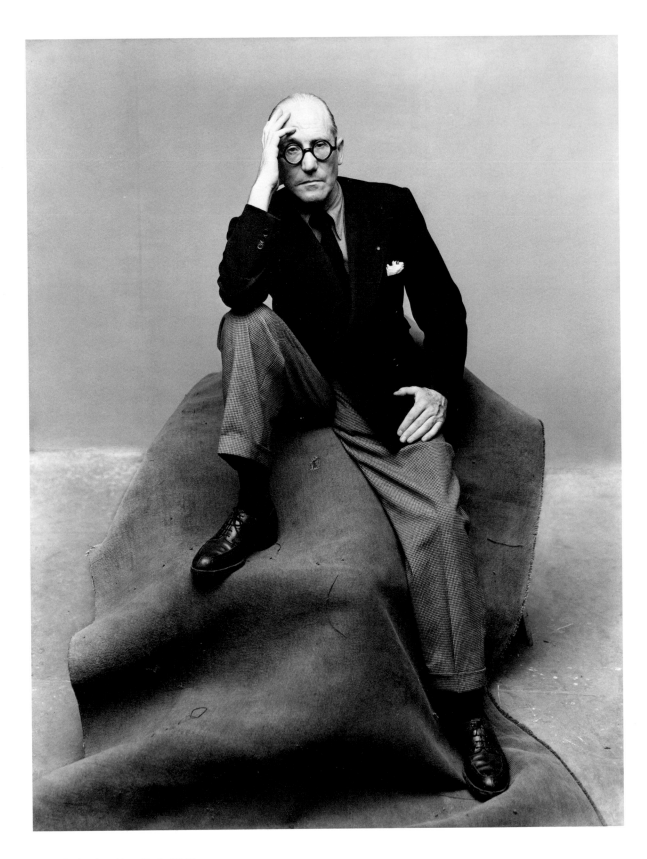

3. Le Corbusier, *New York, 1947*

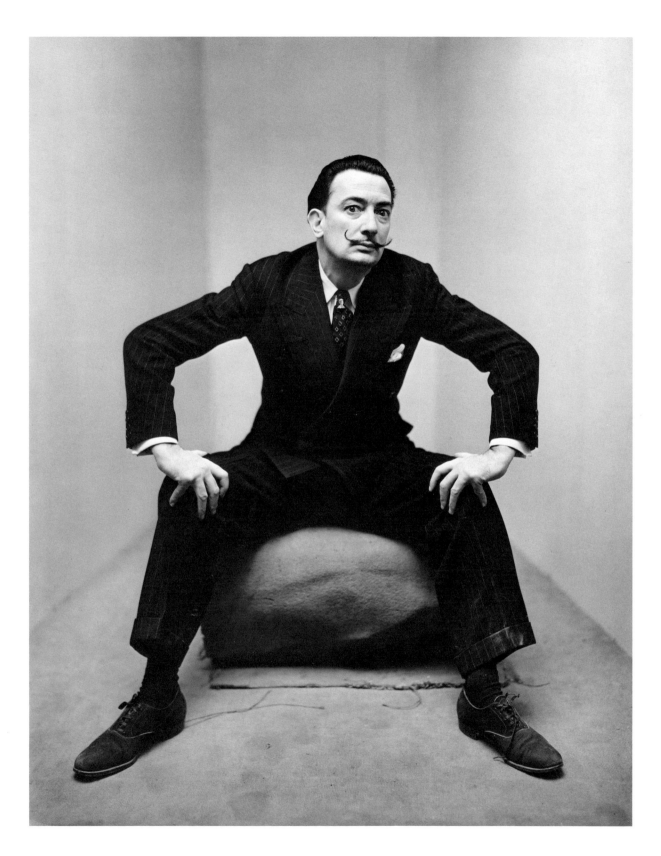

4. Salvador Dali, *New York, February 20, 1947*

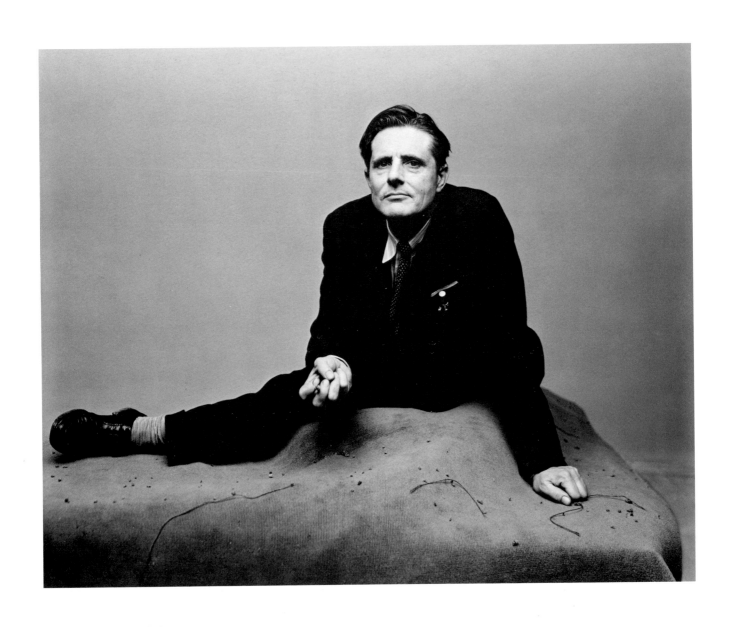

5. Stanley William Hayter, *New York, July 10, 1947*

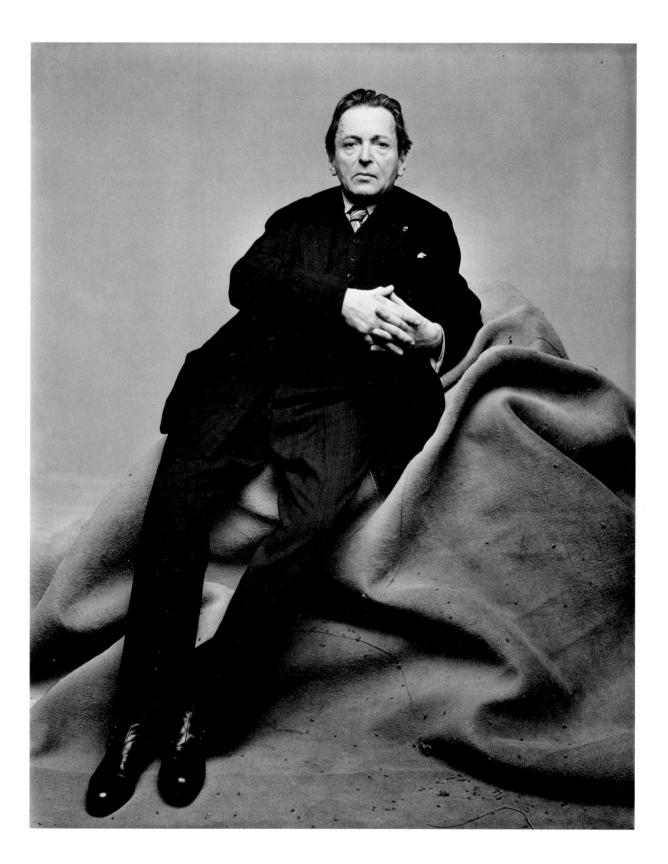

6. Georges Enesco, *New York, January 24, 1948*

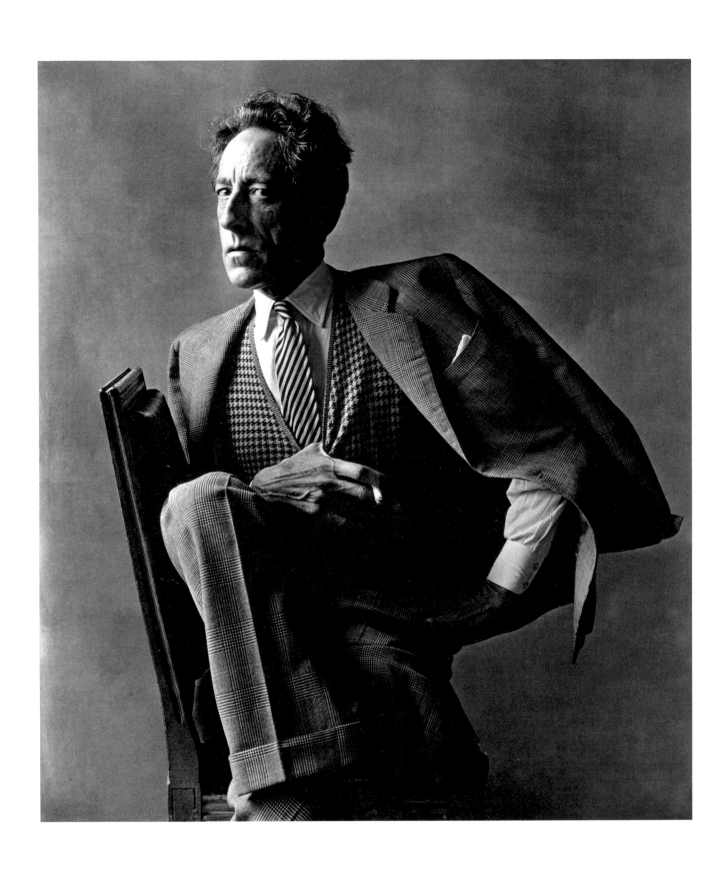

7. Jean Cocteau, *Paris, 1948*

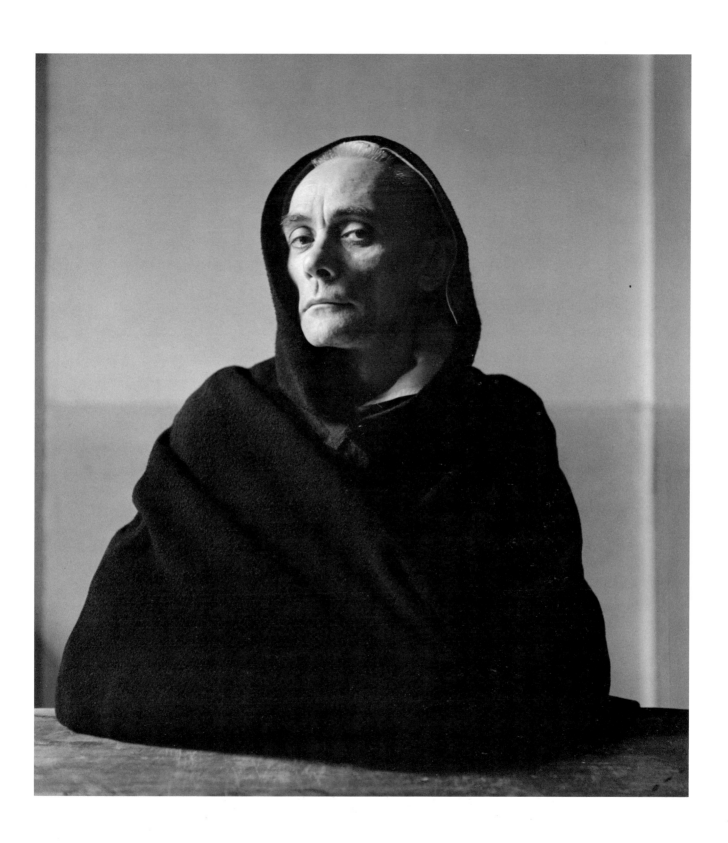

8. Père Couturier, *Paris, July 26, 1948*

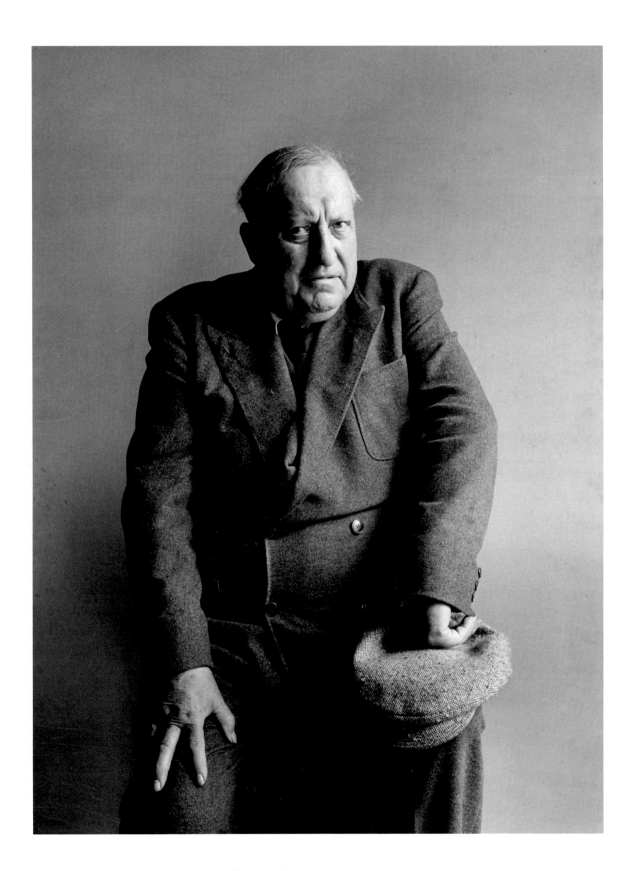

9. André Derain, *St. Germain, France, July 26, 1948*

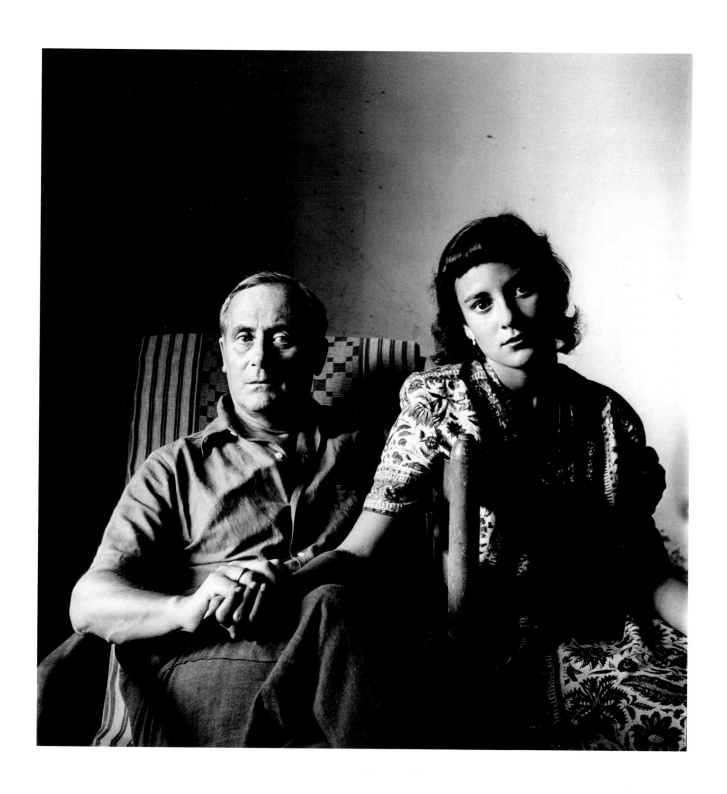

10. Joan Miró and Daughter, Dolores, *Tarragona, Spain, November 5, 1948*

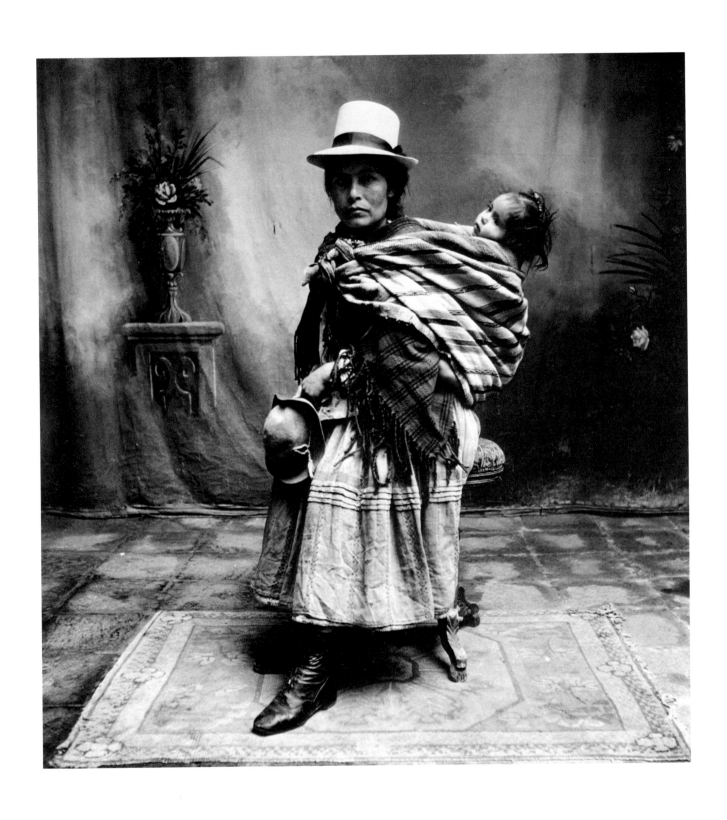

11. Cuzco Woman with High Shoes, *1948*

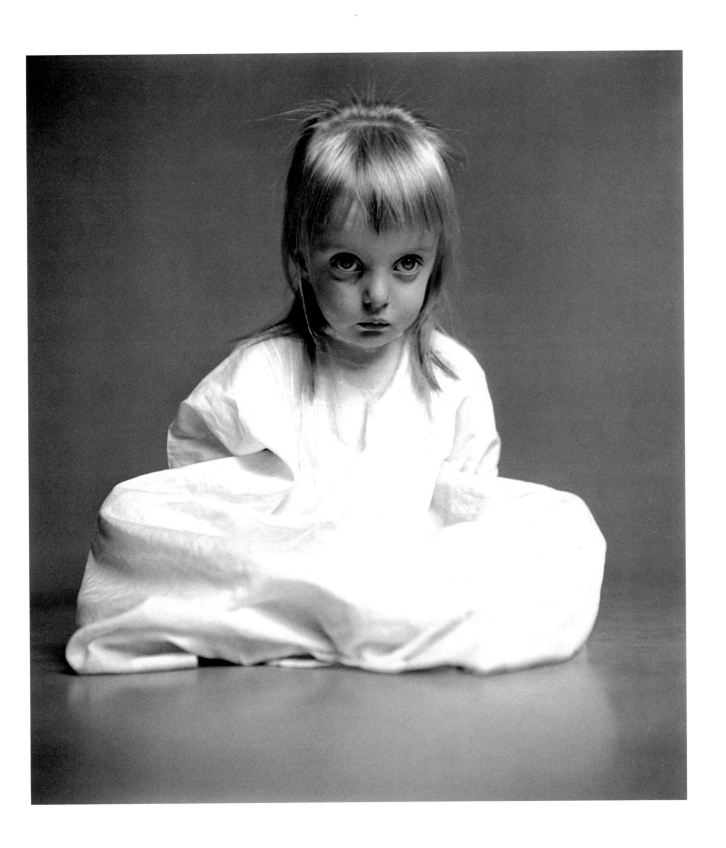

12. New York Child (Juliet Auchincloss), *New York, May 26, 1949*

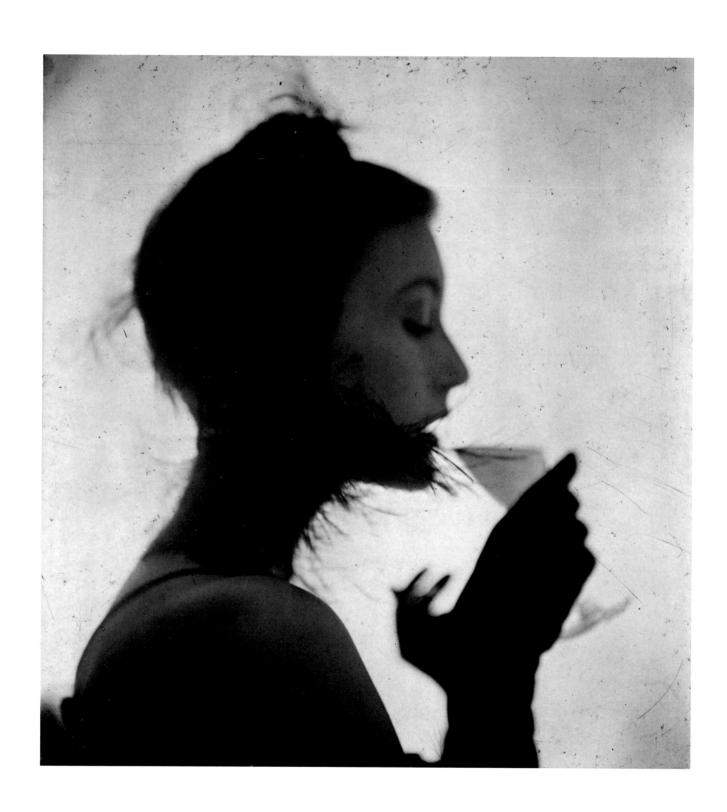

13. Girl Drinking (Mary Jane Russell), *New York, 1949*

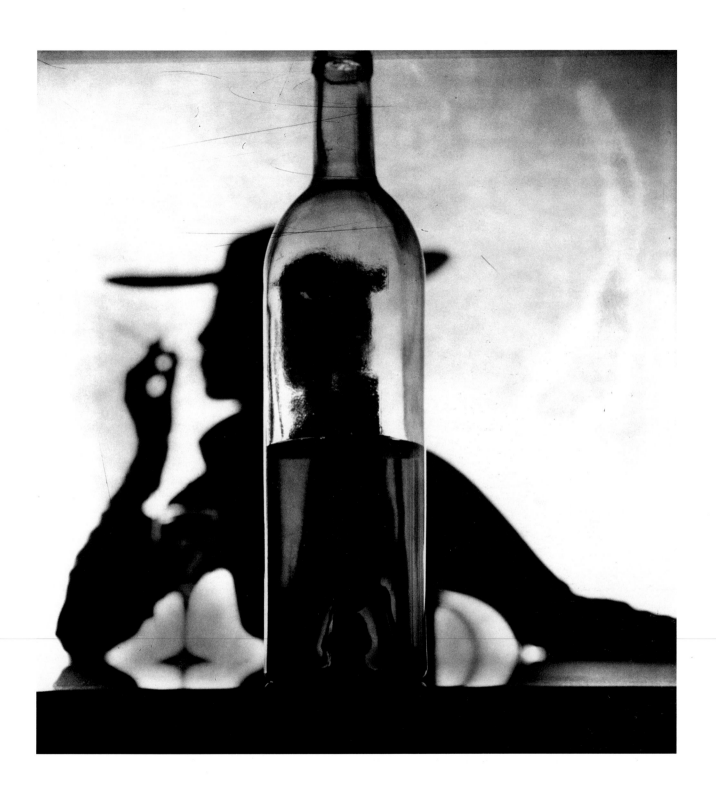

14. Girl Behind Bottle, *New York, 1949*

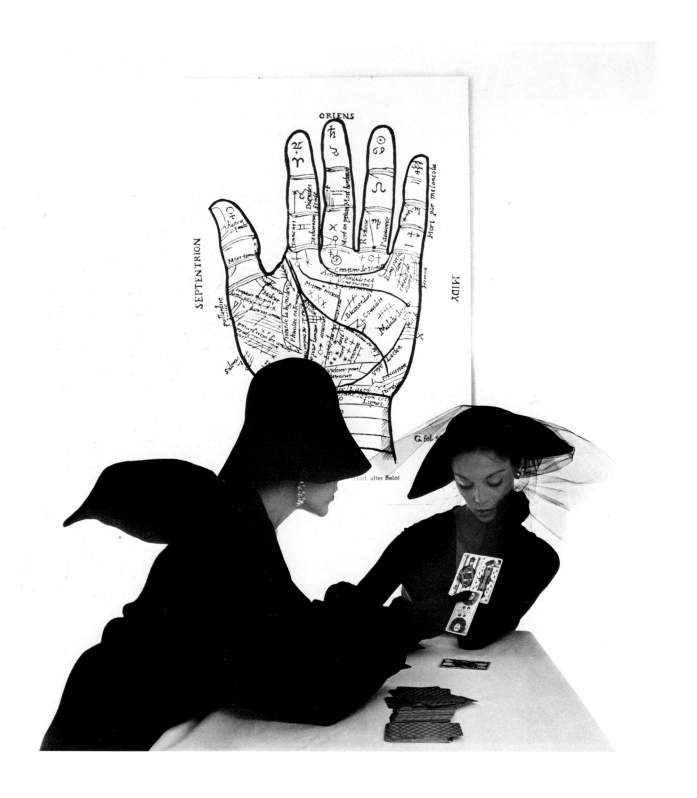

15. The Tarot Reader (Jean Patchett and Bridget Tichenor), *New York, 1949*

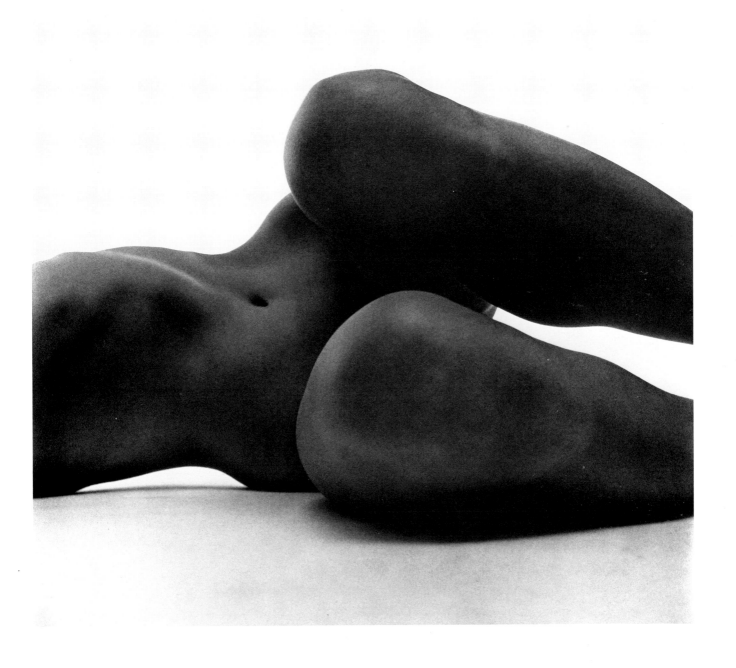

16. Nude No. 58, *New York, 1949—1950*

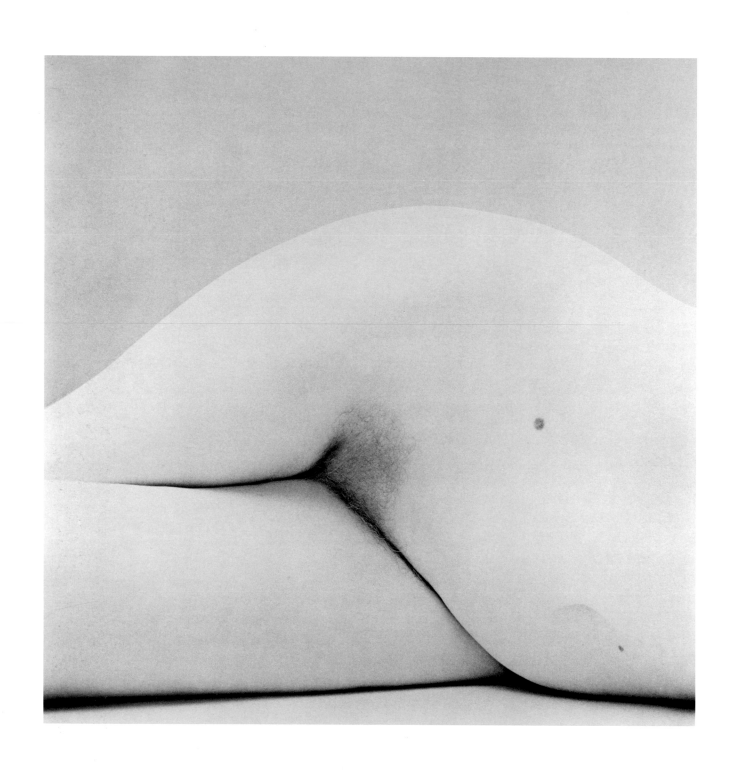

17. Nude No. 147, *New York, 1949–1950*

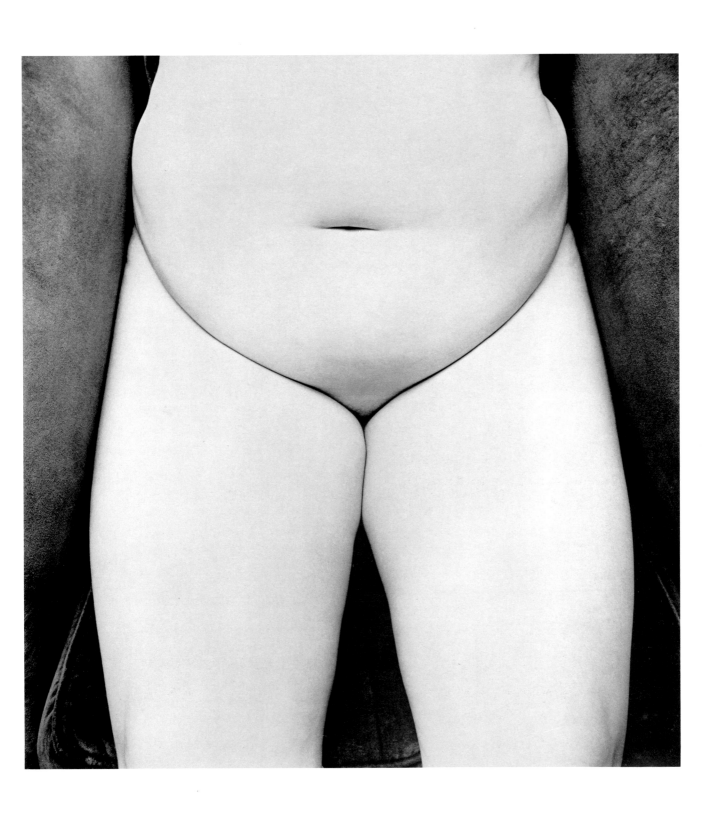

18. Nude No. 150, *New York, 1949–1950*

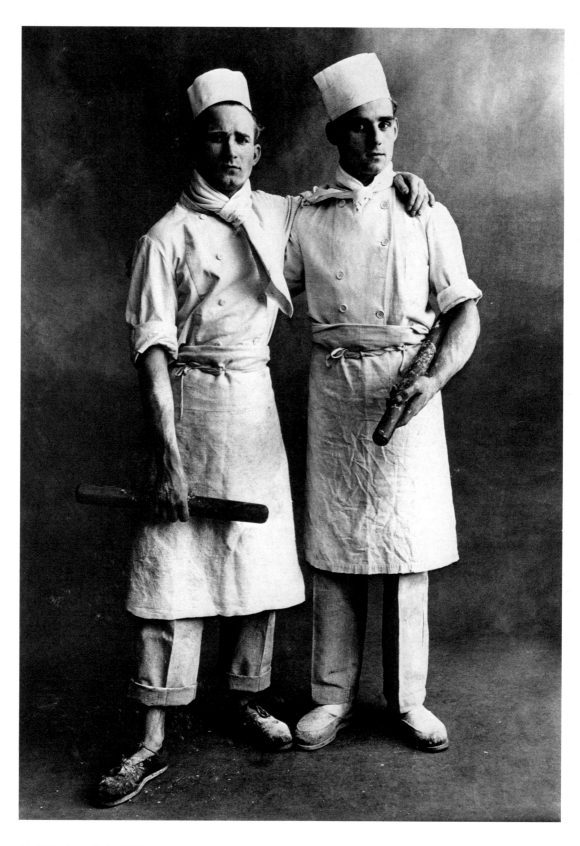

19. Pâtissiers, *Paris, 1950*

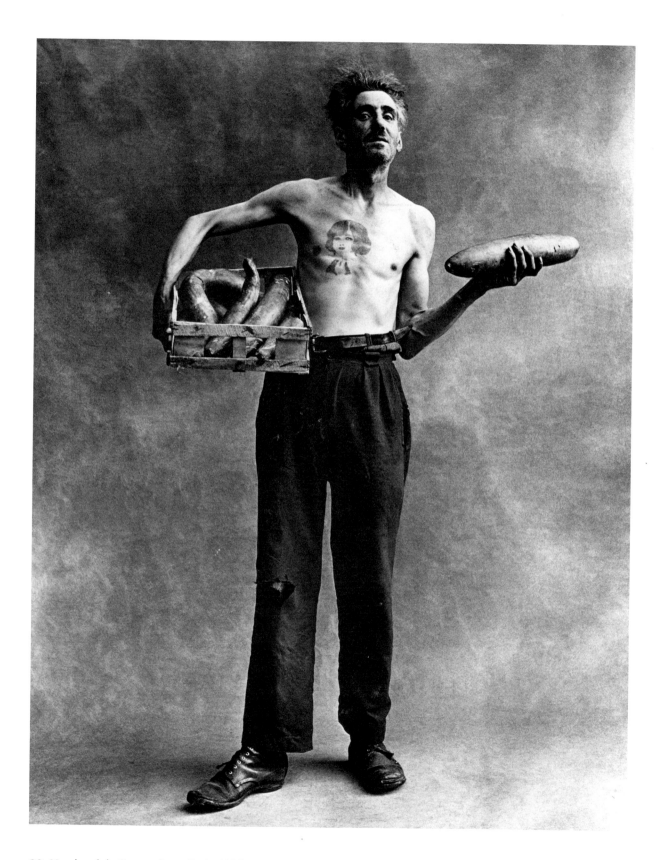

20. Marchand de Concombres, *Paris, 1950*

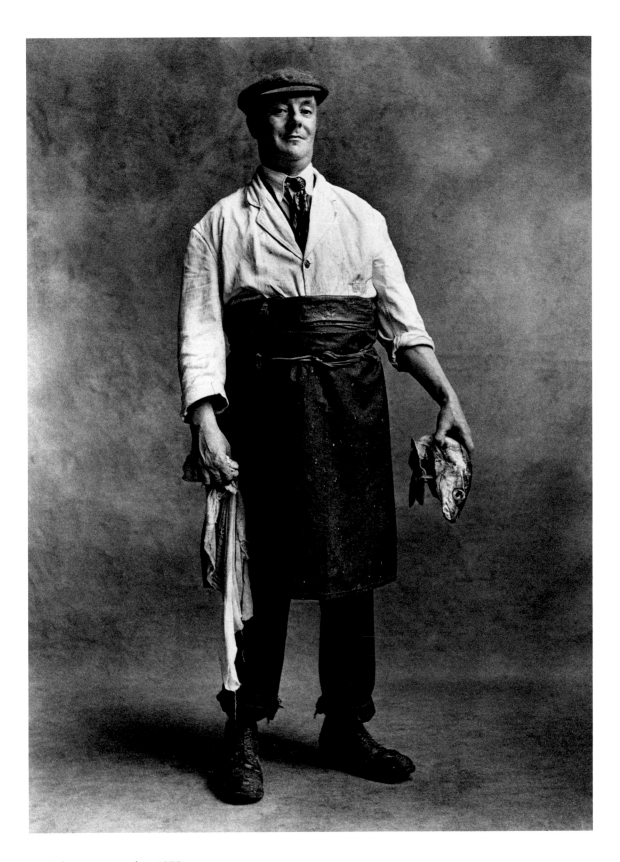

21. Fishmonger, *London, 1950*

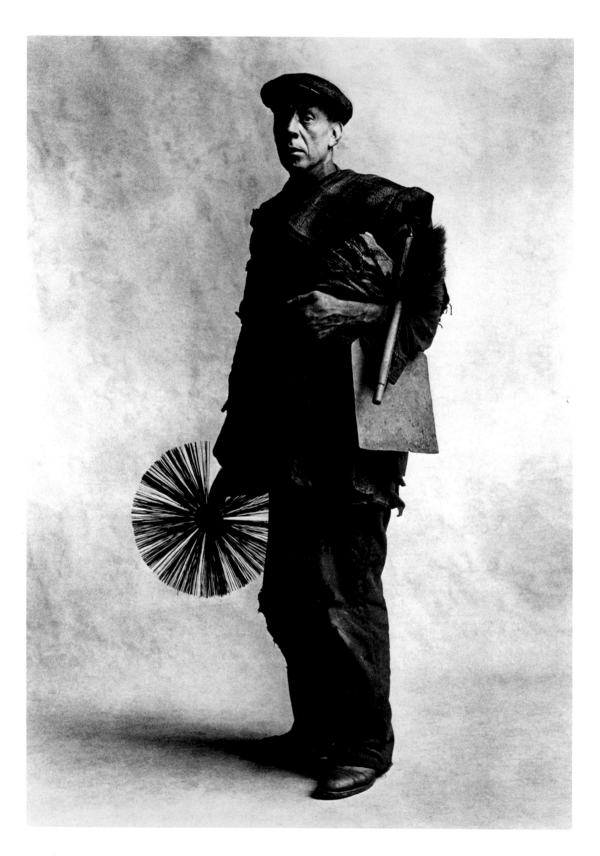

22. Chimney Sweep, *London, 1950*

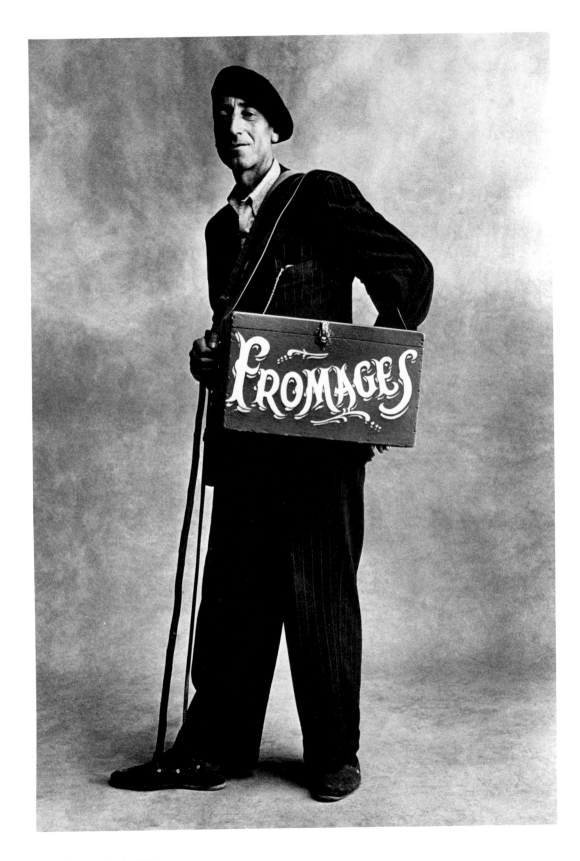

23. Chevrier, *Paris, 1950*

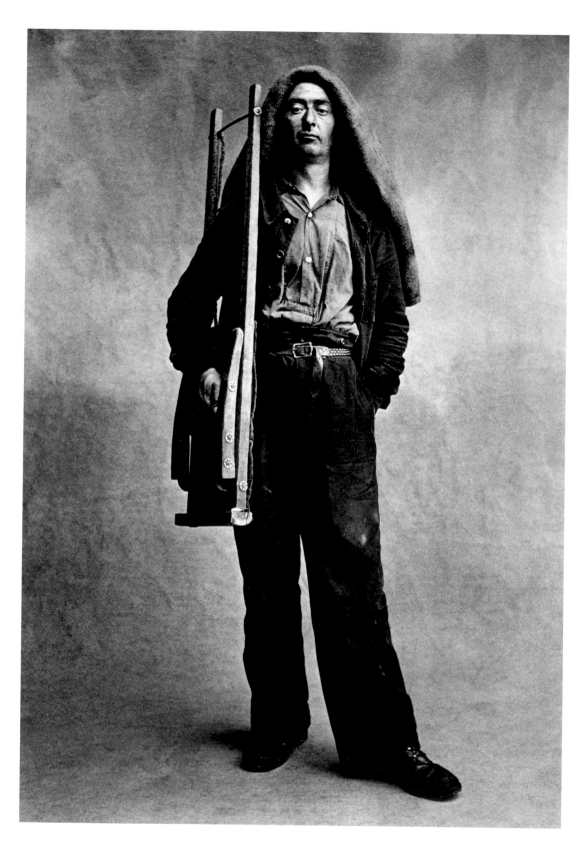

24. Charbonnier, *Paris, 1950*

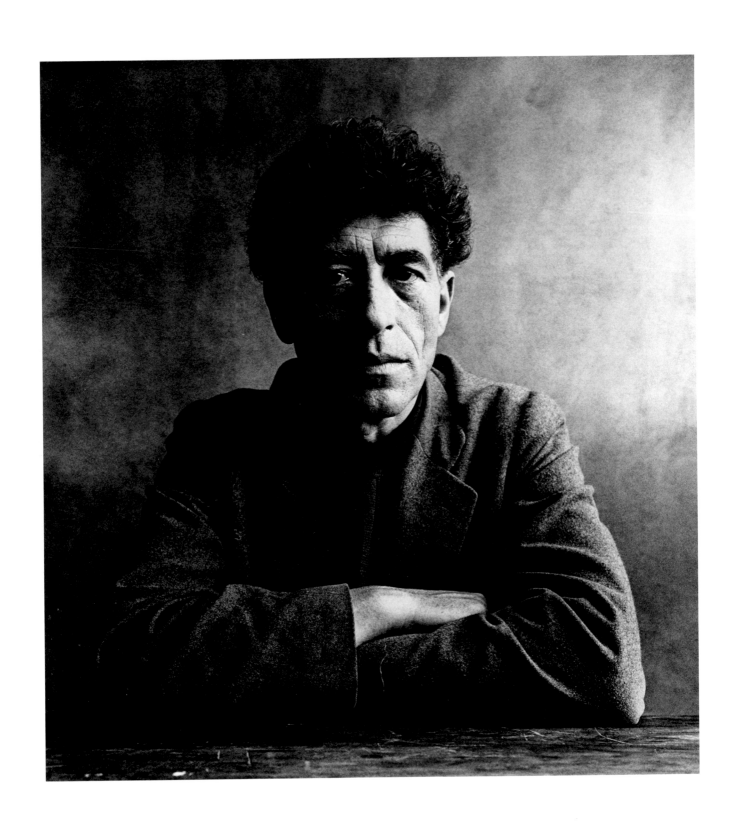

25. Alberto Giacometti, *Paris, 1950*

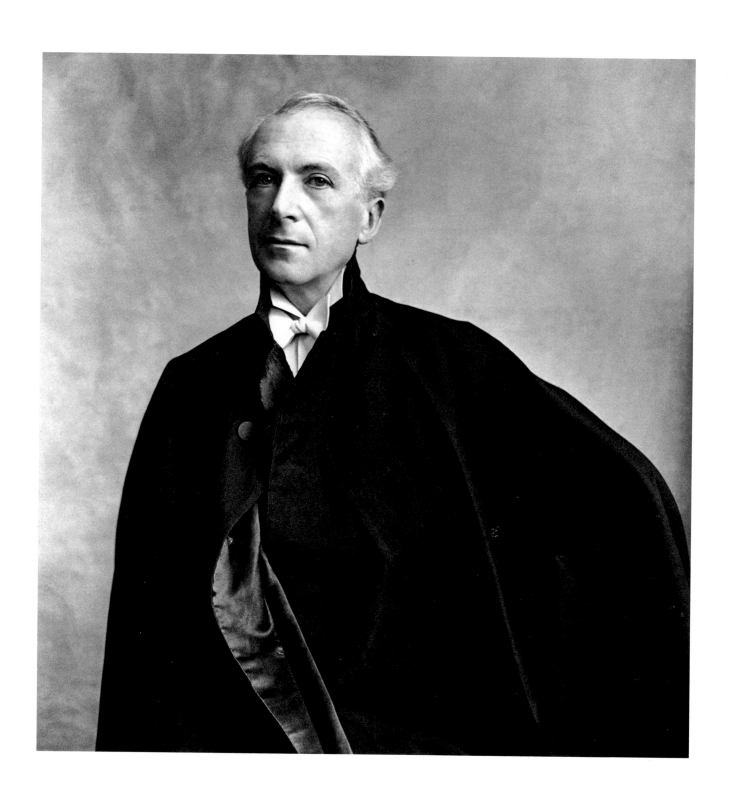

26. Cecil Beaton, *London, 1950*

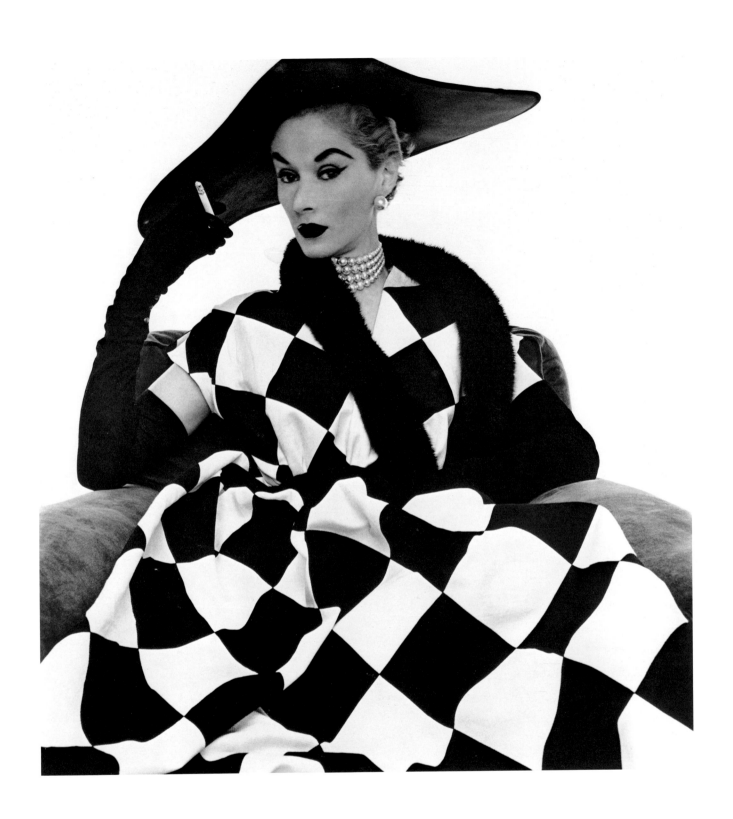

27. Harlequin Dress (Lisa Fonssagrives-Penn), *New York, 1950*

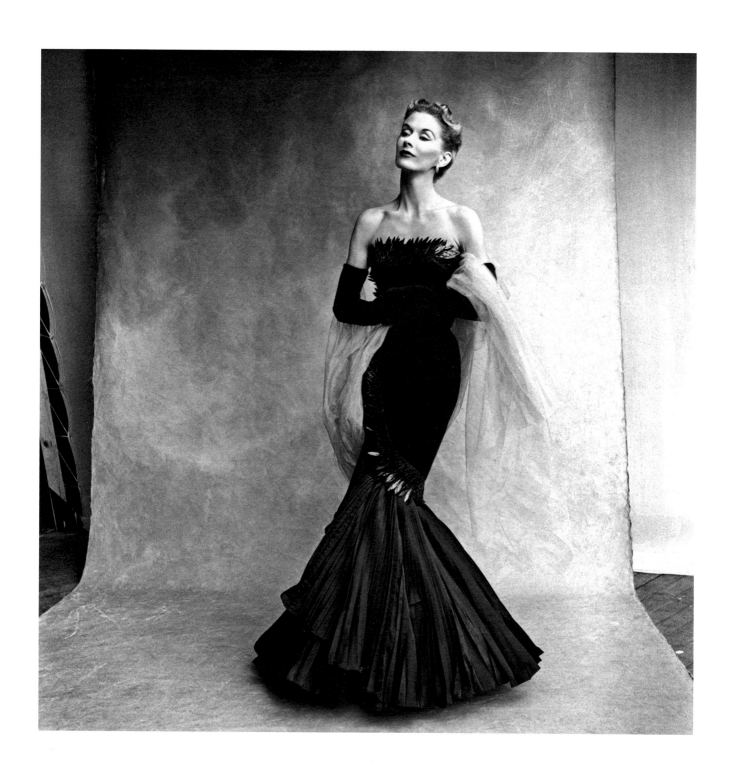

28. Rochas Mermaid Dress (Lisa Fonssagrives-Penn), *Paris, 1950*

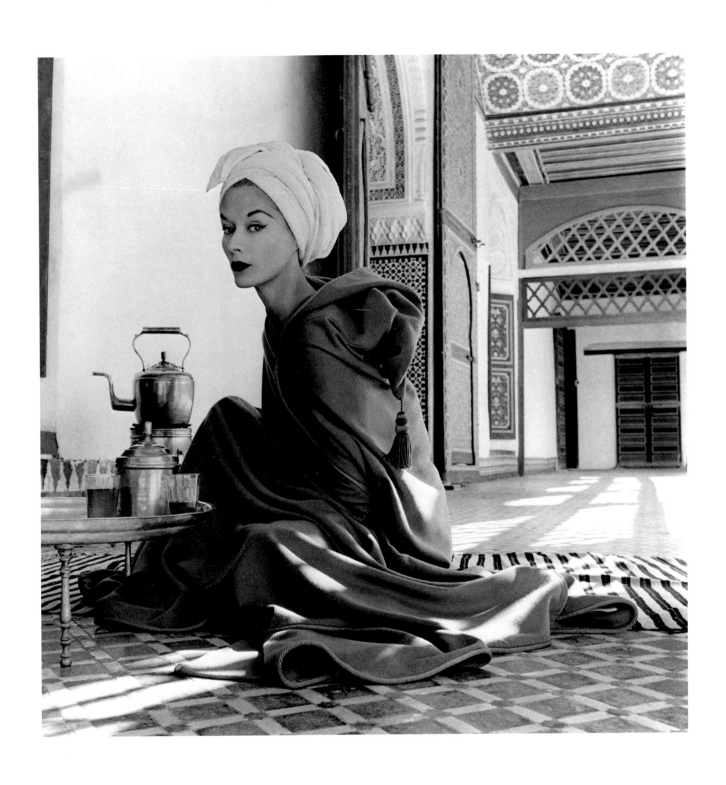

29. Woman in Moroccan Palace (Lisa Fonssagrives-Penn), *Marrakech, 1951*

30. Woman in Dior Hat with Martini (Lisa Fonssagrives-Penn), *New York, 1952*

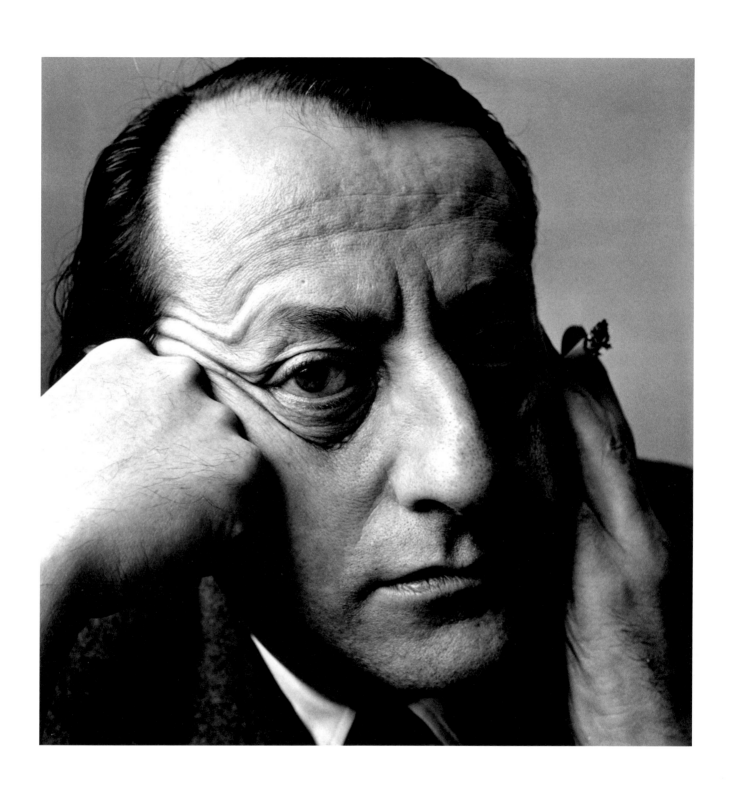

31. André Malraux, *New York, 1954*

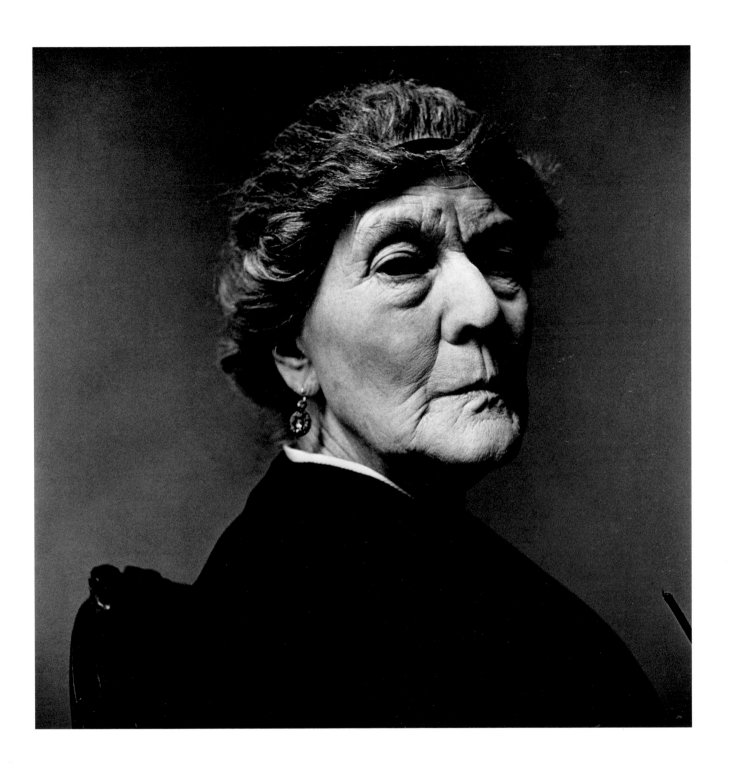

32. Ivy Compton Burnett, *London, 1958*

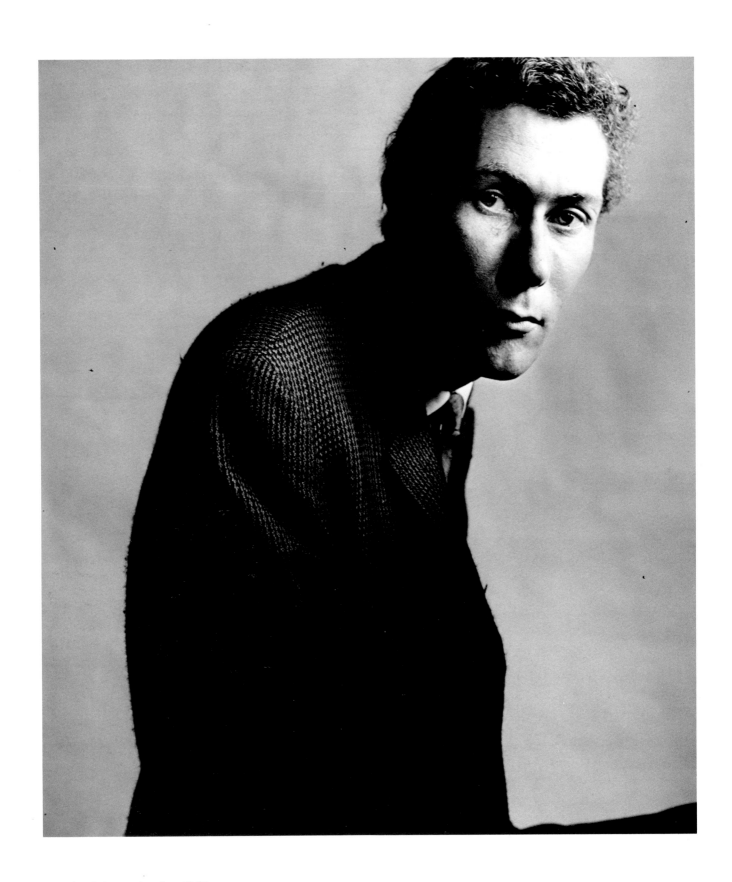

33. John Osborne, *London, 1958*

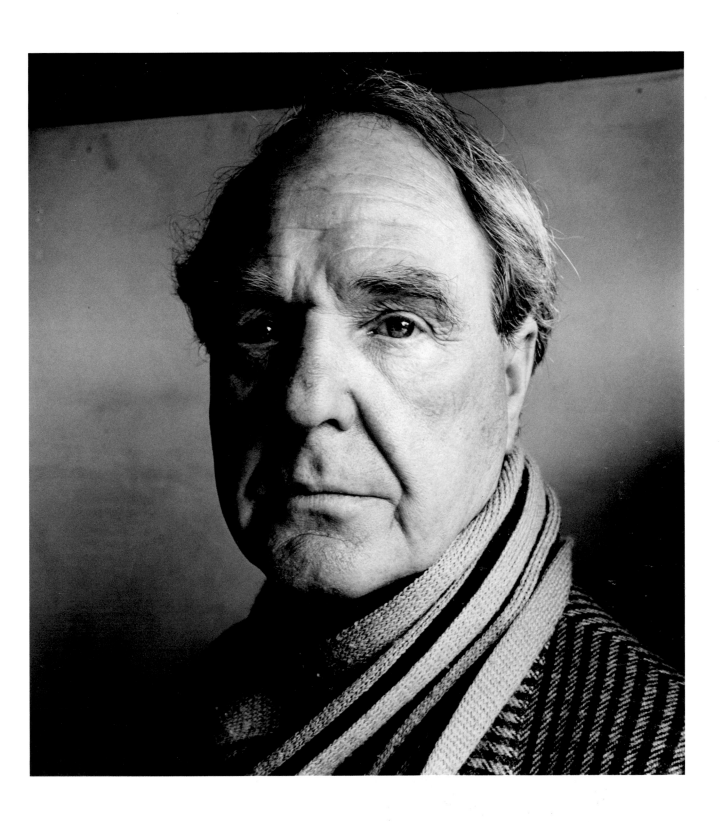

34. Henry Moore, *Much Hadham, England, 1962*

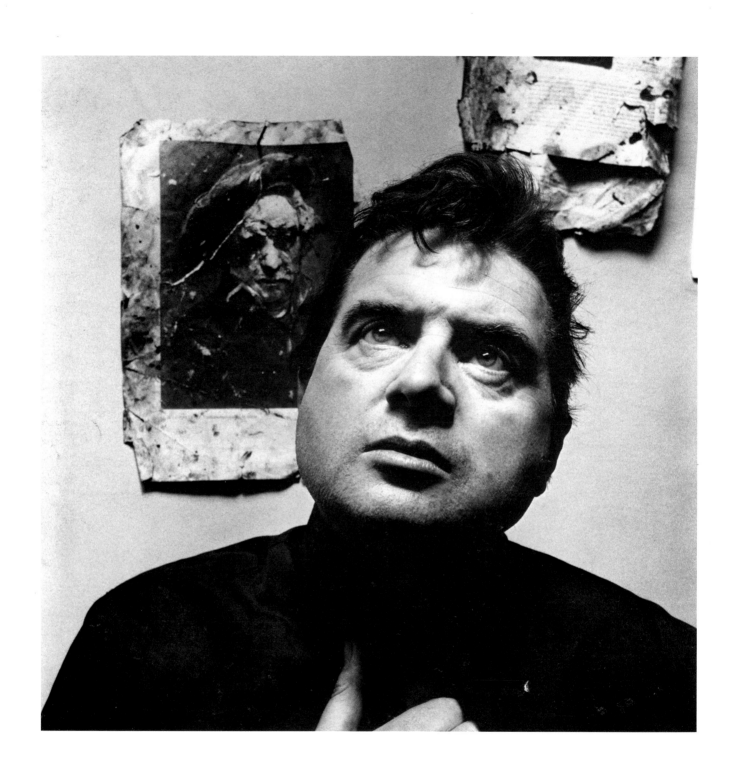

35. Francis Bacon, *London, 1962*

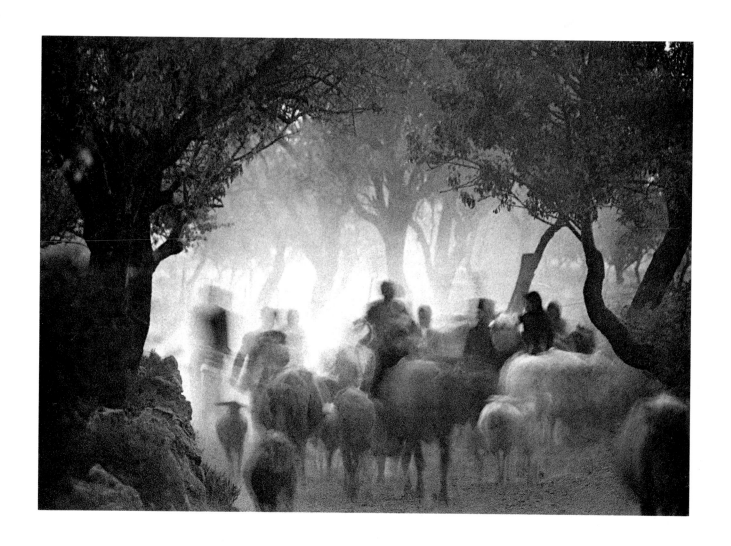

36. Cretan Landscape, *1964*

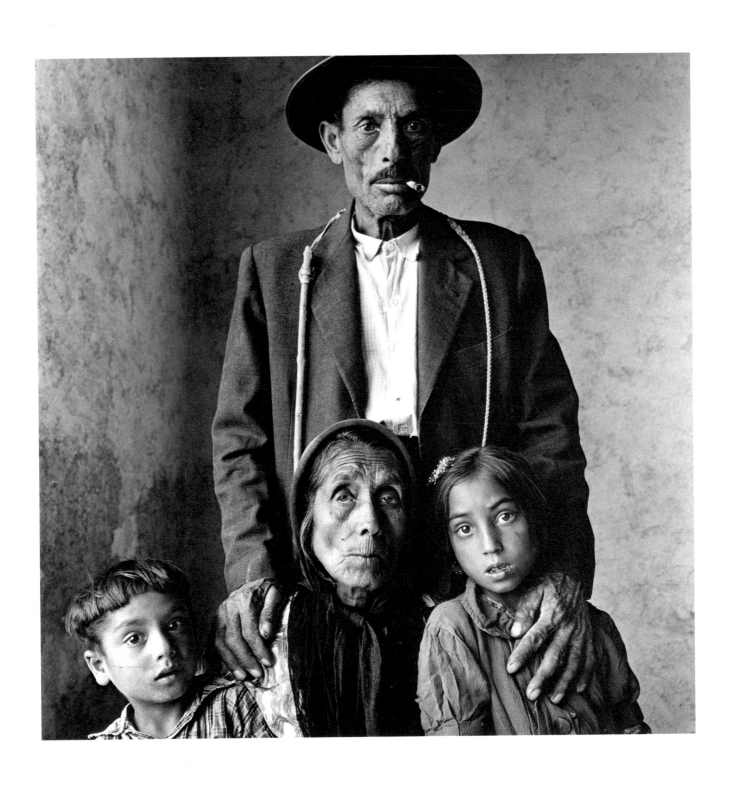

37. Gypsy Family, *Extremadura, 1965*

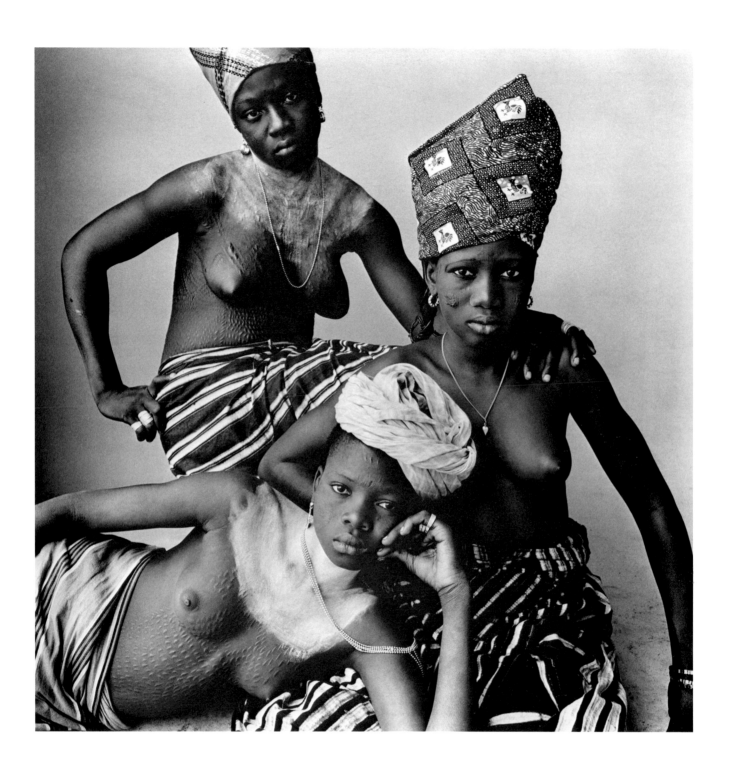

38. Three Dahomey Girls, One Reclining, *1967*

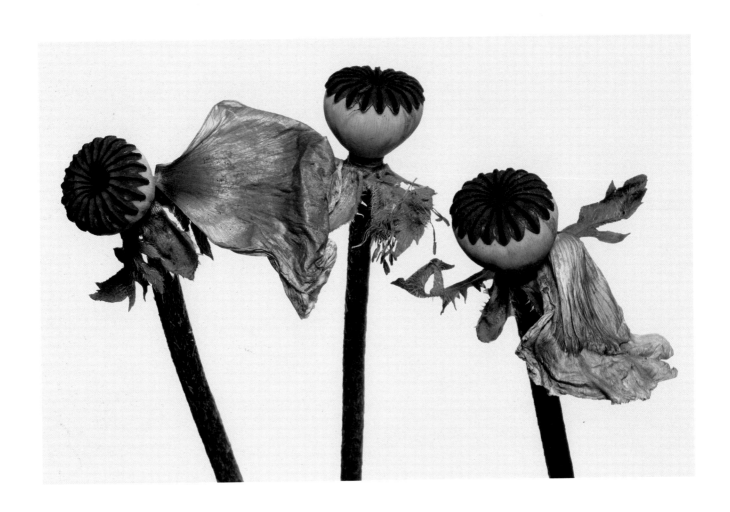

39. Single Oriental Poppy, *New York, 1968*

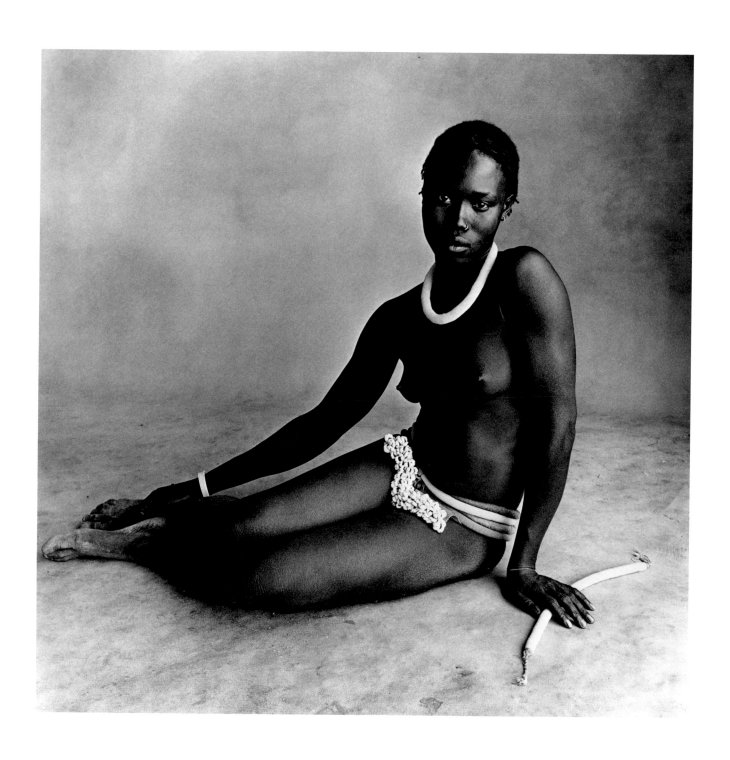

40. Nubile Young Beauty of Diamaré, *Cameroon, 1969*

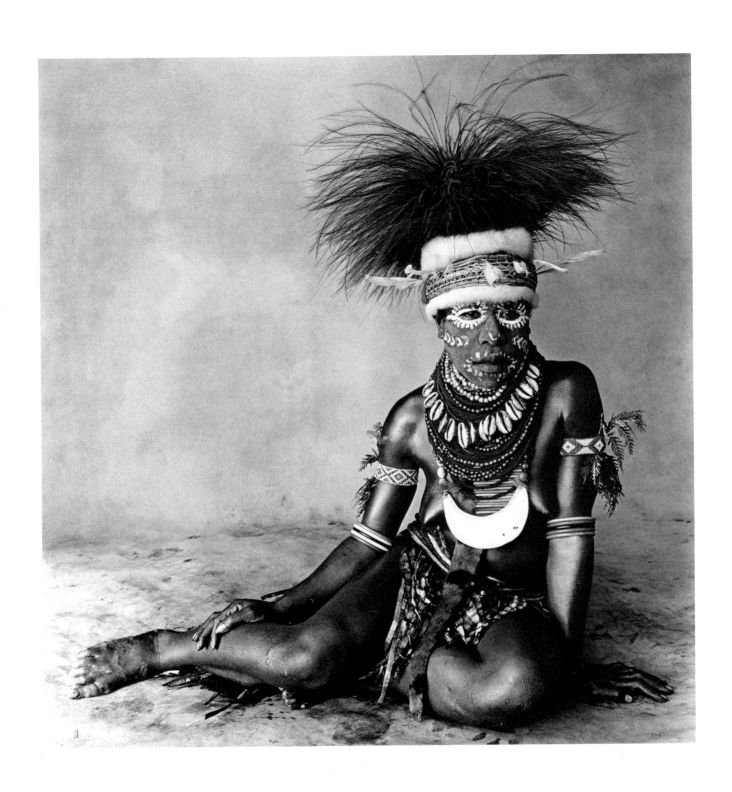

41. Sitting Enga Woman, *New Guinea, 1970*

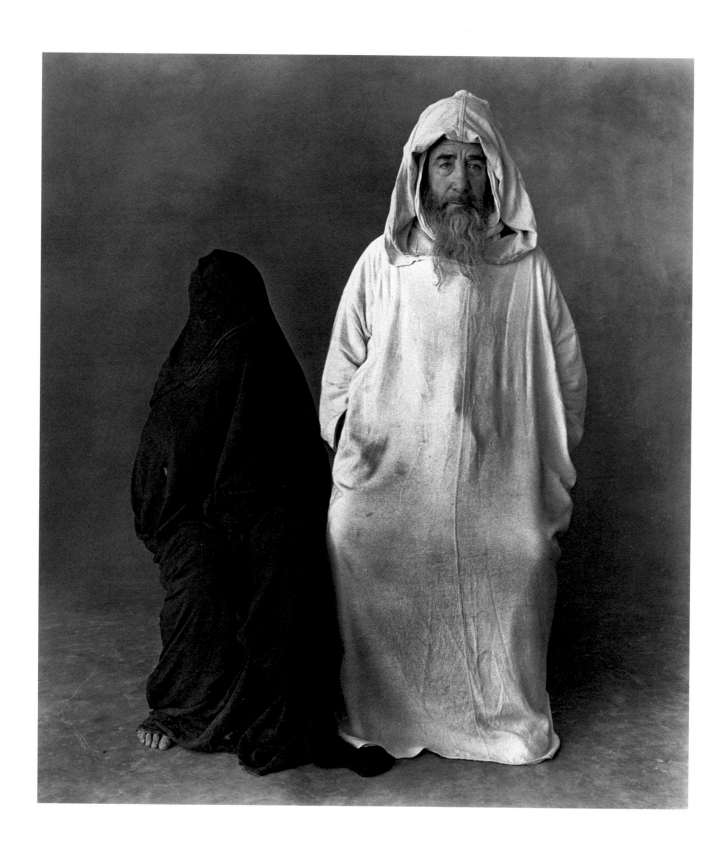

42. Man in White, Woman in Black, *Morocco, 1971*

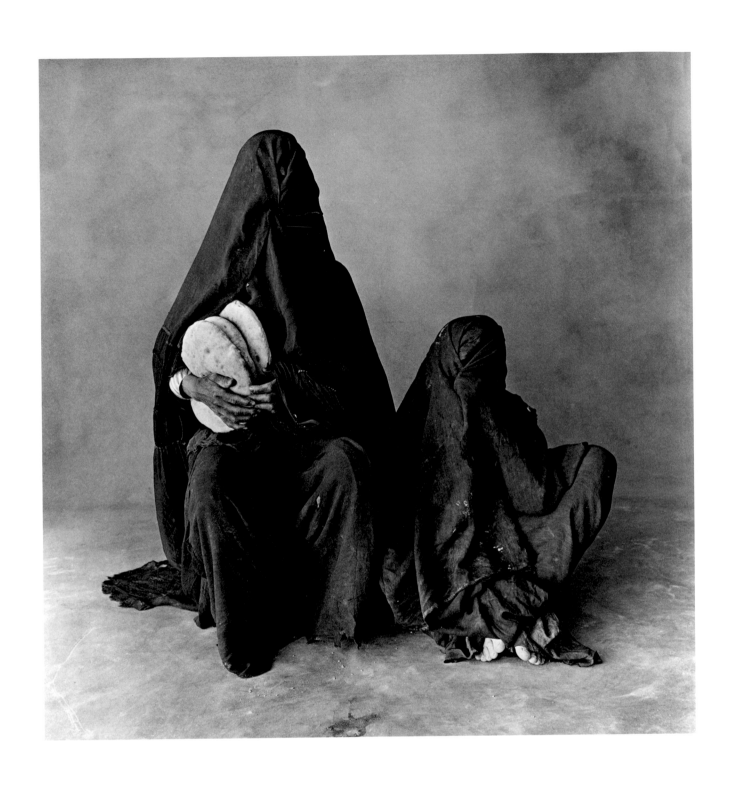

43. Two Rissani Women in Black with Bread, *Morocco, 1971*

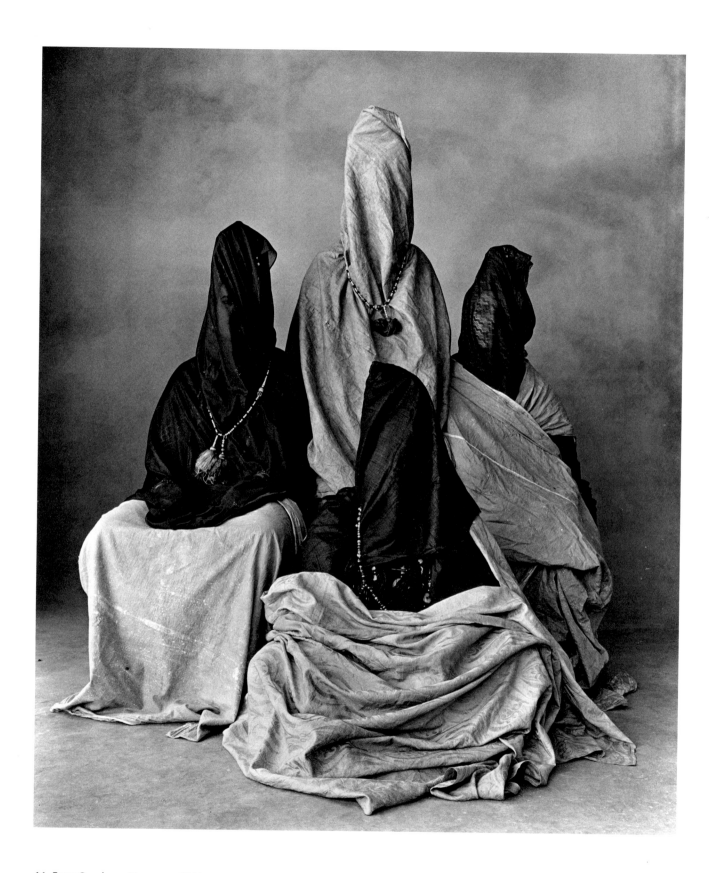

44. Four Guedras, *Morocco, 1971*

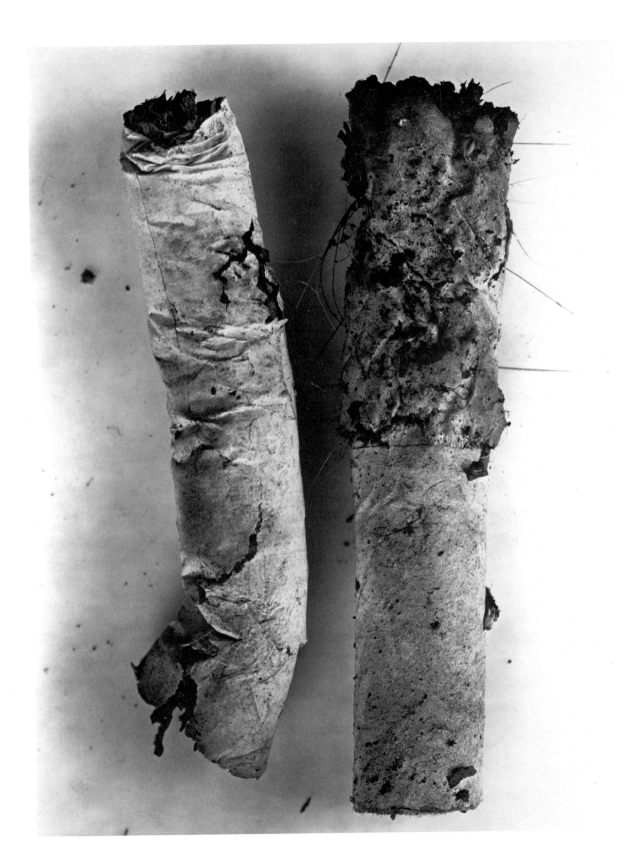

45. Cigarette No. 17, *New York, 1972*

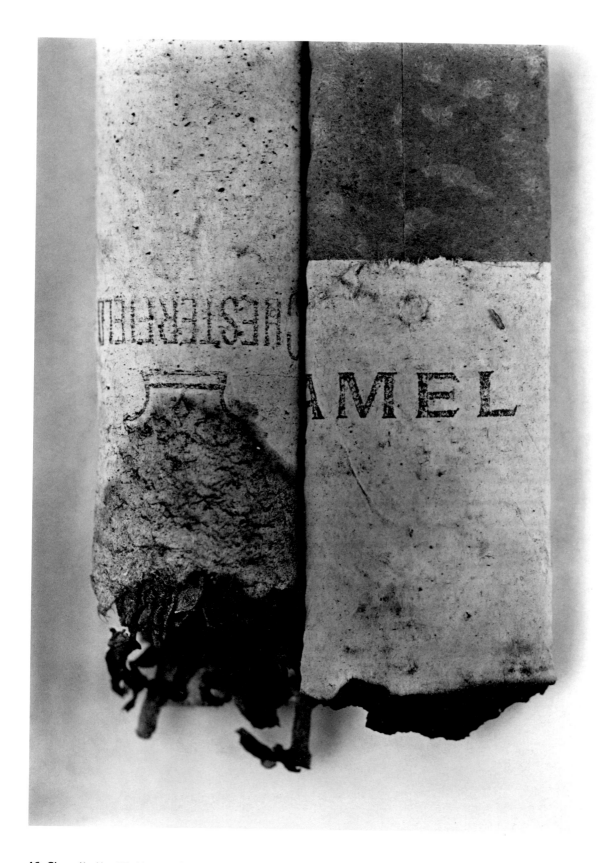

46. Cigarette No. 37, *New York, 1972*

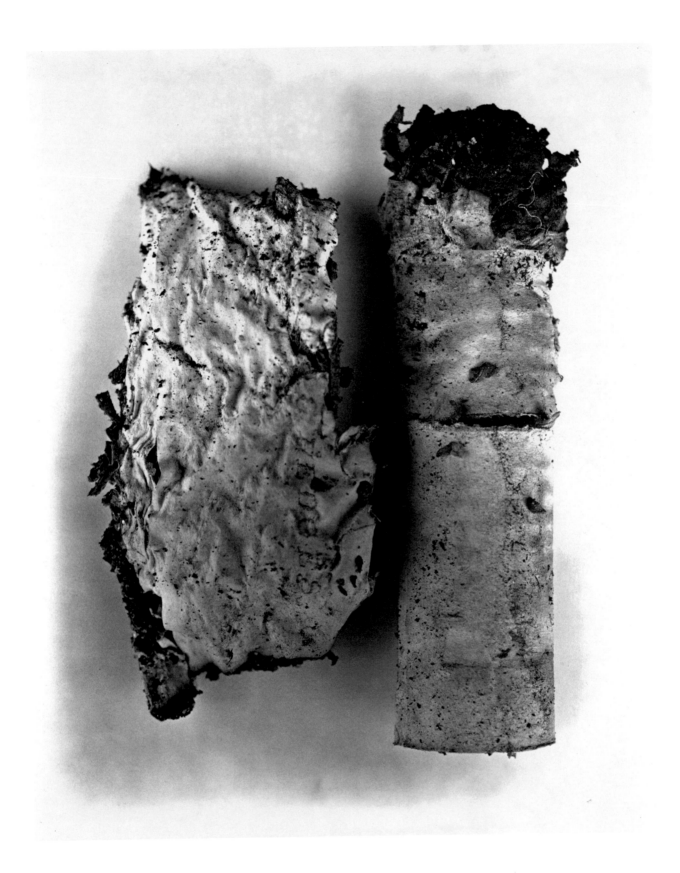

47. Cigarette No. 42, *New York, 1972*

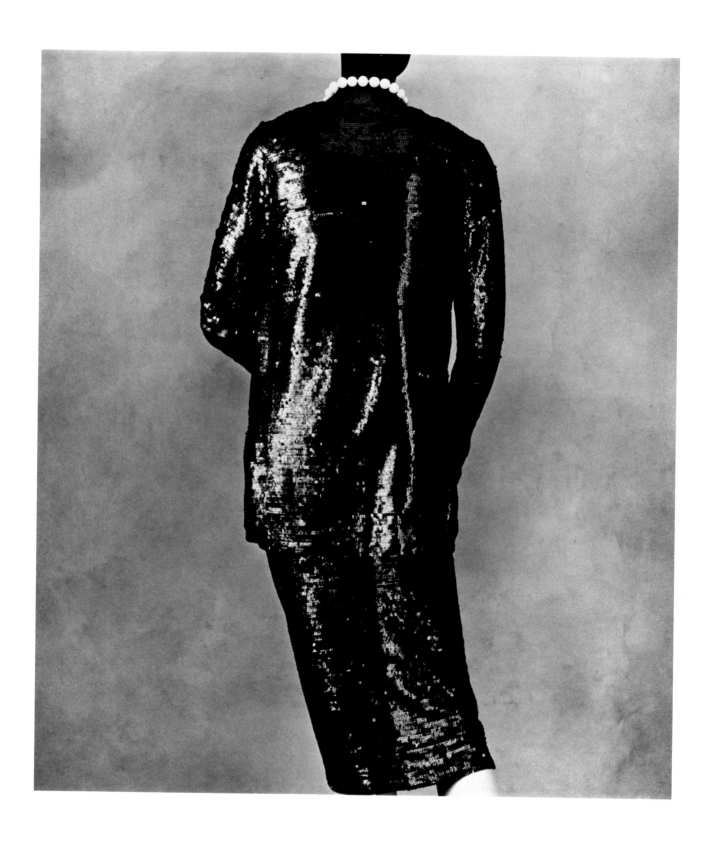

48. Chanel Sequined Suit, *New York, 1974*

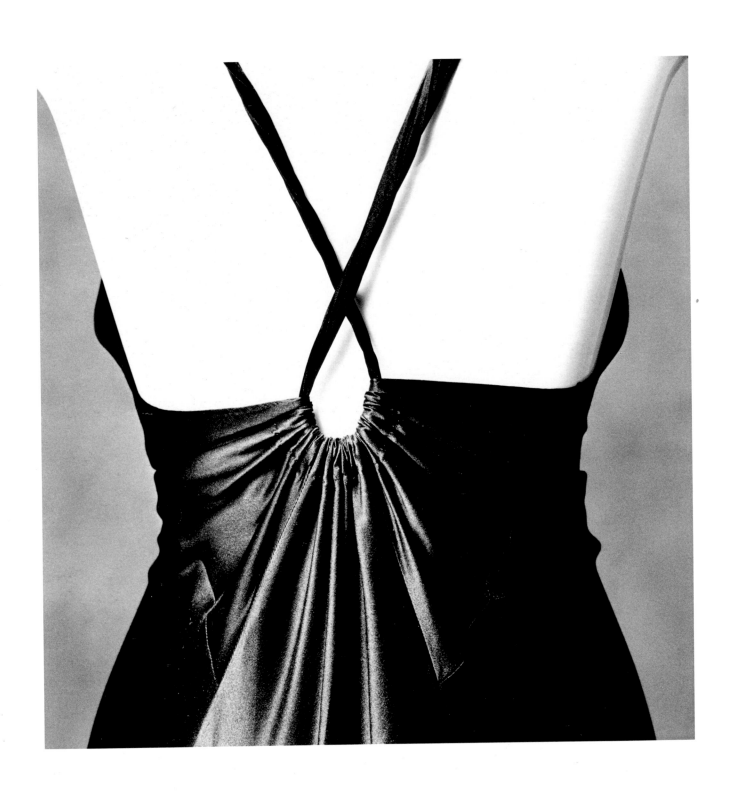

49. Vionnet Harness Dress, *New York, 1974*

50. Callot Swallow Tail Dress, *New York, 1974*

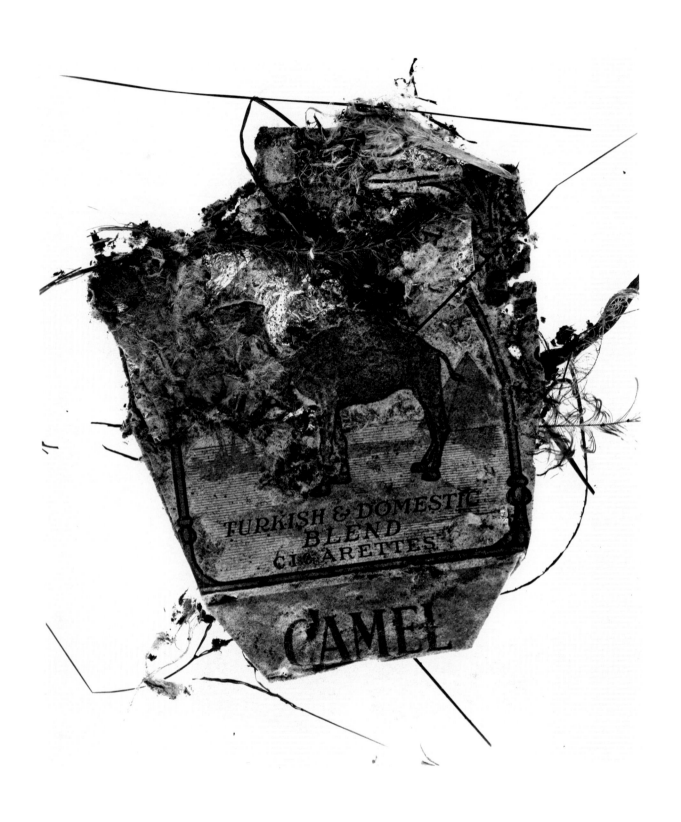

51. Camel Pack, *New York, 1975*

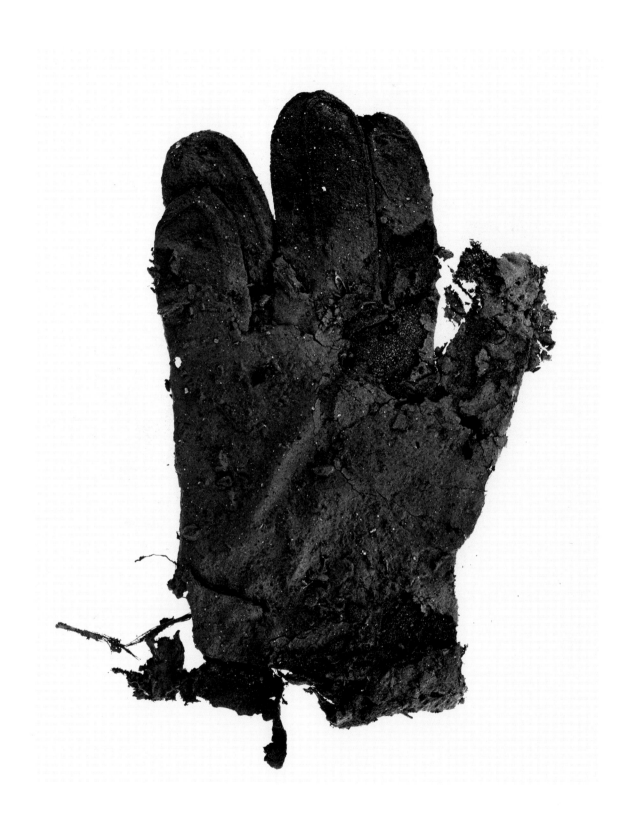

52. Mud Glove, *New York, 1975*

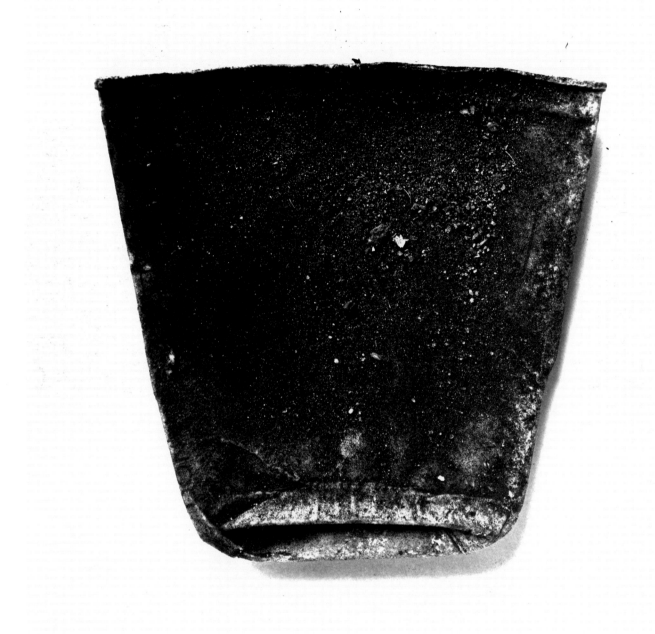

53. Paper Cup with Shadow, *New York, 1975*

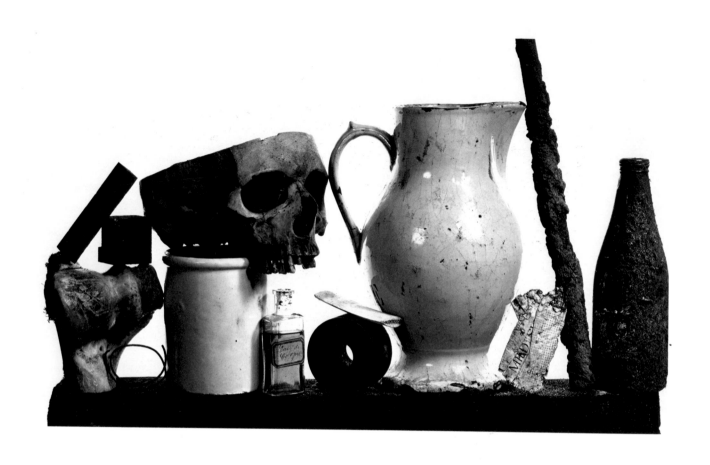

54. Composition with Pitcher and Eau de Cologne, *New York, December 7, 1979*

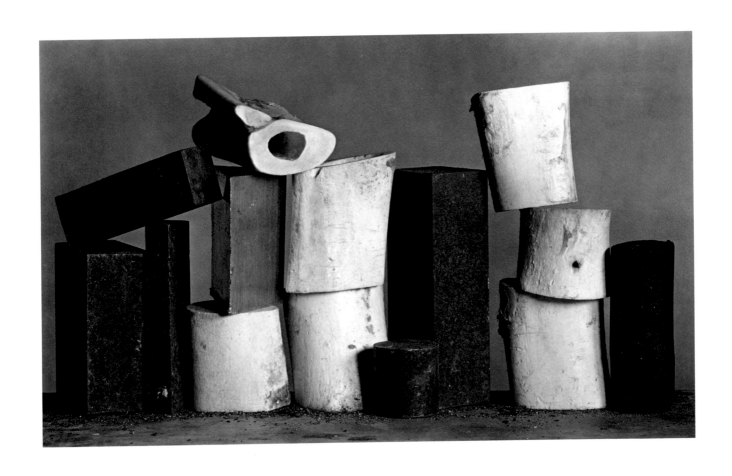

55. Seven Metal, Seven Bone, *New York, February 1980*

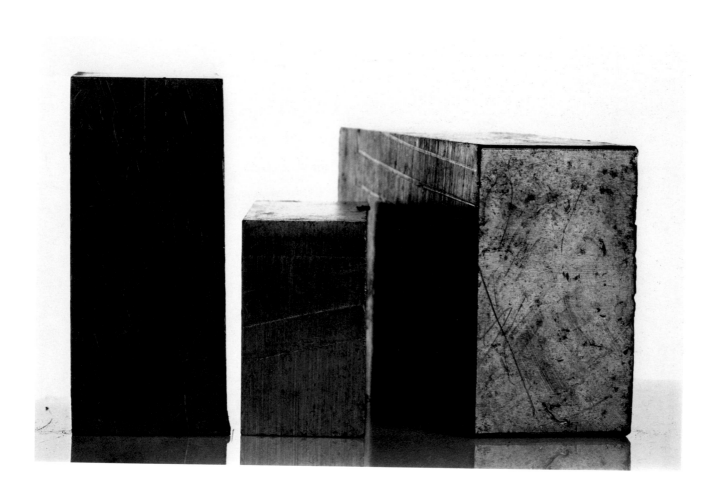

56. Three Steel Blocks, *New York, April 1980*

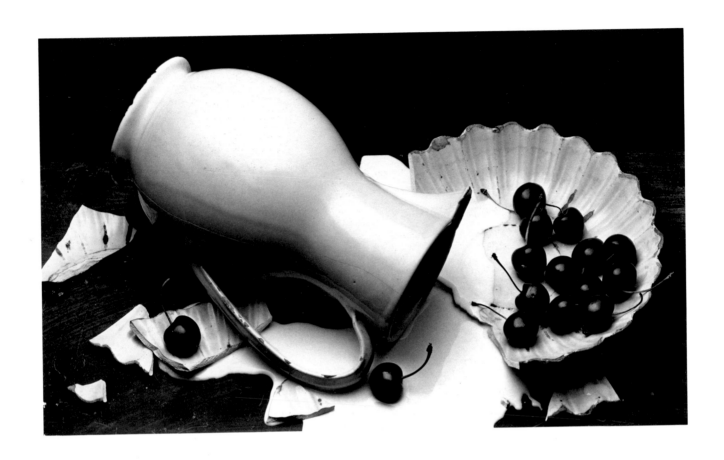

57. The Spilled Cream, *New York, June 12, 1980*

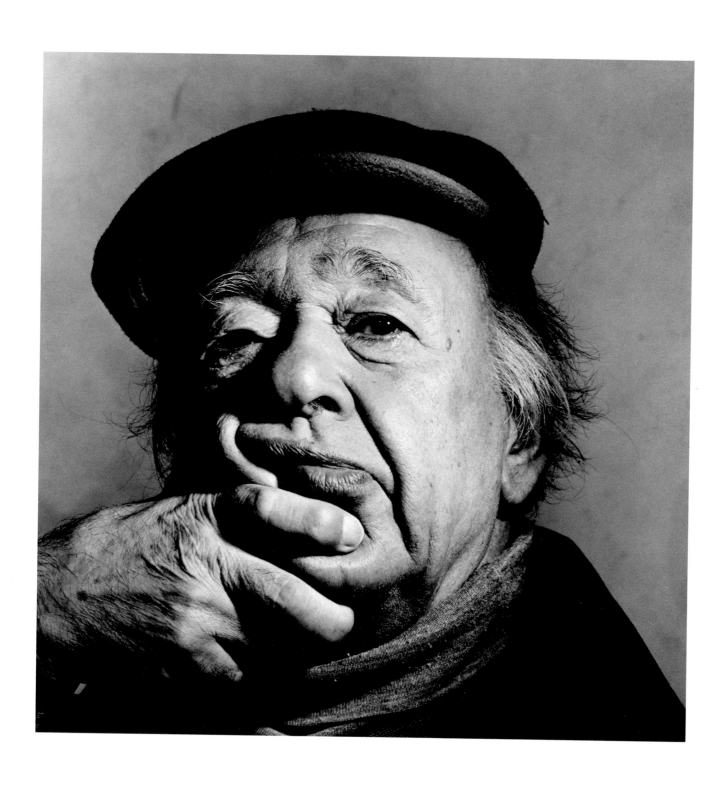

58. Eugène Ionesco, *New York, October 21, 1983*

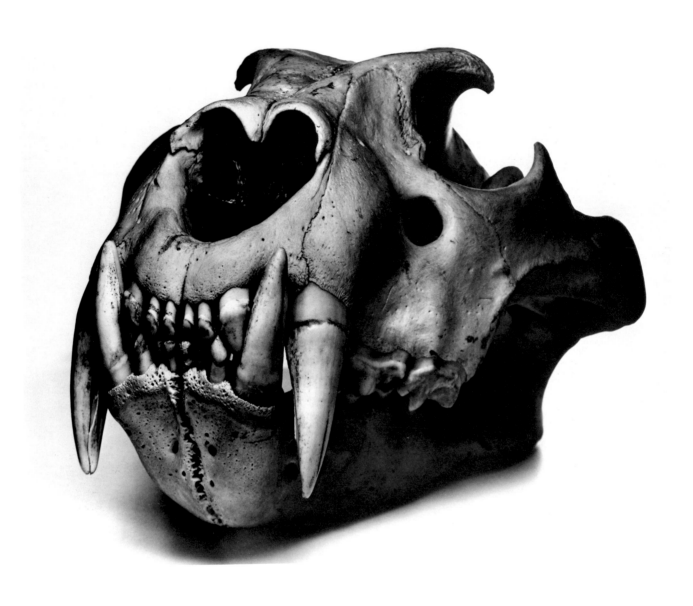

59. Lion, 3/4 View, *Prague, 1986*

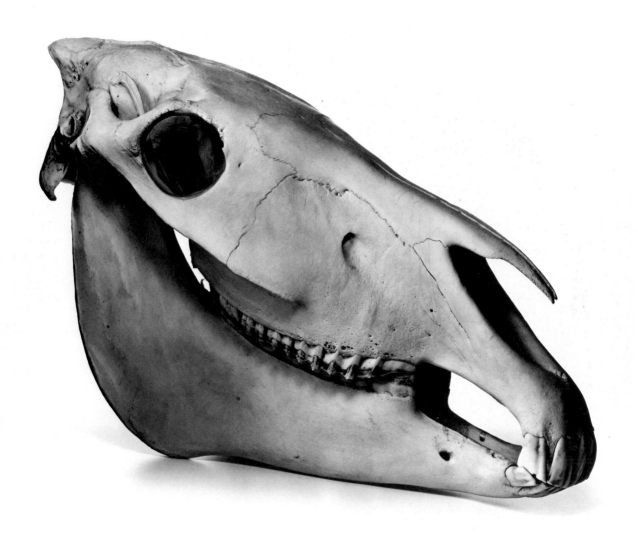

60. Zebra, *Prague, 1986*

1.

Giorgio de Chirico, *Rome*

DATE OF NEGATIVE: 1944

DATE OF PRINT: 1983

PRINT MEDIUM: Selenium toned gelatin silver

SUPPORT: Paper

DIMENSIONS

 IMAGE: 27.4 × 27.3 cm. ($10\frac{13}{16}$ × $10\frac{3}{4}$ in.)

 SHEET: 35.5 × 27.6 cm. (14 × $10\frac{7}{8}$ in.)

 MOUNT: Unmounted

NUMBER/SIZE OF EDITION: No more than fifteen signed silver prints

ACCESSION NUMBER: 1988.83.19

PENN'S REFERENCE NUMBER: 12587

COPYRIGHT: 1983 by Irving Penn

2.

Still Life with Food, *New York*

DATE OF NEGATIVE: 1947

DATE OF PRINT: November–December 1978

PRINT MEDIUM: Platinum-palladium, multiple coating and printing

SUPPORT: Rives paper on aluminum panel

DIMENSIONS

 IMAGE: 44.9 × 58.6 cm. ($17\frac{11}{16}$ × $23\frac{1}{16}$ in.)

 SHEET: 55.9 × 63.2 cm. (22 × $24\frac{7}{8}$ in.)

 MOUNT: 55.9 × 66 cm. (22 × 26 in.)

NUMBER/SIZE OF EDITION: Number twenty-nine of an edition of sixty-five in platinum metals

OTHER PRINTS: No more than twenty unnumbered, signed silver prints

ACCESSION NUMBER: 1988.83.41

PENN'S REFERENCE NUMBER: 1765

COPYRIGHT: 1947 by The Condé Nast Publications Inc. (renewed 1976)

3.

Le Corbusier, *New York*

DATE OF NEGATIVE: 1947

DATE OF PRINT: Before 1960

PRINT MEDIUM: Gelatin silver

SUPPORT: Paper mounted on paperboard

DIMENSIONS

 IMAGE: 49.4 × 39 cm. ($19\frac{7}{16}$ × $15\frac{3}{8}$ in.)

 SHEET: 49.4 × 39 cm. ($19\frac{7}{16}$ × $15\frac{3}{8}$ in.)

 MOUNT: 61 × 50.8 cm. (24 × 20 in.)

NUMBER/SIZE OF EDITION: No more than thirty-two signed silver prints

ACCESSION NUMBER: 1988.83.31

PENN'S REFERENCE NUMBER: 8098

COPYRIGHT: 1948 by The Condé Nast Publications Inc. (renewed 1976)

4.

Salvador Dali, *New York*

DATE OF NEGATIVE: February 20, 1947

DATE OF PRINT: Circa 1947

PRINT MEDIUM: Gelatin silver

SUPPORT: Paper mounted on paperboard

DIMENSIONS

 IMAGE: 25.1 × 20.1 cm. ($9\frac{7}{8}$ × $7\frac{15}{16}$ in.)

 SHEET: 25.1 × 20.1 cm. ($9\frac{7}{8}$ × $7\frac{15}{16}$ in.)

 MOUNT: 35.5 × 27.9 cm. (14 × 11 in.)

NUMBER/SIZE OF EDITION: No more than thirty-one signed silver prints

ACCESSION NUMBER: 1988.83.18

PENN'S REFERENCE NUMBER: 1278

COPYRIGHT: 1960 by Irving Penn, courtesy of *Vogue* (renewed 1988)

5.

Stanley William Hayter, *New York*

DATE OF NEGATIVE: July 10, 1947

DATE OF PRINT: Before 1959

PRINT MEDIUM: Gelatin silver

SUPPORT: Paper

DIMENSIONS

 IMAGE: 19.5 × 24.3 cm. ($7\frac{11}{16}$ × $9\frac{9}{16}$ in.)

 SHEET: 20.3 × 25.2 cm. (8 × $9\frac{15}{16}$ in.)

 MOUNT: Unmounted

NUMBER/SIZE OF EDITION: No more than ten signed silver prints

ACCESSION NUMBER: 1988.83.29

PENN'S REFERENCE NUMBER: 2729

COPYRIGHT: 1983 by Irving Penn, courtesy of *Vogue*

6.

Georges Enesco, *New York*

DATE OF NEGATIVE: January 24, 1948

DATE OF PRINT: 1983

PRINT MEDIUM: Selenium toned gelatin silver

SUPPORT: Paper

DIMENSIONS

 IMAGE: 24.3 × 19.3 cm. ($9\frac{9}{16}$ × $7\frac{5}{8}$ in.)

 SHEET: 24.9 × 19.8 cm. ($9\frac{13}{16}$ × $7\frac{13}{16}$ in.)

 MOUNT: Unmounted

NUMBER/SIZE OF EDITION: No more than fifteen signed silver prints

ACCESSION NUMBER: 1988.83.21

PENN'S REFERENCE NUMBER: 12488

COPYRIGHT: 1983 by Irving Penn, courtesy of *Vogue*

7.

Jean Cocteau, *Paris*

DATE OF NEGATIVE: 1948

DATE OF PRINT: June 1982

PRINT MEDIUM: Platinum-palladium, single coating, multiple printing

SUPPORT: Rives paper on aluminum panel

DIMENSIONS

 IMAGE: 35.7 × 31.6 cm. ($14\frac{1}{16}$ × $12\frac{7}{16}$ in.)

 SHEET: 58.1 × 50.8 cm. ($22\frac{7}{8}$ × 20 in.)

 MOUNT: 61 × 76.2 cm. (24 × 30 in.)

NUMBER/SIZE OF EDITION: Number fifteen of an edition of thirty-five in platinum metals

OTHER PRINTS: No more than fifteen unnumbered, signed silver prints

ACCESSION NUMBER: 1988.83.13

PENN'S REFERENCE NUMBER: 1073

COPYRIGHT: 1949 by The Condé Nast Publications Inc. (renewed 1977)

8.

Père Couturier, *Paris*

DATE OF NEGATIVE: July 26, 1948

DATE OF PRINT: October 27, 1948

PRINT MEDIUM: Gelatin silver

SUPPORT: Paper

DIMENSIONS

 IMAGE: 27.9 × 27.9 cm. (11 × 11 in.)

 SHEET: 27.9 × 27.9 cm. (11 × 11 in.)

 MOUNT: Unmounted

NUMBER/SIZE OF EDITION: No more than thirty-one signed silver prints

ACCESSION NUMBER: 1988.83.15

PENN'S REFERENCE NUMBER: 6574

COPYRIGHT: 1949 by The Condé Nast Publications Inc. (renewed 1977)

9.

André Derain, *St. Germain, France*

DATE OF NEGATIVE: July 26, 1948

DATE OF PRINT: Circa 1948

PRINT MEDIUM: Gelatin silver

SUPPORT: Paper mounted on paperboard

DIMENSIONS

 IMAGE: 31.6 × 24.1 cm. ($12\frac{7}{16}$ × $9\frac{1}{2}$ in.)

 SHEET: 31.6 × 24.1 cm. ($12\frac{7}{16}$ × $9\frac{1}{2}$ in.)

 MOUNT: 35.5 × 28.3 cm. (14 × $11\frac{1}{8}$ in.)

NUMBER/SIZE OF EDITION: No more than twenty-six signed silver prints

ACCESSION NUMBER: 1988.83.20

PENN'S REFERENCE NUMBER: 1292

COPYRIGHT: 1960 by Irving Penn, courtesy of *Vogue* (renewed 1988)

10.

Joan Miró and Daughter, Dolores, *Tarragona, Spain*

DATE OF NEGATIVE: November 5, 1948

DATE OF PRINT: 1983

PRINT MEDIUM: Selenium toned gelatin silver

SUPPORT: Paper

DIMENSIONS

 IMAGE: 27.8 × 26.8 cm. ($10\frac{15}{16}$ × $10\frac{9}{16}$ in.)

 SHEET: 35.2 × 27.9 cm. ($13\frac{7}{8}$ × 11 in.)

 MOUNT: Unmounted

NUMBER/SIZE OF EDITION: No more than twenty-five signed silver prints

ACCESSION NUMBER: 1988.83.36

PENN'S REFERENCE NUMBER: 7027

COPYRIGHT: 1960 by Irving Penn, courtesy of *Vogue* (renewed 1988)

11.

Cuzco Woman with High Shoes

DATE OF NEGATIVE: 1948

DATE OF PRINT: June 1978

PRINT MEDIUM: Platinum-palladium

SUPPORT: Rives paper on aluminum panel

DIMENSIONS

 IMAGE: 29.8 × 28.6 cm. ($11\frac{3}{4}$ × $11\frac{1}{4}$ in.)

 SHEET: 56.5 × 36.2 cm. ($22\frac{1}{4}$ × $14\frac{1}{4}$ in.)

 MOUNT: 56.5 × 36.2 cm. ($22\frac{1}{4}$ × $14\frac{1}{4}$ in.)

NUMBER/SIZE OF EDITION: Number one of an edition of twenty in platinum metals

ACCESSION NUMBER: 1988.83.17

PENN'S REFERENCE NUMBER: 1671

COPYRIGHT: 1978 by Irving Penn, courtesy of *Vogue*

12.

New York Child (Juliet Auchincloss), *New York*

DATE OF NEGATIVE: May 26, 1949

DATE OF PRINT: Circa 1949–1953

PRINT MEDIUM: Gelatin silver

SUPPORT: Paper mounted on paperboard

DIMENSIONS

 IMAGE: 44.2 × 40 cm. ($17\frac{3}{8}$ × $15\frac{3}{4}$ in.)

 SHEET: 44.2 × 40 cm. ($17\frac{3}{8}$ × $15\frac{3}{4}$ in.)

 MOUNT: 50.8 × 50.8 cm. (20 × 20 in.)

NUMBER/SIZE OF EDITION: No more than thirty-six signed silver prints

ACCESSION NUMBER: 1988.83.40

PENN'S REFERENCE NUMBER: 8227

COPYRIGHT: 1953 by The Condé Nast Publications Inc. (renewed 1981)

13.

Girl Drinking (Mary Jane Russell), *New York*

DATE OF NEGATIVE: 1949

DATE OF PRINT: August 1979

PRINT MEDIUM: Platinum-palladium/platinum-iridium, multiple coating and printing

SUPPORT: Rives paper on aluminum panel

DIMENSIONS

IMAGE: 51.9 × 49.2 cm. (20$\frac{7}{16}$ × 19$\frac{3}{8}$ in.)

SHEET: 63 × 55.9 cm. (24$\frac{13}{16}$ × 22 in.)

MOUNT: 65.9 × 55.9 cm. (25$\frac{15}{16}$ × 22 in.)

NUMBER/SIZE OF EDITION: Number fourteen of an edition of twenty-five in platinum metals

OTHER PRINTS: No more than fifteen unnumbered, signed silver prints

ACCESSION NUMBER: 1988.83.26

PENN'S REFERENCE NUMBER: 2178

COPYRIGHT: 1949 by The Condé Nast Publications Inc. (renewed 1977)

14.

Girl Behind Bottle, *New York*

DATE OF NEGATIVE: 1949

DATE OF PRINT: June 1978

PRINT MEDIUM: Platinum-palladium, single coating, multiple printing

SUPPORT: Rives paper on aluminum panel

DIMENSIONS

IMAGE: 47.2 × 45.4 cm. (18$\frac{9}{16}$ × 17$\frac{7}{8}$ in.)

SHEET: 60.7 × 51 cm. (23$\frac{7}{8}$ × 20$\frac{1}{16}$ in.)

MOUNT: 63.5 × 51 cm. (25 × 20$\frac{1}{16}$ in.)

NUMBER/SIZE OF EDITION: Number twelve of an edition of thirty-three in platinum metals

OTHER PRINTS: No more than six unnumbered, signed silver prints

ACCESSION NUMBER: 1988.83.25

PENN'S REFERENCE NUMBER: 1573

COPYRIGHT: 1960 by Irving Penn, courtesy of *Vogue* (renewed 1988)

15.

The Tarot Reader (Jean Patchett and Bridget Tichenor), *New York*

DATE OF NEGATIVE: 1949

DATE OF PRINT: 1984

PRINT MEDIUM: Selenium toned gelatin silver

SUPPORT: Paper

DIMENSIONS

IMAGE: 48.9 × 47 cm. (19$\frac{1}{4}$ × 18$\frac{1}{2}$ in.)

SHEET: 48.9 × 47 cm. (19$\frac{1}{4}$ × 18$\frac{1}{2}$ in.)

MOUNT: 55.9 × 55.9 cm. (22 × 22 in.)

NUMBER/SIZE OF EDITION: No more than twenty-six signed silver prints

ACCESSION NUMBER: 1988.83.53

PENN'S REFERENCE NUMBER: 13837

COPYRIGHT: 1949 by The Condé Nast Publications Inc. (renewed 1977)

16.

Nude No. 58, *New York*

DATE OF NEGATIVE: 1949–1950

DATE OF PRINT: June 1976

PRINT MEDIUM: Platinum-palladium, single coating, multiple printing

SUPPORT: Arches paper on aluminum panel

DIMENSIONS

IMAGE: 47.6 × 45.7 cm. (18$\frac{3}{4}$ × 18 in.)

SHEET: 63.3 × 56.2 cm. (24$\frac{15}{16}$ × 22$\frac{1}{8}$ in.)

MOUNT: 66 × 56.2 cm. (26 × 22$\frac{1}{8}$ in.)

NUMBER/SIZE OF EDITION: Number nine of an edition of thirty-three in platinum metals

OTHER PRINTS: No more than eleven unnumbered, signed silver prints

ACCESSION NUMBER: 1988.83.42

PENN'S REFERENCE NUMBER: 693

COPYRIGHT: 1950 by Irving Penn, courtesy of *Vogue* (renewed 1978)

17.

Nude No. 147, *New York*

DATE OF NEGATIVE: 1949–1950

DATE OF PRINT: April 1969

PRINT MEDIUM: Platinum-palladium/palladium-iridium, multiple coating and printing

SUPPORT: Wiggins-Teape paper on aluminum panel

DIMENSIONS

IMAGE: 47.3 × 48.1 cm. (18$\frac{5}{8}$ × 18$\frac{15}{16}$ in.)

SHEET: 62.8 × 55.9 cm. (24$\frac{3}{4}$ × 22 in.)

MOUNT: 66 × 55.9 cm. (26 × 22 in.)

NUMBER/SIZE OF EDITION: Number twenty-eight of an edition of fifty-three in platinum metals

OTHER PRINTS: No more than twenty-two unnumbered, signed silver prints

ACCESSION NUMBER: 1988.83.43

PENN'S REFERENCE NUMBER: 159

COPYRIGHT: 1950 by Irving Penn, courtesy of *Vogue* (renewed 1978)

18.

Nude No. 150, *New York*

DATE OF NEGATIVE: 1949–1950

DATE OF PRINT: March 1986

PRINT MEDIUM: Platinum-palladium/palladium-iridium, multiple coating and printing

SUPPORT: Rives paper on aluminum panel

DIMENSIONS

IMAGE: 47.8 × 44.1 cm. (18¹³⁄₁₆ × 17⅜ in.)

SHEET: 63.2 × 55.9 cm. (24⅞ × 22 in.)

MOUNT: 66 × 55.9 cm. (26 × 22 in.)

NUMBER/SIZE OF EDITION: Number one of an edition of fifty-seven in platinum metals

OTHER PRINTS: No more than thirty unnumbered, signed silver prints

ACCESSION NUMBER: 1988.83.44

PENN'S REFERENCE NUMBER: 273

COPYRIGHT: 1950 by Irving Penn, courtesy of *Vogue* (renewed 1978)

19.

Pâtissiers, *Paris*

DATE OF NEGATIVE: 1950

DATE OF PRINT: 1967

PRINT MEDIUM: Platinum-palladium

SUPPORT: Arches paper

DIMENSIONS

IMAGE: 49.8 × 36.6 cm. (19⅝ × 14⁷⁄₁₆ in.)

SHEET: 57.1 × 45.7 cm. (22½ × 18 in.)

MOUNT: Unmounted

NUMBER/SIZE OF EDITION: Number one of an edition of thirty-five in platinum metals

OTHER PRINTS: No more than six unnumbered, signed silver prints

ACCESSION NUMBER: 1988.83.47

PENN'S REFERENCE NUMBER: P386

COPYRIGHT: 1951 by Les Editions Condé Nast S.A.

20.

Marchand de Concombres, *Paris*

DATE OF NEGATIVE: 1950

DATE OF PRINT: 1967

PRINT MEDIUM: Platinum-palladium

SUPPORT: Arches Satiné paper

DIMENSIONS

IMAGE: 41.3 × 32 cm. (16¼ × 12⅝ in.)

SHEET: 57.1 × 45.7 cm. (22½ × 18 in.)

MOUNT: Unmounted

NUMBER/SIZE OF EDITION: Number nineteen of an edition of forty-one in platinum metals

OTHER PRINTS: No more than eight unnumbered, signed silver prints

ACCESSION NUMBER: 1988.83.35

PENN'S REFERENCE NUMBER: P723

COPYRIGHT: 1951 by Les Editions Condé Nast S.A.

21.

Fishmonger, *London*

DATE OF NEGATIVE: 1950

DATE OF PRINT: 1967

PRINT MEDIUM: Platinum-palladium

SUPPORT: Arches Satiné paper

DIMENSIONS

IMAGE: 50.3 × 37.8 cm. (19¹³⁄₁₆ × 14⁷⁄₈ in.)

SHEET: 57.1 × 45.7 cm. (22½ × 18 in.)

MOUNT: Unmounted

NUMBER/SIZE OF EDITION: Number sixteen of an edition of thirty-four in platinum metals

OTHER PRINTS: No more than six unnumbered, signed silver prints

ACCESSION NUMBER: 1988.83.22

PENN'S REFERENCE NUMBER: P175

COPYRIGHT: 1951 by The Condé Nast Publications Ltd.

22.

Chimney Sweep, *London*

DATE OF NEGATIVE: 1950

DATE OF PRINT: August 1976

PRINT MEDIUM: Platinum-palladium

SUPPORT: Arches paper

DIMENSIONS

IMAGE: 49.2 × 37.5 cm. (19⅜ × 14¾ in.)

SHEET: 57.2 × 45.4 cm. (22½ × 17⅞ in.)

MOUNT: Unmounted

NUMBER/SIZE OF EDITION: Number twenty-four of an edition of twenty-seven in platinum metals

OTHER PRINTS: No more than four unnumbered, signed silver prints

ACCESSION NUMBER: 1988.83.12

PENN'S REFERENCE NUMBER: P1311

COPYRIGHT: 1951 by The Condé Nast Publications Ltd.

23.

Chevrier, *Paris*

DATE OF NEGATIVE: 1950

DATE OF PRINT: 1967

PRINT MEDIUM: Platinum-palladium

SUPPORT: Arches Satiné paper

DIMENSIONS

IMAGE: 50.1 × 35.9 cm. (19¾ × 14⅛ in.)

SHEET: 56.8 × 45.7 cm. (22⅜ × 18 in.)

MOUNT: Unmounted

NUMBER/SIZE OF EDITION: Number four of an edition of twenty-five in platinum metals

OTHER PRINTS: No more than six unnumbered, signed silver prints

ACCESSION NUMBER: 1988.83.11

PENN'S REFERENCE NUMBER: P693

COPYRIGHT: 1951 by Les Editions Condé Nast S.A.

24.

Charbonnier, *Paris*

DATE OF NEGATIVE: 1950

DATE OF PRINT: November 1976

PRINT MEDIUM: Platinum-palladium

SUPPORT: Arches Satiné paper

DIMENSIONS

 IMAGE: 41.4 × 29.4 cm. ($16\frac{5}{16}$ × $11\frac{9}{16}$ in.)

 SHEET: 57.2 × 42.5 cm. ($22\frac{1}{2}$ × $16\frac{3}{4}$ in.)

 MOUNT: Unmounted

NUMBER/SIZE OF EDITION: Number twenty-seven of an edition of thirty-one in platinum metals

OTHER PRINTS: No more than eight unnumbered, signed silver prints

ACCESSION NUMBER: 1988.83.10

PENN'S REFERENCE NUMBER: P1352

COPYRIGHT: 1951 by Les Editions Condé Nast S.A.

25.

Alberto Giacometti, *Paris*

DATE OF NEGATIVE: 1950

DATE OF PRINT: October 1976

PRINT MEDIUM: Platinum-palladium

SUPPORT: Arches paper

DIMENSIONS

 IMAGE: 37.1 × 35 cm. ($14\frac{5}{8}$ × $13\frac{13}{16}$ in.)

 SHEET: 56.8 × 50.8 cm. ($22\frac{3}{8}$ × 20 in.)

 MOUNT: Unmounted

NUMBER/SIZE OF EDITION: Number two of an edition of forty-five in platinum metals

OTHER PRINTS: No more than twenty unnumbered, signed silver prints

ACCESSION NUMBER: 1988.83.24

PENN'S REFERENCE NUMBER: P1806

COPYRIGHT: 1951 by The Condé Nast Publications Inc. (renewed 1979)

26.

Cecil Beaton, *London*

DATE OF NEGATIVE: 1950

DATE OF PRINT: April 1977

PRINT MEDIUM: Platinum-palladium, multiple coating and printing

SUPPORT: BF 360 paper on aluminum panel

DIMENSIONS

 IMAGE: 38.1 × 37.2 cm. (15 × $14\frac{5}{8}$ in.)

 SHEET: 60.7 × 50.8 cm. ($23\frac{7}{8}$ × 20 in.)

 MOUNT: 63.5 × 50.8 cm. (25 × 20 in.)

NUMBER/SIZE OF EDITION: Number three of an edition of fifteen in platinum metals

OTHER PRINTS: No more than fifteen unnumbered, signed silver prints

ACCESSION NUMBER: 1988.83.2

PENN'S REFERENCE NUMBER: 1281

COPYRIGHT: 1958 by Les Editions Condé Nast S.A.

27.

Harlequin Dress (Lisa Fonssagrives-Penn), *New York*

DATE OF NEGATIVE: 1950

DATE OF PRINT: November 1979

PRINT MEDIUM: Platinum-palladium, multiple coating and printing

SUPPORT: Rives paper on aluminum panel

DIMENSIONS

 IMAGE: 50.5 × 48 cm. ($19\frac{7}{8}$ × $18\frac{7}{8}$ in.)

 SHEET: 63.3 × 56 cm. ($24\frac{15}{16}$ × $22\frac{1}{16}$ in.)

 MOUNT: 66 × 56 cm. (26 × $22\frac{1}{16}$ in.)

NUMBER/SIZE OF EDITION: Number twenty of an edition of thirty in platinum metals

OTHER PRINTS: No more than ten unnumbered, signed silver prints

ACCESSION NUMBER: 1988.83.28

PENN'S REFERENCE NUMBER: 2308

COPYRIGHT: 1950 by The Condé Nast Publications Inc. (renewed 1978)

28.

Rochas Mermaid Dress (Lisa Fonssagrives-Penn), *Paris*

DATE OF NEGATIVE: 1950

DATE OF PRINT: June 1979

PRINT MEDIUM: Platinum-palladium, multiple coating and printing

SUPPORT: Rives paper on aluminum panel

DIMENSIONS

 IMAGE: 49.8 × 50 cm. ($19\frac{5}{8}$ × $19\frac{11}{16}$ in.)

 SHEET: 63.2 × 56 cm. ($24\frac{7}{8}$ × $22\frac{1}{16}$ in.)

 MOUNT: 66 × 56 cm. (26 × $22\frac{1}{16}$ in.)

NUMBER/SIZE OF EDITION: Number one of an edition of twenty-five in platinum metals

OTHER PRINTS: No more than seven unnumbered, signed silver prints

ACCESSION NUMBER: 1988.83.37

PENN'S REFERENCE NUMBER: 2518

COPYRIGHT: 1950 by The Condé Nast Publications Inc. (renewed 1978)

29.

Woman in Moroccan Palace (Lisa Fonssagrives-Penn), *Marrakech*

DATE OF NEGATIVE: 1951

DATE OF PRINT: May–June 1969

PRINT MEDIUM: Platinum-palladium/platinum-iridium, multiple coating and printing

SUPPORT: Wiggins-Teape paper on aluminum panel
DIMENSIONS
 IMAGE: 49.9 × 49.7 cm. ($19\frac{5}{8}$ × $19\frac{9}{16}$ in.)
 SHEET: 63.2 × 55.9 cm. ($24\frac{7}{8}$ × 22 in.)
 MOUNT: 66 × 55.9 cm. (26 × 22 in.)
NUMBER/SIZE OF EDITION: Number two of an edition of forty in platinum metals
OTHER PRINTS: No more than forty unnumbered, signed silver prints
ACCESSION NUMBER: 1988.83.59
PENN'S REFERENCE NUMBER: 201
COPYRIGHT: 1951 by The Condé Nast Publications Inc. (renewed 1979)

30.
Woman in Dior Hat with Martini (Lisa Fonssagrives-Penn), *New York*
DATE OF NEGATIVE: 1952
DATE OF PRINT: 1984
PRINT MEDIUM: Selenium toned gelatin silver
SUPPORT: Paper mounted on paperboard
DIMENSIONS
 IMAGE: 38.4 × 40.5 cm. ($15\frac{1}{8}$ × $15\frac{15}{16}$ in.)
 SHEET: 38.4 × 40.5 cm. ($15\frac{1}{8}$ × $15\frac{15}{16}$ in.)
 MOUNT: 50.8 × 50.8 cm. (20 × 20 in.)
NUMBER/SIZE OF EDITION: No more than fourteen signed silver prints
ACCESSION NUMBER: 1988.83.58
PENN'S REFERENCE NUMBER: 12917
COPYRIGHT: 1952 by The Condé Nast Publications Inc. (renewed 1980)

31.
André Malraux, *New York*
DATE OF NEGATIVE: 1954
DATE OF PRINT: April–May 1984
PRINT MEDIUM: Platinum-palladium, multiple coating and printing
SUPPORT: Rives paper on aluminum panel
DIMENSIONS
 IMAGE: 39.7 × 39.4 cm. ($15\frac{5}{8}$ × $15\frac{1}{2}$ in.)
 SHEET: 63.2 × 55.9 cm. ($24\frac{7}{8}$ × 22 in.)
 MOUNT: 66 × 55.9 cm. (26 × 22 in.)
NUMBER/SIZE OF EDITION: Number ten of an edition of thirteen in platinum metals
OTHER PRINTS: No more than ten unnumbered, signed silver prints
ACCESSION NUMBER: 1988.83.33
PENN'S REFERENCE NUMBER: 1087
COPYRIGHT: 1955 by The Condé Nast Publications Inc. (renewed 1983)

32.
Ivy Compton Burnett, *London*
DATE OF NEGATIVE: 1958
DATE OF PRINT: March 1982
PRINT MEDIUM: Platinum-palladium, single coating, multiple printing
SUPPORT: Rives paper on aluminum panel
DIMENSIONS
 IMAGE: 39.2 × 39.4 cm. ($15\frac{7}{16}$ × $15\frac{1}{2}$ in.)
 SHEET: 57.9 × 50.2 cm. ($22\frac{13}{16}$ × $19\frac{3}{4}$ in.)
 MOUNT: 61 × 50.2 cm. (24 × $19\frac{3}{4}$ in.)
NUMBER/SIZE OF EDITION: Number two of an edition of thirty in platinum metals
OTHER PRINTS: No more than twelve unnumbered, signed silver prints
ACCESSION NUMBER: 1988.83.3
PENN'S REFERENCE NUMBER: 2894
COPYRIGHT: 1965 by The Condé Nast Publications Inc.

33.
John Osborne, *London*
DATE OF NEGATIVE: 1958
DATE OF PRINT: 1983
PRINT MEDIUM: Selenium toned gelatin silver
SUPPORT: Paper
DIMENSIONS
 IMAGE: 30.5 × 26.7 cm. (12 × $10\frac{1}{2}$ in.)
 SHEET: 35.2 × 27.8 cm. ($13\frac{7}{8}$ × $10\frac{15}{16}$ in.)
 MOUNT: Unmounted
NUMBER/SIZE OF EDITION: No more than twenty-one signed silver prints
ACCESSION NUMBER: 1988.83.45
PENN'S REFERENCE NUMBER: 12371
COPYRIGHT: 1959 by The Condé Nast Publications Inc. (renewed 1987)

34.
Henry Moore, *Much Hadham, England*
DATE OF NEGATIVE: 1962
DATE OF PRINT: 1962
PRINT MEDIUM: Gelatin silver
SUPPORT: Paper mounted on paperboard
DIMENSIONS
 IMAGE: 41.8 × 39.7 cm. ($16\frac{7}{16}$ × $15\frac{5}{8}$ in.)
 SHEET: 41.8 × 39.7 cm. ($16\frac{7}{16}$ × $15\frac{5}{8}$ in.)
 MOUNT: 48.3 × 48.3 cm. (19 × 19 in.)
NUMBER/SIZE OF EDITION: No more than seven signed silver prints
ACCESSION NUMBER: 1988.83.38
PENN'S REFERENCE NUMBER: 8104
COPYRIGHT: 1963 by Irving Penn

35.

Francis Bacon, *London*

DATE OF NEGATIVE: 1962

DATE OF PRINT: November 1980

PRINT MEDIUM: Platinum-palladium, single coating, multiple printing

SUPPORT: Rives paper on aluminum panel

DIMENSIONS

IMAGE: 31.6 × 32.5 cm. ($12\frac{7}{16}$ × $12\frac{13}{16}$ in.)

SHEET: 60.3 × 50.8 cm. ($23\frac{3}{4}$ × 20 in.)

MOUNT: 63.5 × 50.8 cm. (25 × 20 in.)

NUMBER/SIZE OF EDITION: Number thirteen of an edition of thirty in platinum metals

OTHER PRINTS: No more than fifteen unnumbered, signed silver prints

ACCESSION NUMBER: 1988.83.1

PENN'S REFERENCE NUMBER: 1289

COPYRIGHT: 1963 by The Condé Nast Publications Inc.

36.

Cretan Landscape

DATE OF NEGATIVE: 1964

DATE OF PRINT: 1964

PRINT MEDIUM: Pigment

SUPPORT: Porcelainized steel

DIMENSIONS

IMAGE: 39.4 × 55.9 cm. ($15\frac{1}{2}$ × 22 in.)

SHEET: 53.5 × 63.5 cm. (21 × 25 in.)

MOUNT: Unmounted

NUMBER/SIZE OF EDITION: Number seven of an edition of thirteen

ACCESSION NUMBER: 1988.83.16

PENN'S REFERENCE NUMBER: 57

COPYRIGHT: 1964 by The Condé Nast Publications Inc.

37.

Gypsy Family, *Extremadura*

DATE OF NEGATIVE: 1965

DATE OF PRINT: February 1980

PRINT MEDIUM: Platinum-palladium

SUPPORT: Rives paper on aluminum panel

DIMENSIONS

IMAGE: 39.4 × 39.2 cm. ($15\frac{1}{2}$ × $15\frac{7}{16}$ in.)

SHEET: 59.4 × 50.6 cm. ($23\frac{7}{8}$ × $19\frac{15}{16}$ in.)

MOUNT: 63.5 × 50.6 cm. (25 × $19\frac{15}{16}$ in.)

NUMBER/SIZE OF EDITION: Number twenty-five of an edition of twenty-eight in platinum metals

OTHER PRINTS: No more than fifteen unnumbered, signed silver prints

ACCESSION NUMBER: 1988.83.27

PENN'S REFERENCE NUMBER: 2570

COPYRIGHT: 1966 by The Condé Nast Publications Inc.

38.

Three Dahomey Girls, One Reclining

DATE OF NEGATIVE: 1967

DATE OF PRINT: May 1969

PRINT MEDIUM: Platinum-palladium

SUPPORT: Arches paper on aluminum panel

DIMENSIONS

IMAGE: 50 × 49.8 cm. ($19\frac{11}{16}$ × $19\frac{5}{8}$ in.)

SHEET: 55.9 × 63.2 cm. (22 × $24\frac{7}{8}$ in.)

MOUNT: 55.9 × 66 cm. (22 × 26 in.)

NUMBER/SIZE OF EDITION: Number twenty-three of an edition of thirty-five in platinum metals

OTHER PRINTS: No more than fifteen unnumbered, signed silver prints

ACCESSION NUMBER: 1988.83.54

PENN'S REFERENCE NUMBER: 243

COPYRIGHT: 1974 by Irving Penn, courtesy of *Vogue*

39.

Single Oriental Poppy, *New York*

DATE OF NEGATIVE: 1968

DATE OF PRINT: 1987

PRINT MEDIUM: Dye transfer

SUPPORT: Paper mounted on paperboard

DIMENSIONS

IMAGE: 42.9 × 53.3 cm. ($16\frac{7}{8}$ × 21 in.)

SHEET: 45.4 × 55.9 cm. ($17\frac{7}{8}$ × 22 in.)

MOUNT: 50.8 × 60 cm. (20 × $23\frac{5}{8}$ in.)

NUMBER/SIZE OF EDITION: No more than seventeen signed dye transfer prints

OTHER PRINTS: No more than twelve signed, numbered platinum-palladium prints

ACCESSION NUMBER: 1988.83.49

PENN'S REFERENCE NUMBER: 15470

COPYRIGHT: 1980 by Irving Penn, courtesy of *Vogue*

40.

Nubile Young Beauty of Diamaré, *Cameroon*

DATE OF NEGATIVE: 1969

DATE OF PRINT: November 1978

PRINT MEDIUM: Platinum-palladium, single coating, multiple printing

SUPPORT: Rives paper on aluminum panel

DIMENSIONS

IMAGE: 49 × 49.4 cm. ($19\frac{5}{16}$ × $19\frac{7}{16}$ in.)

SHEET: 55.9 × 63 cm. (22 × $24\frac{13}{16}$ in.)

MOUNT: 55.9 × 66 cm. (22 × 26 in.)

NUMBER/SIZE OF EDITION: Number fourteen of an edition of forty in platinum metals

OTHER PRINTS: No more than ten unnumbered, signed silver prints

ACCESSION NUMBER: 1988.83.50

PENN'S REFERENCE NUMBER: 1949

COPYRIGHT: 1974 by Irving Penn, courtesy of *Vogue*

41.

Sitting Enga Woman, *New Guinea*

DATE OF NEGATIVE: 1970

DATE OF PRINT: May–June 1986

PRINT MEDIUM: Platinum-palladium, multiple coating and printing

SUPPORT: Rives paper on aluminum panel

DIMENSIONS

 IMAGE: 49.8 × 49.2 cm. ($19\frac{5}{8}$ × $19\frac{3}{8}$ in.)

 SHEET: 61 × 55.9 cm. (24 × 22 in.)

 MOUNT: 66.2 × 55.9 cm. ($26\frac{1}{16}$ × 22 in.)

NUMBER/SIZE OF EDITION: Number one of an edition of seventeen in platinum metals

OTHER PRINTS: No more than twenty unnumbered, signed silver prints

ACCESSION NUMBER: 1988.83.51

PENN'S REFERENCE NUMBER: 849

COPYRIGHT: 1983 by Irving Penn, courtesy of *Vogue*

42.

Man in White, Woman in Black, *Morocco*

DATE OF NEGATIVE: 1971

DATE OF PRINT: February 1977

PRINT MEDIUM: Platinum-palladium, multiple coating and printing

SUPPORT: Paper on aluminum panel

DIMENSIONS

 IMAGE: 55.7 × 49.8 cm. ($21\frac{15}{16}$ × $19\frac{5}{8}$ in.)

 SHEET: 63.2 × 55.9 cm. ($24\frac{7}{8}$ × 22 in.)

 MOUNT: 66 × 55.9 cm. (26 × 22 in.)

NUMBER/SIZE OF EDITION: Number two of an edition of twenty-five in platinum metals

OTHER PRINTS: No more than twelve unnumbered, signed silver prints

ACCESSION NUMBER: 1988.83.34

PENN'S REFERENCE NUMBER: 940

COPYRIGHT: 1974 by Irving Penn, courtesy of *Vogue*

43.

Two Rissani Women in Black with Bread, *Morocco*

DATE OF NEGATIVE: 1971

DATE OF PRINT: January–February 1986

PRINT MEDIUM: Platinum-palladium, multiple coating and printing

SUPPORT: Paper

DIMENSIONS

 IMAGE: 50 × 49.5 cm. ($19\frac{11}{16}$ × $19\frac{1}{2}$ in.)

SHEET: 63.2 × 56 cm. ($24\frac{7}{8}$ × $22\frac{1}{16}$ in.)

MOUNT: 66.2 × 56 cm. ($26\frac{1}{16}$ × $22\frac{1}{16}$ in)

NUMBER/SIZE OF EDITION: Number ten of an edition of twenty-one in platinum metals

OTHER PRINTS: No more than three unnumbered, signed silver prints

ACCESSION NUMBER: 1988.83.56

PENN'S REFERENCE NUMBER: 444

COPYRIGHT: 1986 by Irving Penn, courtesy of *Vogue*

44.

Four Guedras, *Morocco*

DATE OF NEGATIVE: 1971

DATE OF PRINT: November 1985

PRINT MEDIUM: Platinum-palladium, single coating, multiple printing

SUPPORT: Rives paper on aluminum panel

DIMENSIONS

 IMAGE: 58.4 × 50 cm. (23 × $19\frac{11}{16}$ in.)

 SHEET: 62.9 × 55.9 cm. ($24\frac{3}{4}$ × 22 in.)

 MOUNT: 66 × 55.9 cm. (26 × 22 in.)

NUMBER/SIZE OF EDITION: Number eight of an edition of eighteen in platinum metals

OTHER PRINTS: No more than eighteen unnumbered, signed silver prints

ACCESSION NUMBER: 1988.83.23

PENN'S REFERENCE NUMBER: 3338

COPYRIGHT: 1984 by Irving Penn, courtesy of *Vogue*

45.

Cigarette No. 17, *New York*

DATE OF NEGATIVE: 1972

DATE OF PRINT: April 1975

PRINT MEDIUM: Platinum-palladium, multiple coating and printing

SUPPORT: Rives paper on aluminum panel

DIMENSIONS

 IMAGE: 59.2 × 48.3 cm. ($23\frac{5}{16}$ × 19 in.)

 SHEET: 63.2 × 55.9 cm. ($24\frac{7}{8}$ × 22 in.)

 MOUNT: 66 × 55.9 cm. (26 × 22 in.)

NUMBER/SIZE OF EDITION: Number thirty-nine of an edition of sixty-four in platinum metals

ACCESSION NUMBER: 1988.83.6

PENN'S REFERENCE NUMBER: C117

COPYRIGHT: 1974 by Irving Penn

46.

Cigarette No. 37, *New York*

DATE OF NEGATIVE: 1972

DATE OF PRINT: April–May 1975

PRINT MEDIUM: Platinum-palladium, multiple coating and printing

SUPPORT: Arches paper on aluminum panel

DIMENSIONS

 IMAGE: 58.9 × 43.8 cm. (23$\frac{3}{16}$ × 17$\frac{1}{4}$ in.)

 SHEET: 63.2 × 56 cm. (24$\frac{7}{8}$ × 22$\frac{1}{16}$ in.)

 MOUNT: 66 × 56 cm. (26 × 22$\frac{1}{16}$ in.)

NUMBER/SIZE OF EDITION: Number thirty-two of an edition of seventy in platinum metals

ACCESSION NUMBER: 1988.83.7

PENN'S REFERENCE NUMBER: C53

COPYRIGHT: 1974 by Irving Penn

47.

Cigarette No. 42, *New York*

DATE OF NEGATIVE: 1972

DATE OF PRINT: 1974

PRINT MEDIUM: Platinum-palladium, multiple coating and printing

SUPPORT: Arches paper on aluminum panel

DIMENSIONS

 IMAGE: 60.3 × 50.8 cm. (23$\frac{3}{4}$ × 20 in.)

 SHEET: 63.2 × 55.9 cm. (24$\frac{7}{8}$ × 22 in.)

 MOUNT: 66 × 55.9 cm. (26 × 22 in.)

NUMBER/SIZE OF EDITION: Number twenty-eight of an edition of thirty-four in platinum metals

ACCESSION NUMBER: 1988.83.8

PENN'S REFERENCE NUMBER: C205

COPYRIGHT: 1974 by Irving Penn

48.

Chanel Sequined Suit, *New York*

DATE OF NEGATIVE: 1974

DATE OF PRINT: July 1979

PRINT MEDIUM: Platinum-palladium, single coating, multiple printing

SUPPORT: Rives paper on aluminum panel

DIMENSIONS

 IMAGE: 52.4 × 48.1 cm. (20$\frac{5}{8}$ × 18$\frac{15}{16}$ in.)

 SHEET: 63.2 × 56.2 cm. (24$\frac{7}{8}$ × 22$\frac{1}{8}$ in.)

 MOUNT: 66 × 56.2 cm. (26 × 22$\frac{1}{8}$ in.)

NUMBER/SIZE OF EDITION: Number thirteen of an edition of twenty-nine in platinum metals

OTHER PRINTS: No more than forty unnumbered, signed silver prints

ACCESSION NUMBER: 1988.83.9

PENN'S REFERENCE NUMBER: 2291

COPYRIGHT: 1977 by Irving Penn

49.

Vionnet Harness Dress, *New York*

DATE OF NEGATIVE: 1974

DATE OF PRINT: 1984

PRINT MEDIUM: Selenium toned gelatin silver

SUPPORT: Strathmore paper mounted on paper

DIMENSIONS

 IMAGE: 34.9 × 34.6 cm. (13$\frac{3}{4}$ × 13$\frac{5}{8}$ in.)

 SHEET: 40 × 39.3 cm. (15$\frac{3}{4}$ × 15$\frac{1}{2}$ in.)

 MOUNT: 40 × 39.3 cm. (15$\frac{3}{4}$ × 15$\frac{1}{2}$ in.)

NUMBER/SIZE OF EDITION: No more than fifteen signed silver prints

ACCESSION NUMBER: 1988.83.57

PENN'S REFERENCE NUMBER: 13562

COPYRIGHT: 1977 by Irving Penn

50.

Callot Swallow Tail Dress, *New York*

DATE OF NEGATIVE: 1974

DATE OF PRINT: March 1978

PRINT MEDIUM: Platinum-palladium

SUPPORT: BF paper on aluminum panel

DIMENSIONS

 IMAGE: 51.9 × 45.9 cm. (20$\frac{7}{16}$ × 18$\frac{1}{16}$ in.)

 SHEET: 63.2 × 55.9 cm. (24$\frac{7}{8}$ × 22 in.)

 MOUNT: 66 × 55.9 cm. (26 × 22 in.)

NUMBER/SIZE OF EDITION: Number ten of an edition of nineteen in platinum metals

OTHER PRINTS: No more than ten unnumbered, signed silver prints

ACCESSION NUMBER: 1988.83.4

PENN'S REFERENCE NUMBER: 1541

COPYRIGHT: 1977 by Irving Penn

51.

Camel Pack, *New York*

DATE OF NEGATIVE: 1975

DATE OF PRINT: November 1975

PRINT MEDIUM: Platinum-palladium

SUPPORT: Arches Satiné paper

DIMENSIONS

 IMAGE: 75.6 × 56.5 cm. (29$\frac{3}{4}$ × 22$\frac{1}{4}$ in.)

 SHEET: 75.6 × 56.5 cm. (29$\frac{3}{4}$ × 22$\frac{1}{4}$ in.)

 MOUNT: Unmounted

NUMBER/SIZE OF EDITION: Number four of an edition of sixty-eight in platinum metals

ACCESSION NUMBER: 1988.83.5

PENN'S REFERENCE NUMBER: SM XXXXII

COPYRIGHT: 1975 by Irving Penn

52.

Mud Glove, *New York*

DATE OF NEGATIVE: 1975
DATE OF PRINT: March 1976
PRINT MEDIUM: Platinum-palladium
SUPPORT: Arches paper
DIMENSIONS
 IMAGE: 75.5 × 56.5 cm. (29¾ × 22¼ in.)
 SHEET: 75.5 × 56.5 cm. (29¾ × 22¼ in.)
 MOUNT: Unmounted
NUMBER/SIZE OF EDITION: Number thirty-nine of an edition of fifty-two in platinum metals
ACCESSION NUMBER: 1988.83.39
PENN'S REFERENCE NUMBER: SM IV
COPYRIGHT: 1975 by Irving Penn

53.

Paper Cup with Shadow, *New York*

DATE OF NEGATIVE: 1975
DATE OF PRINT: March 1976
PRINT MEDIUM: Platinum-palladium
SUPPORT: Arches paper
DIMENSIONS
 IMAGE: 75.9 × 56.5 cm. (29⅞ × 22¼ in.)
 SHEET: 75.9 × 56.5 cm. (29⅞ × 22¼ in.)
 MOUNT: Unmounted
NUMBER/SIZE OF EDITION: Number thirty-four of an edition of fifty-four in platinum metals
ACCESSION NUMBER: 1988.83.46
PENN'S REFERENCE NUMBER: SM XXVIII
COPYRIGHT: 1975 by Irving Penn

54.

Composition with Pitcher and Eau de Cologne, *New York*

DATE OF NEGATIVE: December 7, 1979
DATE OF PRINT: March 1981
PRINT MEDIUM: Platinum-palladium
SUPPORT: Paper on aluminum panel
DIMENSIONS
 IMAGE: 29.2 × 48.9 cm. (11½ × 19¼ in.)
 SHEET: 40.6 × 61 cm. (16 × 24 in.)
 MOUNT: 40.6 × 61 cm. (16 × 24 in.)
NUMBER/SIZE OF EDITION: Number thirteen of an edition of sixty-one in platinum metals
OTHER PRINTS: A number of unsigned silver prints for reproduction in publications
ACCESSION NUMBER: 1988.83.14
PENN'S REFERENCE NUMBER: AR13
COPYRIGHT: 1981 by Irving Penn

55.

Seven Metal, Seven Bone, *New York*

DATE OF NEGATIVE: February 1980
DATE OF PRINT: October 1981
PRINT MEDIUM: Platinum-palladium
SUPPORT: Strathmore paper on aluminum panel
DIMENSIONS
 IMAGE: 28.9 × 48.1 cm. (11⅜ × 18¹⁵⁄₁₆ in.)
 SHEET: 40.7 × 61 cm. (16 × 24 in.)
 MOUNT: 40.7 × 61 cm. (16 × 24 in.)
NUMBER/SIZE OF EDITION: Number twenty of an edition of forty-one in platinum metals
OTHER PRINTS: A number of unsigned silver prints for reproduction in publications
ACCESSION NUMBER: 1988.83.48
PENN'S REFERENCE NUMBER: AR1230
COPYRIGHT: 1980 by Irving Penn

56.

Three Steel Blocks, *New York*

DATE OF NEGATIVE: April 1980
DATE OF PRINT: March 1981
PRINT MEDIUM: Platinum-palladium
SUPPORT: Strathmore paper on aluminum panel
DIMENSIONS
 IMAGE: 29 × 48.4 cm. (11⁷⁄₁₆ × 19¹⁄₁₆ in.)
 SHEET: 40.6 × 61 cm. (16 × 24 in.)
 MOUNT: 40.6 × 61 cm. (16 × 24 in.)
NUMBER/SIZE OF EDITION: Number four of an edition of thirty-four in platinum metals
OTHER PRINTS: A number of unsigned silver prints for reproduction in publications
ACCESSION NUMBER: 1988.83.55
PENN'S REFERENCE NUMBER: AR222
COPYRIGHT: 1981 by Irving Penn

57.

The Spilled Cream, *New York*

DATE OF NEGATIVE: June 12, 1980
DATE OF PRINT: June 1981
PRINT MEDIUM: Platinum-palladium
SUPPORT: Strathmore paper on aluminum panel
DIMENSIONS
 IMAGE: 29.2 × 48.6 cm. (11½ × 19⅛ in.)
 SHEET: 40.6 × 61 cm. (16 × 24 in.)
 MOUNT: 40.6 × 61 cm. (16 × 24 in.)
NUMBER/SIZE OF EDITION: Number forty-eight of an edition of fifty-eight in platinum metals
OTHER PRINTS: A number of unsigned silver prints for reproduction in publications
ACCESSION NUMBER: 1988.83.52

PENN'S REFERENCE NUMBER: AR404
COPYRIGHT: 1981 by Irving Penn

58.
Eugène Ionesco, *New York*
DATE OF NEGATIVE: October 21, 1983
DATE OF PRINT: 1984
PRINT MEDIUM: Selenium toned gelatin silver
SUPPORT: Paper
DIMENSIONS
 IMAGE: 39.4 × 39 cm. (15$\frac{1}{2}$ × 15$\frac{3}{8}$ in.)
 SHEET: 50.8 × 40.3 cm. (20 × 15$\frac{7}{8}$ in.)
 MOUNT: Unmounted
NUMBER/SIZE OF EDITION: No more than sixteen signed
silver prints
ACCESSION NUMBER: 1988.83.30
PENN'S REFERENCE NUMBER: 12695
COPYRIGHT: 1984 by The Condé Nast Publications Inc.

59.
Lion, $\frac{3}{4}$ View, *Prague*
DATE OF NEGATIVE: 1986
DATE OF PRINT: 1986
PRINT MEDIUM: Selenium toned gelatin silver
SUPPORT: Paper mounted on paperboard
DIMENSIONS
 IMAGE: 48.1 × 59.7 cm. (18$\frac{15}{16}$ × 23$\frac{1}{2}$ in.)
 SHEET: 48.1 × 59.7 cm. (18$\frac{15}{16}$ × 23$\frac{1}{2}$ in.)
 MOUNT: 55.9 × 65.6 cm. (22 × 25$\frac{13}{16}$ in.)
NUMBER/SIZE OF EDITION: No more than nineteen signed
silver prints
ACCESSION NUMBER: 1988.83.32
PENN'S REFERENCE NUMBER: SK38
COPYRIGHT: 1986 by Irving Penn

60.
Zebra, *Prague*
DATE OF NEGATIVE: 1986
DATE OF PRINT: 1986
PRINT MEDIUM: Selenium toned gelatin silver
SUPPORT: Paper mounted on paperboard
DIMENSIONS
 IMAGE: 47.8 × 59.5 cm. (18$\frac{13}{16}$ × 23$\frac{7}{16}$ in.)
 SHEET: 47.8 × 59.5 cm. (18$\frac{13}{16}$ × 23$\frac{7}{16}$ in.)
 MOUNT: 55.9 × 66 cm. (22 × 26 in.)
NUMBER/SIZE OF EDITION: No more than eleven signed
silver prints
ACCESSION NUMBER: 1988.83.60
PENN'S REFERENCE NUMBER: SK93
COPYRIGHT: 1986 by Irving Penn

William F. Stapp

Penn as Portraitist

This collection of sixty photographs by Irving Penn is the photographer's personal selection from what is one of the major bodies of American photographic portraiture produced since the end of World War II. The images span the greater part of Penn's professional career and reflect his long and productive association with Condé Nast Publications, and in particular with *Vogue* magazine, which originally commissioned and published many of the portraits. The collection comprises vintage and more recent conventional silver prints from the original negatives, as well as large-format platinum prints, a tedious but extraordinarily beautiful non-silver printing process of which Penn has become a master practitioner. The earliest photograph in the collection dates from Penn's return to the staff of *Vogue* in 1946, after a one-year absence, during which he served as a volunteer ambulance driver and photographer for the American Field Service with the British army in Italy and India; the most recent are from a series of portraits commissioned by *Vanity Fair*, another Condé Nast publication, in 1984. Considered as a body, these works reveal the insistent coherence of Penn's rigorous, disciplined vision as a portrait photographer, just as they demonstrate his peerless craftsmanship as a printmaker. They also document the evolution of a distinctive portrait style that has been innovative and vital from its very beginning.

Penn's association with Condé Nast began in 1943, when he was hired by Alexander Liberman, the new art director of *Vogue* magazine, to be his assistant.[1] Penn's initial assignment was to suggest designs for cover art for *Vogue*'s senior staff photographers, who at the time were primarily Horst P. Horst and John Rawlings. When this kind of collaboration proved problematic, Liberman suggested that Penn take his own photographs of his designs and assigned

him a studio assistant to help with the 8 × 10-inch view camera that was then the standard studio equipment. The experiment was immediately successful; the transformation of Irving Penn from virtually anonymous designer to credited staff photographer followed almost at once. The first *Vogue* image credited to him was a black-and-white still life of shellfish, which was published in the August 1, 1943, issue to illustrate an article on seafood; the credit line read "Irving Penn." A month later his credit line was simply "Penn." His first cover, a color still life of autumn accessories, appeared on the October 1 issue.[2] From this point on, Penn's still-life photographs were used increasingly in *Vogue*. In 1944 his work appeared regularly.

Penn's rapidly growing prominence at *Vogue* certainly depended to a certain extent on the impact of the war on *Vogue*'s senior photographic staff, which was exclusively male: Horst in New York, Cecil Beaton in London, and a number of other photographers whose work appeared frequently in *Vogue* and other Condé Nast publications. These men took leaves for the duration to contribute in practical ways to the war effort. The vacancies they left were filled—in part by a number of talented women, including Kay Bell, Toni Frissell, Frances McLaughlin, and Lee Miller (who contributed from the European front as an accredited photojournalist), to whom this represented an unprecedented opportunity in the commercial world; in part by experienced European refugee men like Serge Balkin and Erwin Blumenfeld, who quickly became a major contributor to *Vogue;* and in part by young American male photographers like George Platt Lynes and Penn himself, who had been refused for military service. By the time Penn took leave from *Vogue* late in 1944 to join the American Volunteer Field Service as an ambulance driver and photographer, he had achieved a status on the staff that was remarkable, given the brevity of his career as professional photographer.

But Penn had also, unquestionably, been identified and was being groomed by Liberman as an exceptional talent whose precise eye for the organization of forms and for the elegance of simplicity in composition was distinctive, original, and extremely sophisticated. Furthermore, even though his formal training was in painting and graphic design, it is quite clear that Penn was already a capable and informed photographer by the time *Vogue* hired him. Little is actually known about Penn's education as a photographer, but the few pre-*Vogue* photographs included in his retrospective organized by the Museum of Modern Art in 1984 are extremely competent, well-made images in the documentary tradition of the 1930s, reflecting the influence of both Walker Evans and Eugène Atget on the young Irving Penn's pictorial style and choice of subject matter.[3] It is certain, too, that Penn had already developed a sufficiently substantial commitment to photography to have acquired and used advanced equipment before he joined *Vogue*, for according to John Szarkowski, director of the Department of Photography at the Museum of Modern Art, Penn had invested in a Rolleiflex

camera (one of the most sophisticated "miniature" instruments then on the market) in the late 1930s, and had carried a 4 × 5-inch view camera to Mexico in 1942, when he went there to paint.[4] Both cameras required a reasonably high level of technical proficiency to be used effectively, and are therefore indicative of Penn's active, serious interest in the medium before he moved into the *Vogue* studio. Given this, the 1943–1944 period at *Vogue* served as Penn's practical apprenticeship in the studio, where he could refine and develop the distinctive, strikingly original vision that is suddenly apparent, without any transitional images, in his first *Vogue* still life, and apply it to other subjects as the number and variety of his assignments increased. Penn photographs appeared in *Vogue* throughout 1944, and even during his absence abroad in 1945 with the American Field Service, he occasionally contributed to the magazine.[5]

The great majority of Penn's photographs that were published in the 1943 and 1944 period are fashion-related still lifes, a genre to which his unique sense for the organization of forms into dramatically spare but extraordinarily elegant compositions is particularly suited. He also did some fashion spreads (which he now regards as tentative), as well as seven portraits, which represent the origins of his great postwar portrait *oeuvre* and contain the genesis of the unmistakable, characteristic Penn portrait style.

Of these seven images, the first two likenesses—of Billy Rose and Mike Todd—are too compromised by the page layout to be even minimally informative about distinctive elements of style or composition.[6] Another two, portraits of Margaret Sullavan and Fredric March, represent the first two of seven "portraits with symbols" that *Vogue* commissioned from Penn and published between 1944 and 1948. Also identified as "allegorical portraits," these seven likenesses comprise an atypical, extremely self-conscious series inspired by the game of "Allegories": In each, a prominent figure in the performing arts is posed inside a surrealistic still-life arrangement of objects that allude rather preciously, and more or less obviously, to his or her career and personality.[7] While the still-life arrangements in these allegorical portraits are pure Irving Penn, the concept itself—and consequently the images—seem decidedly outside the mainstream of his work. The likenesses of cartoonists George Price, Helen Hokinson, and James Thurber, however, commissioned from Penn by *Vogue* and published in April 1944, relate obviously and directly to his more familiar postwar *oeuvre*. In these three images the figures are each placed in a bare studio space that consists of a white floor and a wall or backdrop of a slightly darker tonality, with the seam where the floor and backdrop meet clearly visible; the lighting appears to be diffused natural light and is uniform. In the Price portrait the figure is stretched out on the floor parallel to the backdrop; his legs are crossed, and his shoulders are elevated so that his head is above the floor while he gazes into the lens. Hokinson stands in the center of the space, tentatively facing the camera as if suddenly interrupted while reading the letter she

is holding in her hands. Thurber sits in a plain wood chair with his back parallel to the wall, quietly contemplating the camera. Harking back, in their visual simplicity, to studio portraits of the mid-nineteenth century, the compositions are at once stark, theatrical, understated—and yet thoroughly engaging.[8] A photograph of writer and editor Quentin Reynolds and his wife Virginia, taken at about the same time but published in the February 15, 1945, issue, was organized according to this same stringent formula. Posed in a similarly severe, anonymous studio setting, the total neutrality of which is relieved only by a rectangular patch of carpet on the floor, Reynolds sits in a simple chair in the background, his wife Virginia stands isolated in the foreground, and their dog rests on the floor between them. As in the portraits of the three cartoonists, the potential bleakness of this composition is offset by its graphic boldness and its suggestion of emotional stasis.[9] In their original context these four images are particularly striking, for stylistically they were completely unprecedented in *Vogue* or in any other contemporary publication. In their very lack of visual pretense or even the remotest suggestion of narrative content, they were, in fact, the very antithesis of the high-style portraits of celebrities and prominent social figures that *Vogue* and its major rival, *Harper's Bazaar*, regularly featured, often with chatty, gossipy captions. Entirely congruent in their austere formalism with his still-life compositions, but overlooked in the familiar chronology of his work, these four revolutionary images mark Penn's emergence as a major figure in modern portrait photography.

Beginning late in 1944, Penn's professional career was interrupted for a year while he served abroad with the American Field Service. He continued to photograph during this time, taking some images of soldiers in the war zones he visited that indicate an already mature ability to direct individual figures into elegantly organized group portraits that transcend, as pictures, their literal content. Some of these images, as well as individual portraits of figures like the painter de Chirico, whom he encountered by chance on the street in Rome in December 1944, were eventually published in *Vogue*.[10]

Penn's career with *Vogue* and Condé Nast resumed in 1946, immediately after his return from the war. His photograph of the group of *Vogue* photographers [Cat. no. 61] was posed on the grounds of senior photographer Horst P. Horst's Long Island estate. It documents the reunion of the *Vogue* staff photographers. It suggests the fellowship of those who had served during the war (Penn, Beaton, and Horst) with those who had remained or worked in their stead (Balkin, Lynes, Constantin Joffe, and Blumenfeld); and it allegorically describes the rededication of these photographers to the art and muse of fashion, represented by the model Dorian Leigh. This image was not published at the time in the United States, but it appeared in 1947 in an issue of the Paris edition of *Vogue*, which contained the first published article dedicated to Penn as a photographer.[11] Beginning with the February 1, 1946, issue, which featured

a cover by Penn, his still-life and fashion photographs began to appear regularly and in increasing numbers in *Vogue*. In the following year he began to be featured as a portrait photographer.

The series of portraits Penn took for *Vogue* in 1947 and 1948 comprise two distinctive but overlapping bodies of work. Two fashion spreads published in 1946 prefigure the dramatic device of posing portrait subjects in a stark, acutely angled corner space, which Penn adopted in 1947 for his first cohesive group of serious portraits. In the first fashion spread, he photographed Mrs. Drayton Cochran standing in the corner of a room in her country house, where the plain, white surface of the wall is articulated by closed blinds on either side. The obviously genuine domestic nature of the setting, with its open, right-angle corner, softens the psychological tension generated by framing the figure in an almost cramped linear geometry, but the aesthetic potential of that conceit is apparent.[12] In the second spread, Penn posed celebrity couples in a neutral space defined by a back wall, extending partway across the frame, that is parallel to the picture plane, and by a long panel that joins the wall to the side at a very shallow angle: the man peers from behind the panel at the woman standing in the center of the field. These images are more humorous than dramatic in their effect, but the stage setting in itself has significant graphic impact.[13]

A series of four portraits of prominent male humorists, in the November 15, 1946, issue of *Vogue*, further explored this visual device and tested whether the intrusion of the surface details, rough textures, and dark walls of an actual space having this same physically constraining geometry would have a mitigating effect on the impact of the image. In these photographs the men were posed individually, leaning into or against a concrete doorjamb set in the brick wall of what appears to be a Lower East Side alley; one figure is even placed in a shallow corner in the wall.[14] The photographs have visual force because of the incongruous contrast between the grittiness of the setting and the intellectually known high social standing of the subjects, but in psychological terms that same gritty setting dominates the images and lends them an almost social documentary import. Although the men—Frank Sullivan, Abe Burrows, S. J. Perelman, and Ogden Nash—were all professional humorists and well-known celebrities, the ambience and details of the environment, coupled with the slouching poses the men have adopted, so effectively evoke the Bowery that the men are intuitively perceived as its denizens. The theory behind these portraits—that a compelling psychological dynamic is effected by posing the individual in an immutable and confined space—was clearly valid; this specific variation, however, was counterproductive, and Penn did not repeat the experiment. Indeed, these are the only portraits taken by Penn, working as a professional, in a space that is so palpably suggestive of a specific physical context.

Within a short time, the fundamentals of what was to become Penn's signature formula for a major series of portraits in 1948, as well as for an interme-

diate series of fashion studies, had become definite. In early 1947, the stark, plain-walled, sharply angled corner space in which the subject posed, and with which he or she interacted, became a consistent visual element in both his fashion and portrait photographs. Fashion photographs published in February and March exploited the tension inherent in this constrained visual construct, but also quite successfully used the space to enact small, demi-surreal one-person *tableaux vivants*. In one image, photographed in color, Penn placed a cloth-covered table, with a carefully constructed still-life arrangement on it, in the foreground; a clock on the unreal wall; and a glass ball on the floor at the foot of the table. In another, also in color, the space was decorated as an abstracted room: The floor was patterned; the angle of the corner was truncated and became a tall, narrow wall fitted with a door; one of the walls was fitted with a window; objects were hung on the walls and scattered on the floor in deliberate arrangements that juxtaposed patterns of shapes and colors against the spare black-and-white coloration of the space. In the final trial series of four photographs, the ultimate configuration of the space had become fixed as an acute triangle, but here it served as the backdrop to a whimsical drama in the service of fashion: in three images a fashion artist (Count René Bouet-Willaumez, Carl Erickson, and René Bouché) sits at an easel sketching a model wearing a designer dress. The fourth image is wryly entitled *The Photographer: Penn*, for in his absence a camera lens poses symbolically in his place.[15]

In 1948, a year after the essential concept had been fully developed, Penn began an extended series of these "corner portraits" for *Vogue*, a number of which have been included in his gift to the National Portrait Gallery. In these images Penn places his subjects in the very center of the acutely angled triangular space, the apex of which bisects the picture plane. Some subjects stand; others sit in a rather dilapidated wooden chair positioned to suit their fancy. To a great degree the subjects posed themselves, the dynamics of the image depending upon the individual's response to the psychological and physical consequences of being constrained to pose in this cramped, uncomfortable, abnormal space. The sittings become fascinating studies. Both Charles Sheeler [Cat. no. 71] and E. B. White [Cat. no. 73] are obviously tense and uncomfortable in spite of their seemingly relaxed, almost lounging poses. George Grosz [Cat. no. 74] hunches over in the chair, which he has placed parallel to the film plane; his knees are together and both hands clasp his unlit pipe; his head is at an angle to the camera, yet his eyes stare directly into the lens. The pose is altogether awkward and the body language is self-protective; the eyes are alert and perhaps mistrustful. Joe Louis [Cat. no. 72], who was the world-champion heavyweight boxer at the time, sits in trunks and boxing shorts, curiously slack and vulnerable in his body language. His legs are spread wide, with his feet resting loosely against either wall and his bare hands hanging limply in his lap; his shoulders are jammed against the walls, but his body slouches and seems to

offer no significant resistance to gravity; his expression is both tentative and passive. Artur Rubinstein [Cat. no. 75], on the other hand, stands and confronts the camera firmly and confidently, with his body centered squarely in the apex of the triangle, his hands at his side, and a slightly bemused expression on his face. John O'Hara [Cat. no. 76] appears at once open and defiant. He sits in the chair, exactly centered in the space, and tilts back into the space as far as he can. His legs are open, and his calves and knees brush the two walls. His hands rest in his lap; in one he holds a lit cigarette. His eyes are slightly shaded, but his expression seems patient and benevolent. Marcel Duchamp [Cat. no. 77] stands relaxed, leaning back into the space, his ankles crossed, one hand in a trouser pocket and the other holding the bowl of the pipe in his mouth. He has a scarf wrapped around his neck and appears to be both interested in and slightly amused by the photographer. Igor Stravinsky [Cat. no. 80] stands with his legs crossed and patently acts for the camera. For this sitting Penn, frustrated by Stravinsky's customary implacable demeanor, told the Russian composer that there was a mouse in his camera—thus evoking this delightful, playful gesture and the look of concentration. Georgia O'Keeffe [Cat. no. 70], who leans into the corner with her hands behind her back, seems subdued, impatient, and mistrustful. The other women, however, are neither vulnerable nor approachable. The portrait of Mrs. William Rhinelander Stewart [Cat. no. 78] was actually commissioned as a fashion photograph, but she, like the Duchess of Windsor [Cat. no. 79], confronts Penn's camera coolly and confidently.[16]

At this same time, *Vogue* was beginning to commission and publish a different series of portraits by Penn which, in concert with the "corner space" photographs, are the real foundation of his artistic reputation as one of the major portraitists of the postwar era. According to the typical conventions of the period, magazine portraiture in the 1940s and early 1950s was essentially journalistic; the subject was often photographed at home or where he or she worked, or the image made some other obvious visual reference to the subject's occupation or social role. From the beginning, however, Penn's portrait images were entirely anti-journalistic and consciously invoked the spirit, if not the actual studio conventions, of the nineteenth century.[17] This is especially true of the series of portraits Penn began in 1947, where the subjects are posed in a completely neutral, undefined, nonreferential space: the backdrop is a bare, stained, grayish wall that extends across the frame parallel to the picture plane. The floor in this series is either a neutrally colored linoleum or tiled surface that is visibly badly scuffed, or a short-napped industrial carpet. The subjects sit on or behind, or lean against, an amorphous form that is covered by the same carpeting. The carpet is obviously tattered, has ragged edges, and is often sprinkled with bits of coarse twine and what appears to be organic debris vaguely suggestive of decay and deterioration. This setting, like an undressed theater stage, is simultaneously an evocation of the artificiality of the encounter (or of any formal

portrait sitting) and a self-conscious visual denial that the sitting represents a conspiracy to idealize. The space is at once shabby and elegant, austere and dramatic; it provides an informational vacuum and creates a psychological ambiance that obliges the sitter to confront the camera (and hence the viewer) directly, solemnly, and without artifice. The deliberate emotional neutrality of the space; the neutral stance of Penn's camera, which places his sitters in the middle distance; the acuity of his lens, with its sharp depth of field that deliberately extends from the front of the picture plane to the back of the subject, but not to the backdrop; the soft, revealing, natural quality of the light; the quiet intensity of the sitting itself; the relaxed stability of the pose—all contribute to the quality of stasis—the suggestion of time, movement, and even emotion, suspended—that characterizes these portraits. Free of any visual clues about the sitters' personalities, occupations, or lifestyles, the images compel the viewer to study them and engage the subject in a silent dialogue. Few other American portrait photographs of the twentieth century, made for the public, have been and continue to be so consistently compelling even after their contemporary topical interest has dissipated.

Among the images from this series in the National Portrait Gallery collection, the double portrait of Max Ernst and his wife Dorothea Tanning [Cat. no. 62], and of Walter Lippmann [Cat. no. 63], both suggest the freedom and spontaneity that Penn's format allowed the sitter. In the former, Ernst, his head and body at an angle to the camera and his hands in his pockets, perches one knee casually on the draped platform as he looks up at the camera; Tanning, legs crossed, sits almost *soignée* on the platform and leans back, torquing her body to rest her forearms on the platform, so that she has to look over her shoulder into the lens. The poses suggest the small drama of an intimate conversation interrupted by the arrival of an unexpected visitor; the moment forces an uncomfortable meeting. Lippmann, on the other hand, is photographed closely, in what could be taken for a scholar's moment of idle distraction in the library or a boring moment in a dinner-table conversation. The other portraits in the series are less theatrical. The double portrait of George Jean Nathan and H. L. Mencken [Cat. no. 64], the likenesses of John Marin [Cat. no. 65], W. H. Auden [Cat. no. 68], and Janet Flanner [Cat. no. 69] are all equally direct and arresting in their effect. The sitters all seem to be not only conscious of the camera, but to be actually quizzing the viewer, perhaps judgmentally. This startling effect of awareness, even personal engagement, is achieved through the simple devices of gaze and pose; its consistent achievement is a tribute to Penn's ability to engage his sitters in a genuine dialogue with the camera.

Vogue commissioned these portraits beginning in 1947, and published a number of them in photographic essays that year and in 1948, when portraits from the "Corner Series" would also appear with them. But in spite of their appeal, Penn abandoned both these formulas for portraits in 1948, when he

went to Europe and was forced to photograph without the facilities available in his New York studio. The necessity of adapting to available conditions encouraged him to refine his portrait vision and to distill further the parameters of the visual stage on which he photographed. The likeness of Marlene Dietrich [Cat. no. 81] was made on his return to New York according to this simplified vision: the figure is half-length, seated on some indeterminate surface (perhaps a table or a studio riser), posed with her back to the camera and leaning forward and to the side, away from the camera, so that she turns her head to look over her shoulder directly into the lens. The composition has moved closer to the front of the picture; the setting is completely ambiguous; directed, diffused light defines and delineates the face and emphasizes the form of the body. The effect is more graphically bold as a design than in earlier portraits, yet the sense of silent communication between the viewer and the sitter is retained. Penn used essentially the same setting and camera distance in a series of portraits of people in the power structure of Washington, D.C. [Cat. no. 85], as well as in his 1960 portrait of Frederick Kiesler and Willem de Kooning [Cat. no. 87]; but at this point the direction of his portrait concerns had begun to shift.

Portraits taken in 1950 and later become insistently tighter and more dramatic in their composition—and less emotionally compelling. The likenesses of Jacob Epstein [Cat. no. 84] and T. S. Eliot [Cat. no. 83] are transitional. Taken in London while he was also photographing the "Small Trades" series, these are frontally posed, half-length, seated portraits taken against a seamless, wrinkled-cloth backdrop that suggests (in the somewhat more contrasty light that Penn employs) the bare interior of an old castle. There is space around the sitters, but the stoniness of the setting and the central frontality of the poses, together with the seeming reticence of the sitters themselves, impede intimacy. Other likenesses taken in Britain and France in 1950 show that same reserve.

The portrait of Carson McCullers [Cat. no. 82], taken that same year in New York, marks a radical stage in the evolution of Penn's portraiture. In this photograph, the sitter entirely dominates the frame in a tight closeup, taken from below, that places her at the front of the image, virtually breaking through the picture plane and almost completely filling it with her torso and head, which is actually cropped by the frame. The image, almost threatening in its physical proximity to the viewer (particularly in the closeness of the eyes, which gaze relentlessly and without expression into the lens) is powerful but discomfiting, blunt rather than eloquent. From 1950 on, the tight, frame-filling closeup composition becomes an increasingly dominant element of Penn's portraits, so that in 1964 he can create a closeup likeness of Saul Bellow that is overwhelming, if not actually threatening, because the cropped and optically distorted head and hand seem to erupt through the frame [Cat. no. 88]. Somewhat less tightly composed portraits of David Smith [Cat. no. 89], Hans Hofmann [Cat. no. 90], and Truman Capote [Cat. no. 92] have almost the same psychological impact.

The 1966 portrait of Barnett Newman [Cat. no. 93], photographed equally close and tightly cropped, avoids that disturbing distortion, but its proximity, coupled with the sitter's cold, piercing eye behind a monocle, makes it a troubling likeness that is particularly memorable because of its unusually crisp graphic elements. In contrast, portraits of Isaac Bashevis Singer [Cat. no. 94] and Saul Steinberg [Cat. no. 95], from that same year, are far less aggressively composed and almost sentimental in their impact.

From 1970 on, Penn's portraits display a greater stylistic uniformity. The photographs are largely bust-length poses, framed so that the figure is exactly centered and dominates the space in the frame. The camera is close and generally low, so the view is upward into the subject's face and eyes rather than being level with them. This vantage point monumentalizes the figures and makes them sculpturally imposing, if not in fact threatening—a quality emphasized by the contrasty, dramatic lighting. As in the portrait of Tony Smith [Cat. no. 104], the sitters often react visibly to the camera by striking a pose, and, like John Updike [Cat. no. 102] and Duke Ellington [Cat. no. 103], they frequently avoid addressing the lens with their eyes. The effect is theatrical and interpretive rather than engaging, but—like the portraits of Anaïs Nin [Cat. no. 106], Jasper Johns [Cat. no. 119], and Isamu Noguchi [Cat. no. 120]—these images have a consistent, substantial, compelling power in graphic terms, even though their mechanisms do not encourage the private, direct, uplifting encounter between viewer and subject that Penn's earlier, and seemingly more detached, work enabled.

Throughout the course of his career, Penn has been an exceptional photographer of groups. He has always constructed a group portrait like a still life, precisely arranging the disparate elements in the composition to achieve a perfect balance of forms within the image. The 1946 *Group Portrait of Vogue Photographers* [Cat. no. 61] successfully resolves the problems inherent in organizing a group portrait in a visually complex (and potentially confusing) context by varying the poses and by grouping the sitters to mimic and harmonize with the shapes of the masses of foliage in the foreground and background. With its obvious allusions to Édouard Manet's *Déjeuner sur l'herbe*, the image is a personal celebration of these photographers' reunion after the war and an exuberant evocation of their artistic fellowship.

The other groups in the collection are more even consistent with Penn's technique, of which—as in his individual portraits—the neutral studio setting is an important visual element, and deliberately constructed internal balance an essential device. In *Twelve Most Photographed Models* [Cat. no. 66], the women are placed in two equally weighted, similarly organized, pyramid-shaped groups that ground and stabilize the image, which in turn allows each sitter to assume an individual pose without creating visual chaos within. *Ballet Theatre* [Cat. no. 67] is even more formally organized into two pyramid-shaped groups on either

side, with the image being split horizontally by a board stretched between two ladders, upon which three of the figures lounge. The image is utterly stable visually, and—like *Twelve Most Photographed Models*—almost mesmerizing in its steady internal rhythm. Twenty years later, Penn employed these same basic compositional techniques to make a series of group portraits in San Francisco for *Look* magazine, although the setting is the starker, completely empty studio space that Penn had preferred since 1949.[18] *Hell's Angels* [Cat. no. 97] and *Rock Groups* [Cat. no. 101] are in a sense more illustrative than typical Penn images in that referential props (motorcycles in the first, guitars in the second) appear in them, but in both photographs, and in *Hippie Group* [Cat. no. 100]—as in the earlier groups—formal concerns dominate and regulate their visual impact. The smaller casts of characters in the two *Hippie Family* photographs [Cat. nos. 98 and 99] allowed and encouraged greater intimacy in the camera's positioning; this, together with the serious but very appealing faces of these two young couples whose poses are so protective of their children, imparts an unusually sympathetic quality to these two photographs despite their otherwise dispassionate vision.

In spite of an evolution in stylistic detail over the forty years of his professional career, there is a remarkable, unquestionable consistency to Penn's photographic vision and to his portraits. With very few exceptions, a Penn photograph—whether it be from 1943 or 1989—cannot be mistaken for any other photographer's work. His portraiture is distinguished by the strict discipline of its underlying concepts, the rigor and spareness of its composition, and at its best, by the intense, contemplative nature of the private encounter between sitter and viewer that is mediated by the image. His photography is inherently cerebral rather than visceral, but it continues to compel and to convey meaning long after less subtle images have lost their interest. Irving Penn is one of the few photographers of this century whose portraits consistently transcend the immediate historical personalities of his subjects and engage us purely as pictures. It is in this abiding appeal that these images have significance.

Notes

1. From 1934 to 1938, Irving Penn studied painting at the Philadelphia Museum School of Industrial Art (now the University of the Arts), where he took courses with Alexey Brodovitch, a Russian émigré graphic designer and one of the most influential figures in twentieth-century American design. Brodovitch became Penn's mentor. In the summers of 1937 and 1938, Penn worked as his unpaid assistant at *Harper's Bazaar*, one of the two major American fashion publications of the day, where Brodovitch was art director. After graduating from the Museum School in 1938, Penn worked for Brodovitch in New York as a freelance commercial artist, and in 1940 became his assistant at Saks Fifth Avenue, which had hired Brodovitch as art director for its advertising campaign. A year later Brodovitch recommended Penn to succeed him at Saks, a position Penn held for a year before resigning to go to Mexico to paint. After a year in Mexico, dissatisfied with his abilities as a painter, Penn scraped

all his canvases clean and returned to New York. See John Szarkowski, *Irving Penn* (New York, 1984), pp. 18–22.

2. See "Sea Harvest," *Vogue* (August 1, 1943), pp. 66–67 and "Pickle a Peck of Summer," *Vogue* (September 1, 1943), pp. 114–15. Although the October 1, 1943, *Vogue* cover was actually "the first color photograph of his new career" (Szarkowski, *Penn*, p. 21), it was not the first color photograph by Penn to be published. That distinction belongs to a still life composed of fabric swatches illustrating "The Goods," *Vogue* (September 15, 1943), p. 105. Illustrations were often produced on short notice; there was often a delay between the creation of a cover image and its publication.

3. Szarkowski, *Penn,* plates 1–4 and figs. 5 and 6, p. 19, and figs. 31 and 32, p. 39. Szarkowski notes that Penn remembers Alexey Brodovitch showing reproductions of Atget's photographs to his students and also remembers seeing an exhibition of Evans's photographs at the Museum of Modern Art.

4. *Ibid.*, p. 19.

5. Irving Penn, "Someone Is Always Watching You," *Vogue* (March 1, 1945), p. 39.

6. The likenesses of Rose and Todd are vignetted and tightly cropped so that the faces are to the side of the composition and dominate the frame. See "People Are Talking About," *Vogue* (April 1, 1944), p. 85.

7. Margaret Sullavan appeared in the May 15, 1944, issue of *Vogue* (p. 70); Fredric March appeared in the January 1, 1945, issue (p. 69). Allegorical portraits published in *Vogue* after the war were of Dorothy Parker (March 15, 1946, p. 133); Alfred Lunt and Lynn Fontanne (May 15, 1946, p. 156); Orson Welles (August 1, 1946, p. 138); Helen Hayes (August 15, 1946, p. 168); and Ingrid Bergman (March 1, 1947, p. 199). Given the conceit and the compositional consistency of the images, it is likely that the series was actually taken within a relatively compressed time span.

8. "Cartoonists Draw Themselves," *Vogue* (April 15, 1944), pp. 106–7.

9. "*Vogue*'s Spotlight: Quentin Reynolds with His Wife Virginia Peine, and His Dog," *Vogue* (February 15, 1945), p. 99. Although it was published in 1945, the image was taken in 1944, before Penn left *Vogue* to join the American Field Service.

10. Irving Penn, "Overseas Album," *Vogue* (February 15, 1946), pp. 94–99. De Chirico was a personal hero of Penn's, and Penn's portrait of him is atypically whimsical: the artist is shown wearing a victor's crown of laurel sprigs, which he tore from a nearby bush as the men were strolling in the Roman Forum with the comment, "This is laurel, the classical symbol of fame and achievement. I would like you to photograph me as a Roman conqueror." See Irving Penn, *Moments Preserved* (New York, 1960), p. 55.

11. André Ostier, "Le Photographe Penn," Paris *Vogue* (1947), pp. 80–83 (known from an otherwise undated photocopy provided by Irving Penn).

12. "In the Country Now," *Vogue* (March 15, 1946), p. 126.

13. "The Men They Dress For . . . ," *Vogue* (May 15, 1946), pp. 142–43.

14. "Cream of the Jesters," *Vogue* (November 15, 1946), pp. 178–79.

15. "Compositions Around Four American Beauties," *Vogue* (February 1, 1947), p. 161; "What Are New Fashions Made Of?," *Vogue* (March 1, 1947), pp. 178–83; "Made to Order: American," *Vogue* (March 15, 1947), pp. 156–69.

16. Penn made this photograph of Mrs. William Rhinelander Stewart for an article on summer fashions; she was one of three prominent socialites who modeled for Penn for the spread. See "Summer Looks of Nine of New York's Most Beautiful Women," *Vogue* (July 1, 1948), p. 42.

17. In an interview in *Portfolio* magazine in 1950, Penn cited Mathew Brady's portraits as an inspiration for the simplicity of his own portrait style. See Szarkowski, *Penn*, p. 35 ff.

18. Irving Penn, "The Incredibles," *Look* (January 9, 1968), pp. 52–58. In his contract, Penn insisted that the text published with these images be based only on the sitters' own words. Author's interview with Irving Penn, September 9, 1989.

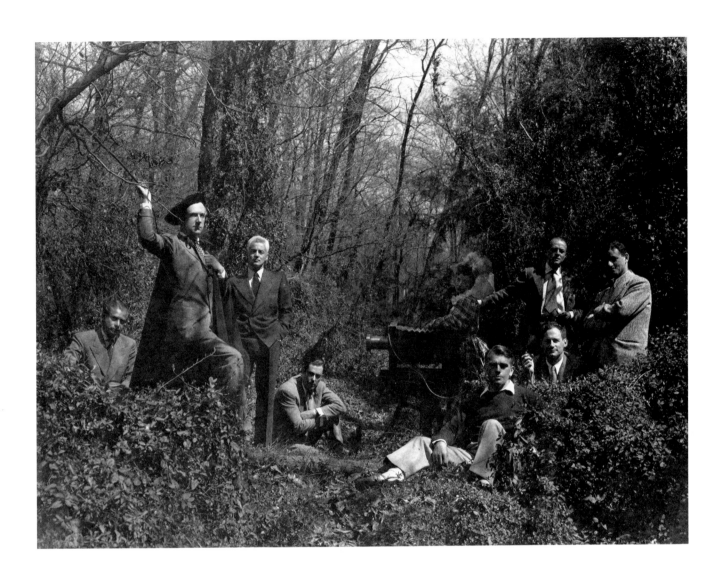

61. Group of *Vogue* Photographers, *Long Island, N.Y., 1946*

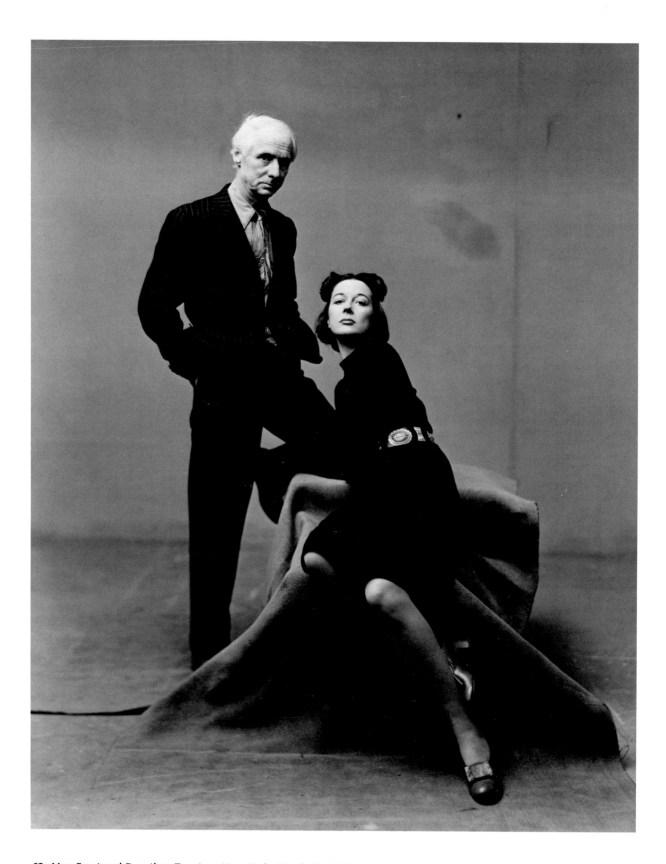

62. Max Ernst and Dorothea Tanning, *New York, March 20, 1947*

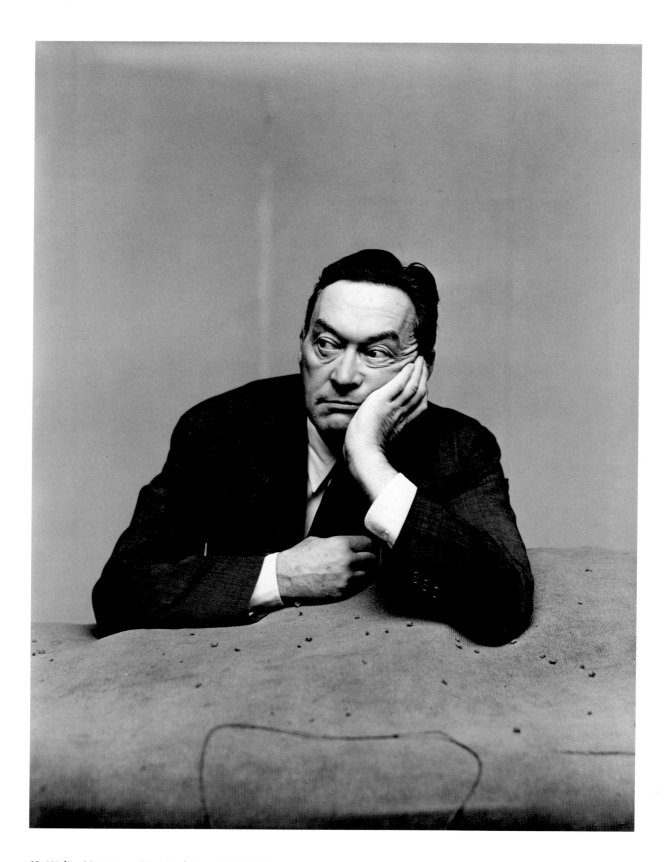

63. Walter Lippmann, *New York, June 27, 1947*

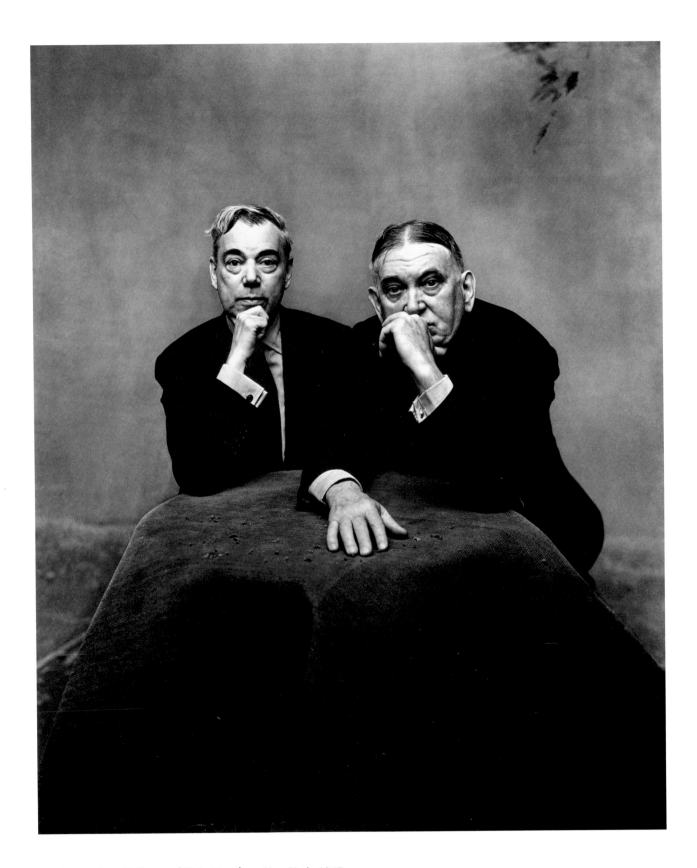

64. George Jean Nathan and H. L. Mencken, *New York, 1947*

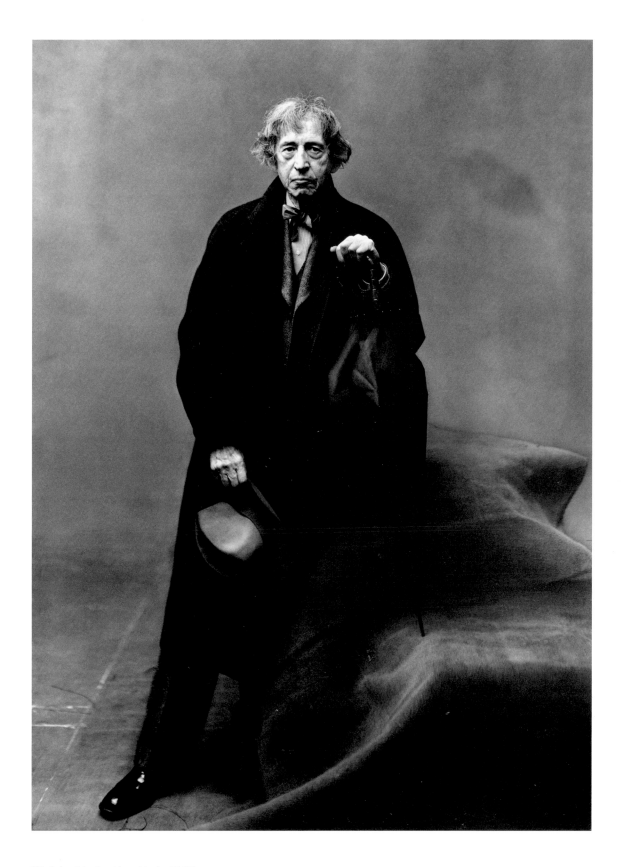

65. John Marin, *New York, 1947*

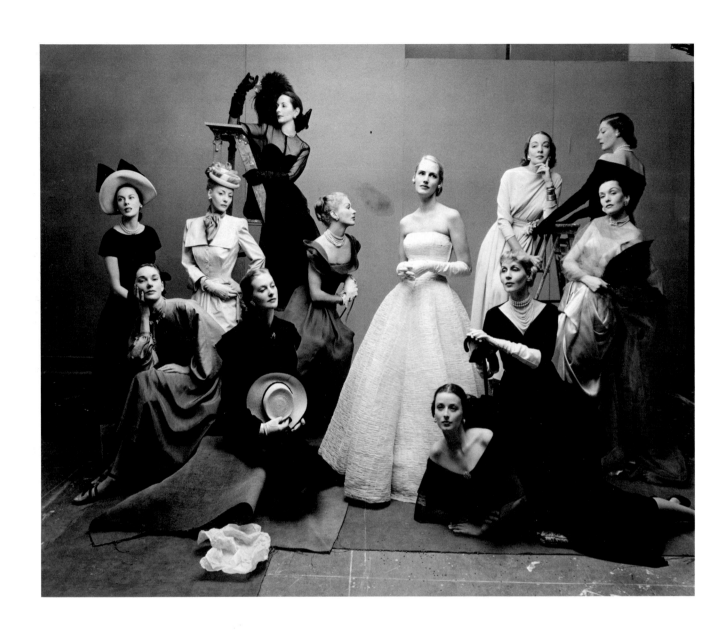

66. Twelve Most Photographed Models, *New York, 1947*

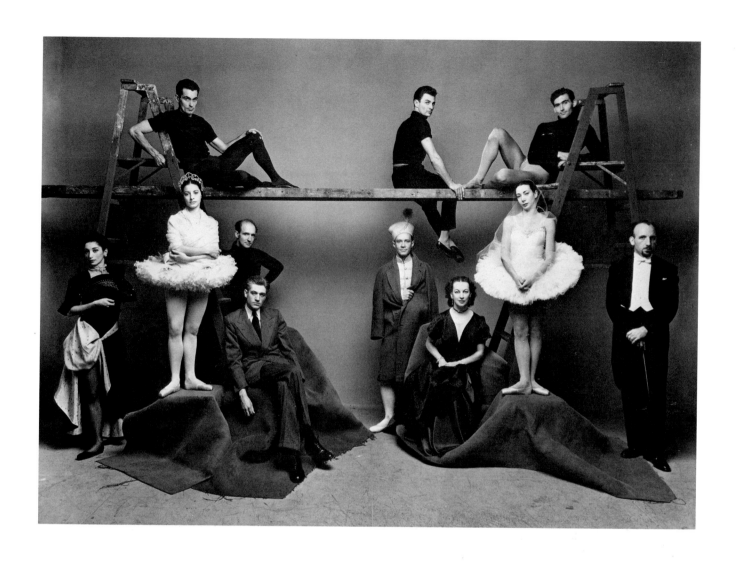

67. Ballet Theatre, *New York, 1947*

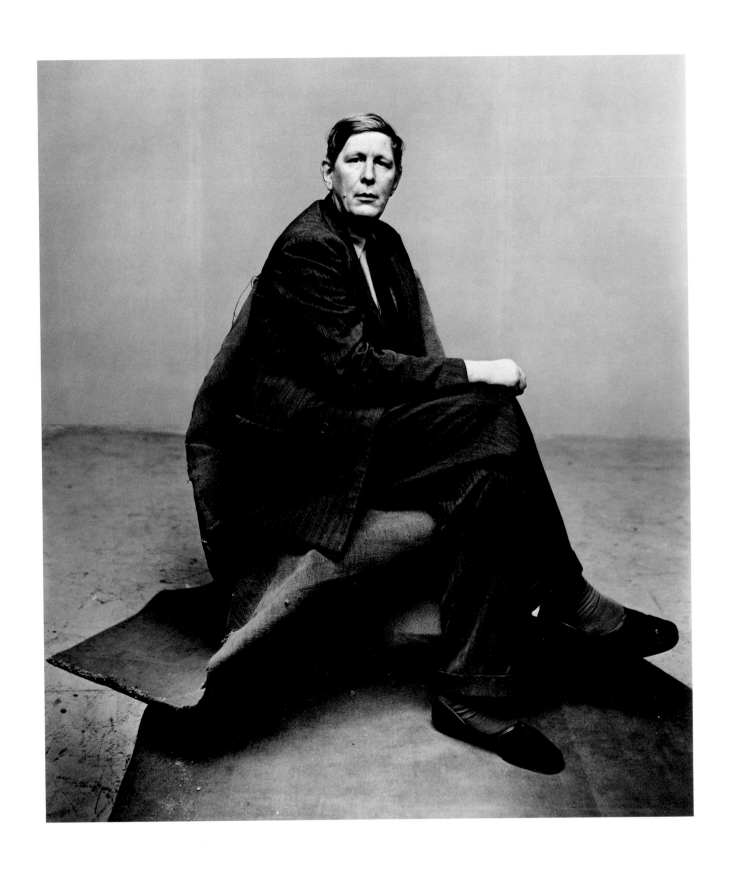

68. W. H. Auden, *New York, October 16, 1947*

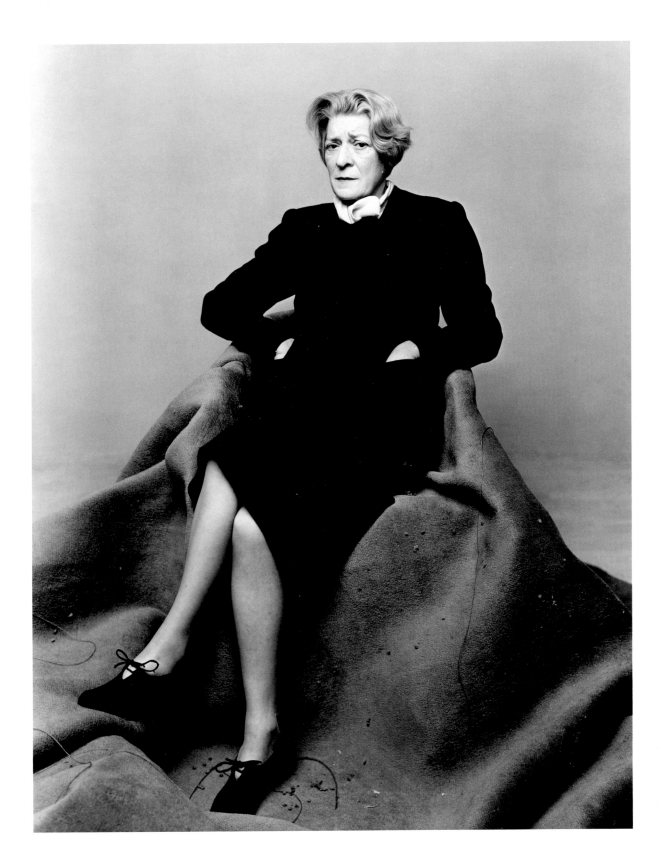

69. Janet Flanner, *New York, 1948*

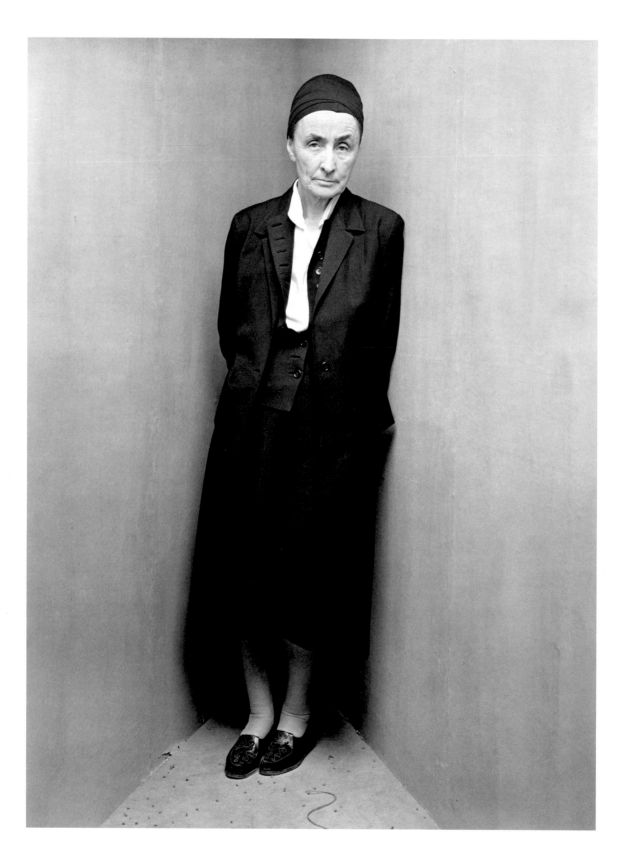

70. Georgia O'Keeffe, *New York, January 31, 1948*

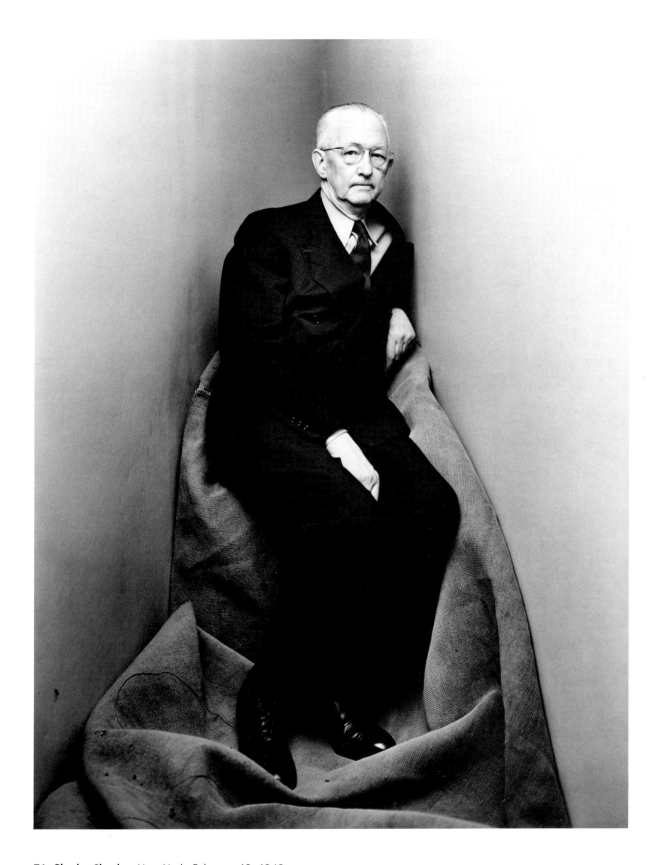

71. Charles Sheeler, *New York, February 13, 1948*

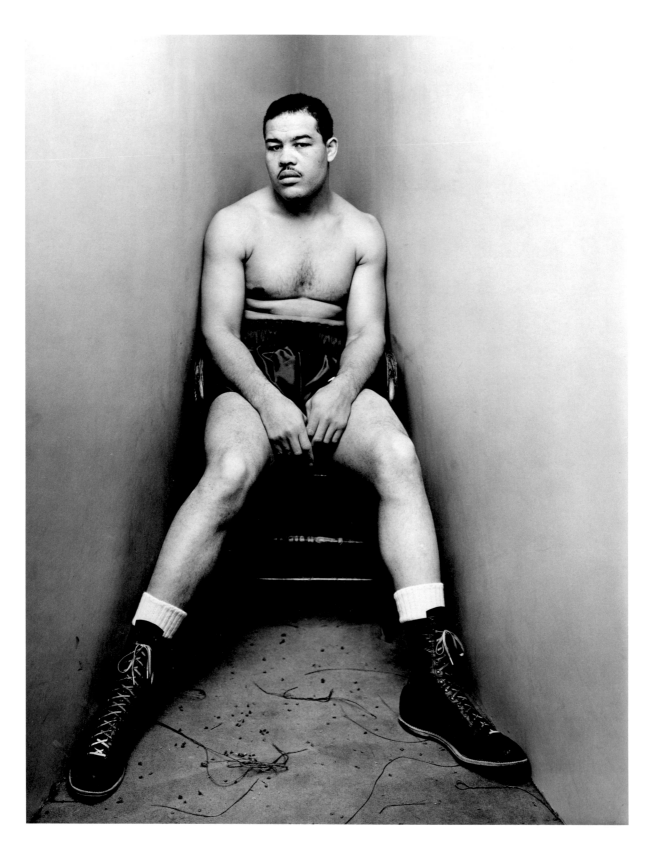

72. Joe Louis, *New York, February 15, 1948*

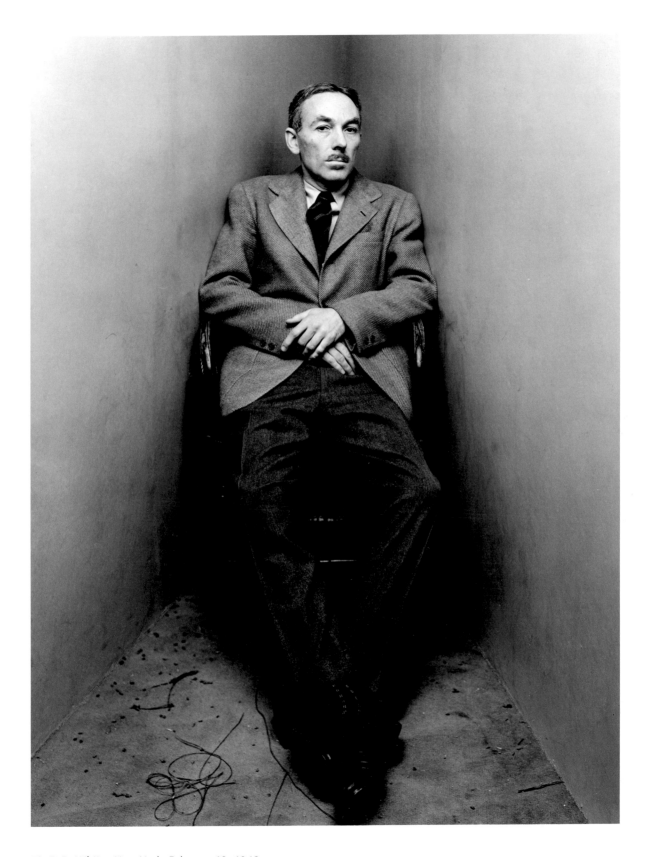

73. E. B. White, *New York, February 19, 1948*

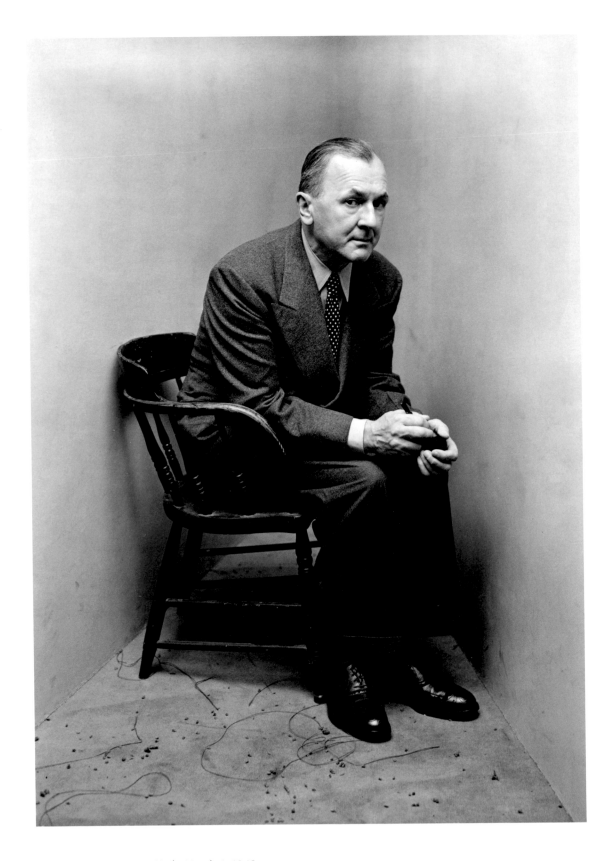

74. George Grosz, *New York, March 4, 1948*

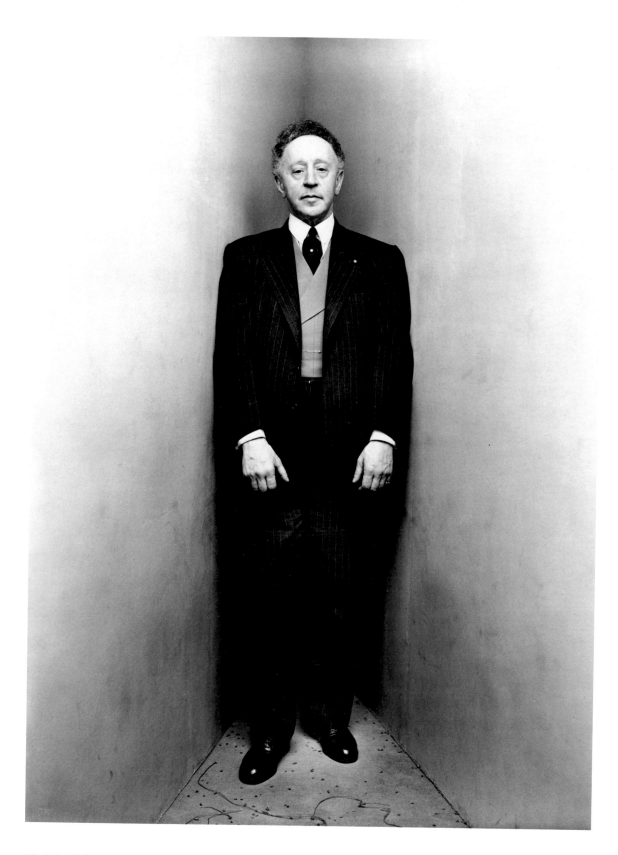

75. Artur Rubinstein, *New York, March 15, 1948*

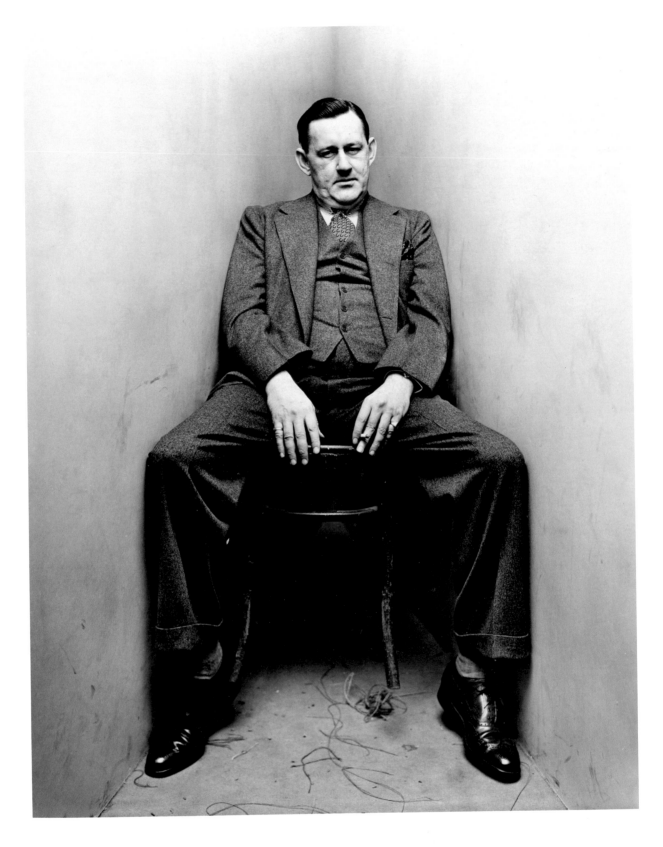

76. John O'Hara, *New York, April 16, 1948*

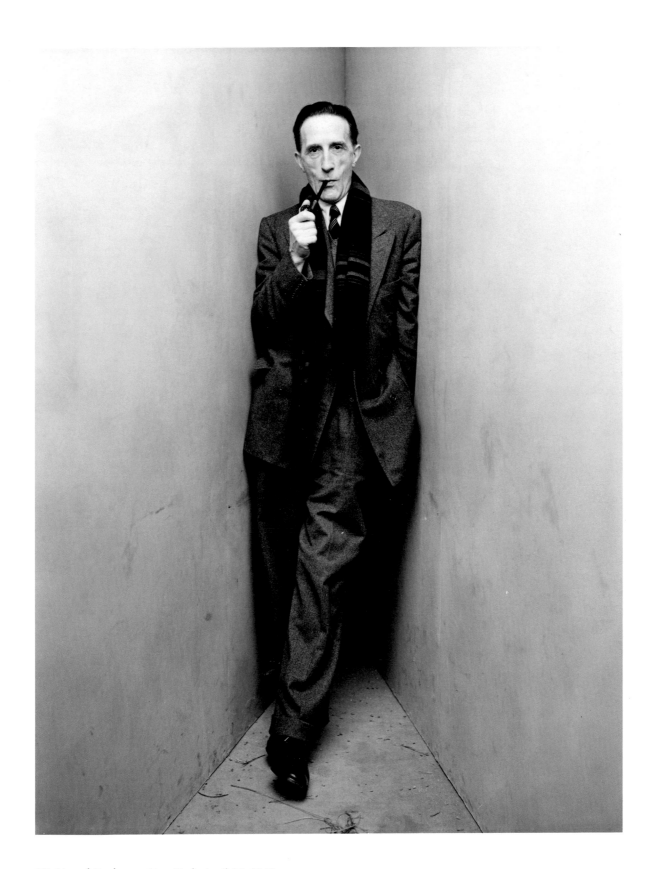

77. Marcel Duchamp, *New York, April 30, 1948*

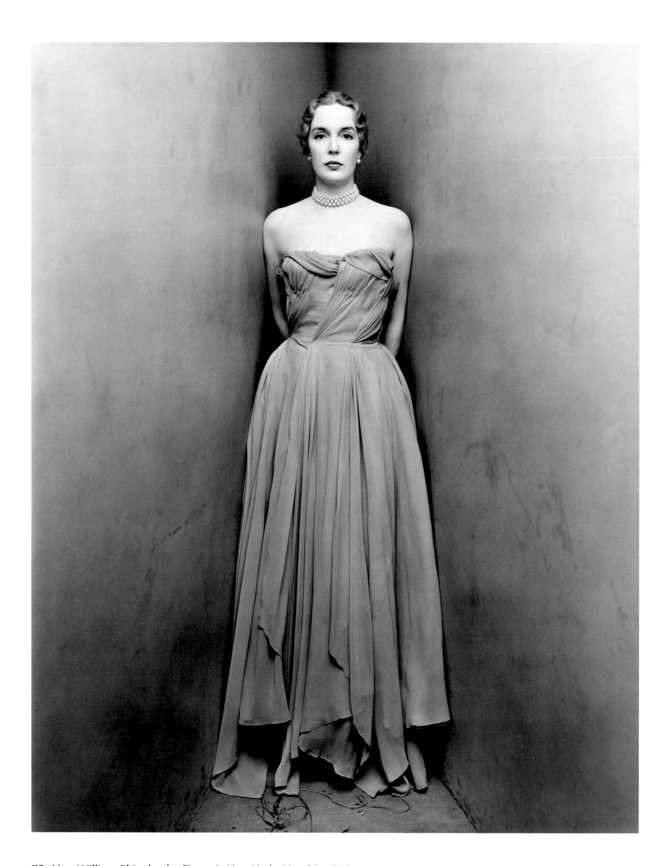

78. Mrs. William Rhinelander Stewart, *New York, May 20, 1948*

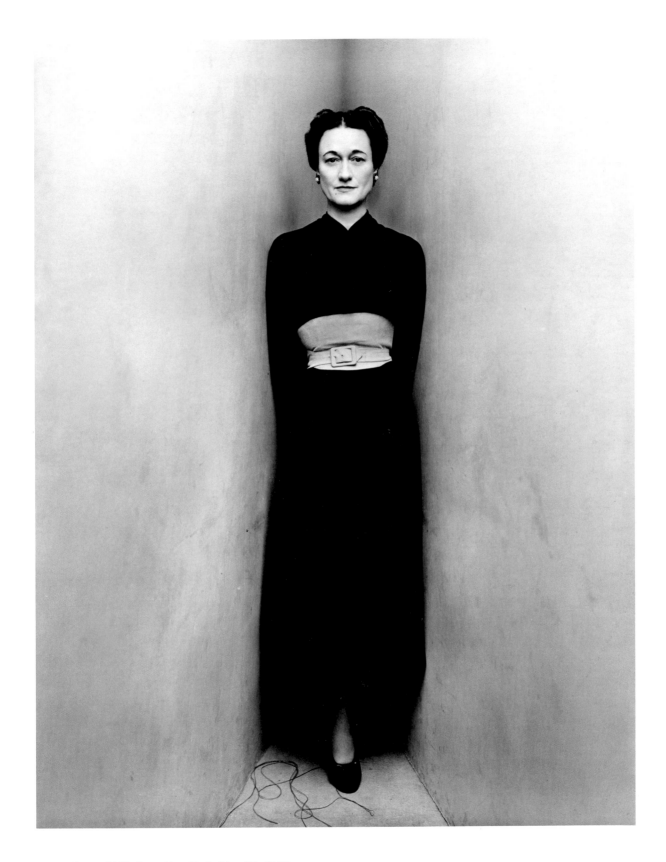

79. Duchess of Windsor, *New York, May 27, 1948*

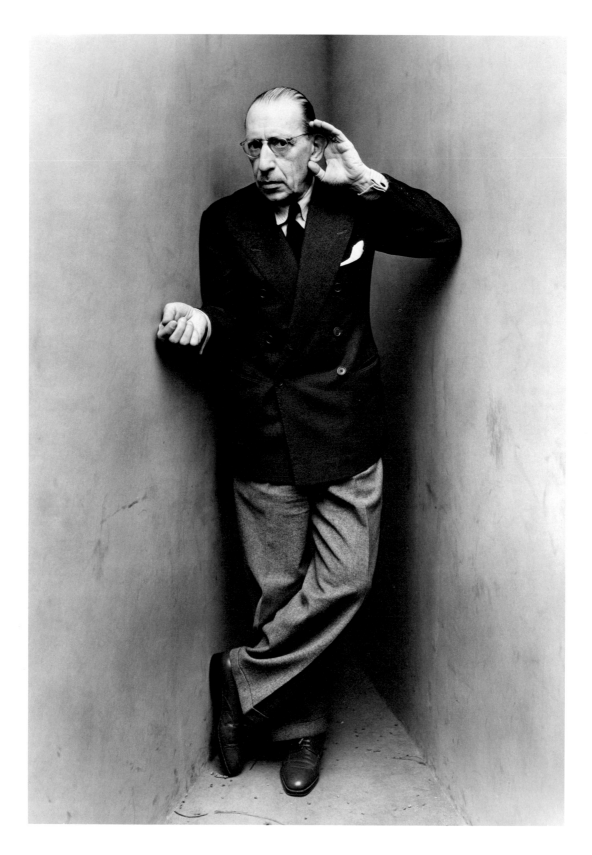

80. Igor Stravinsky, *New York, 1948*

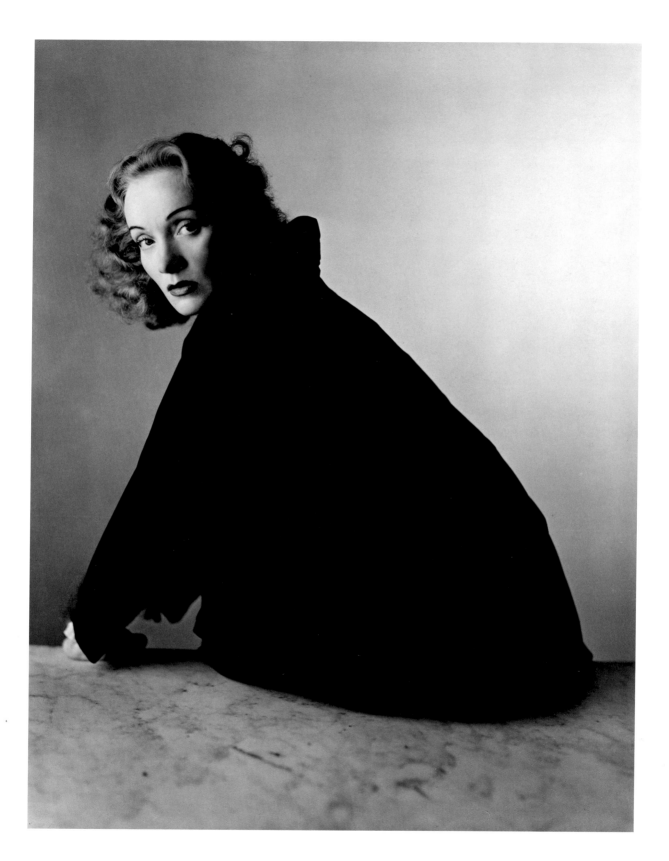

81. Marlene Dietrich, *New York, November 3, 1948*

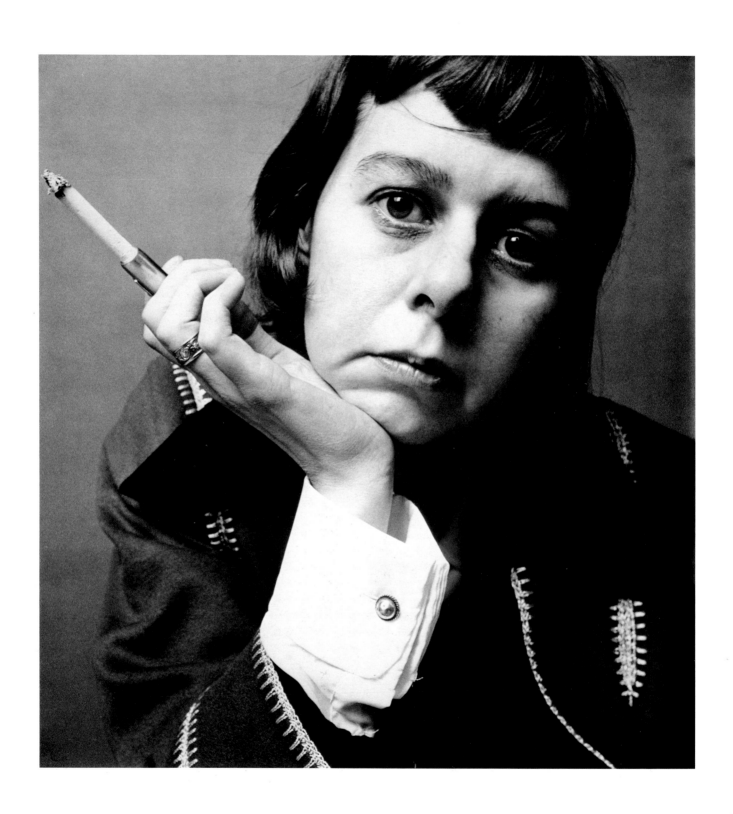

82. Carson McCullers, *New York, May 10, 1950*

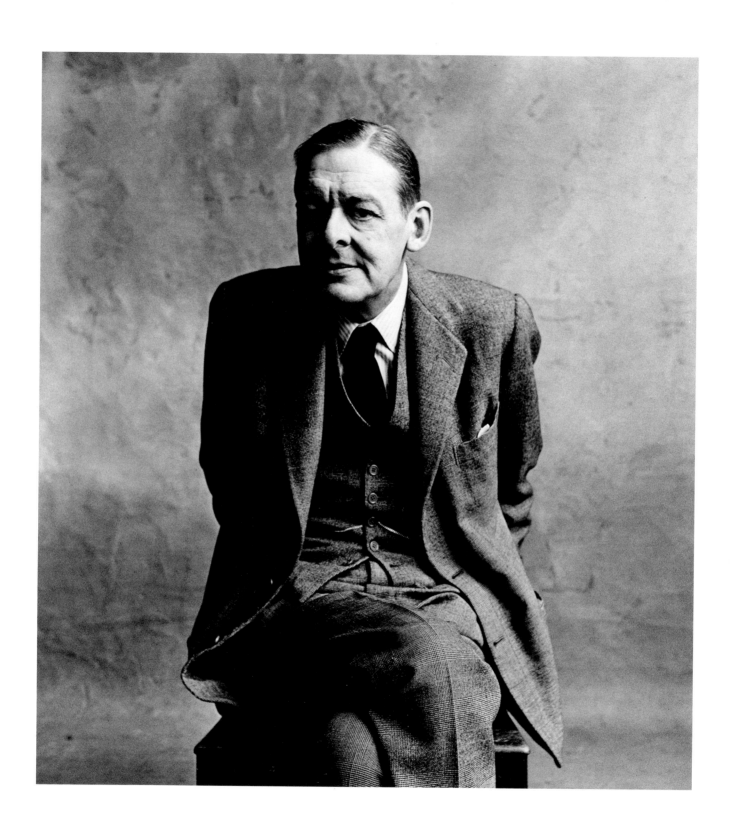

83. T. S. Eliot, *London, 1950*

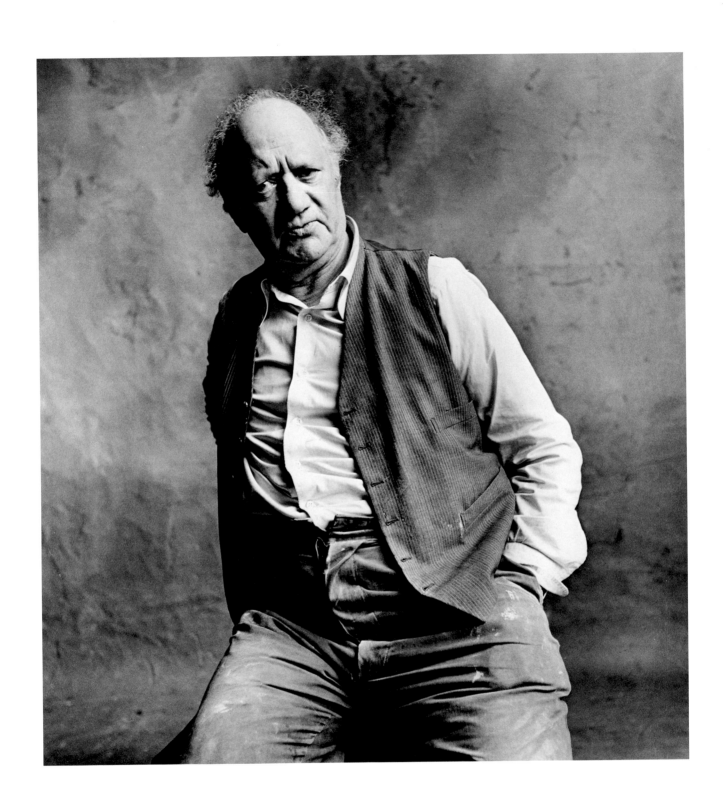

84. Sir Jacob Epstein, *London, 1950*

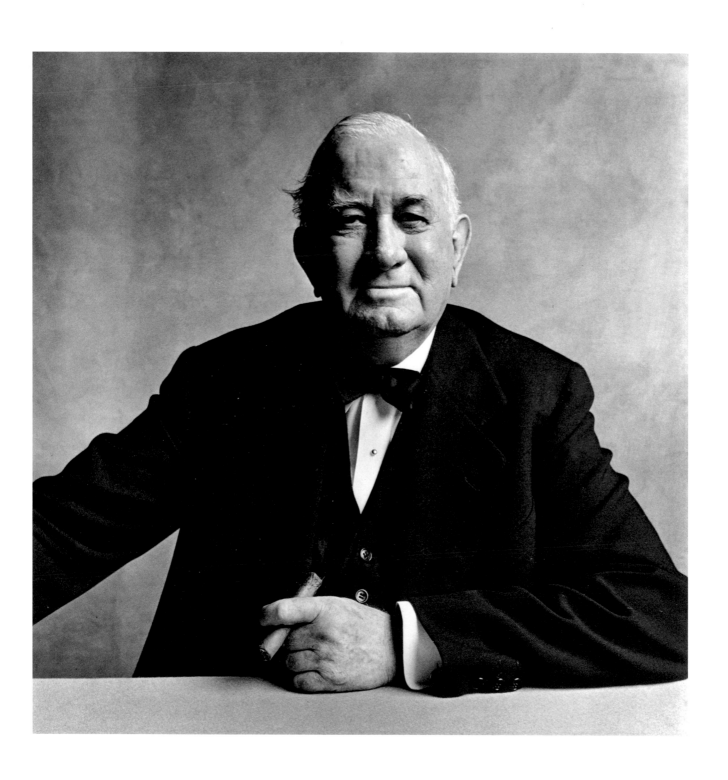

85. Senator Tom Connally, *Washington, 1951*

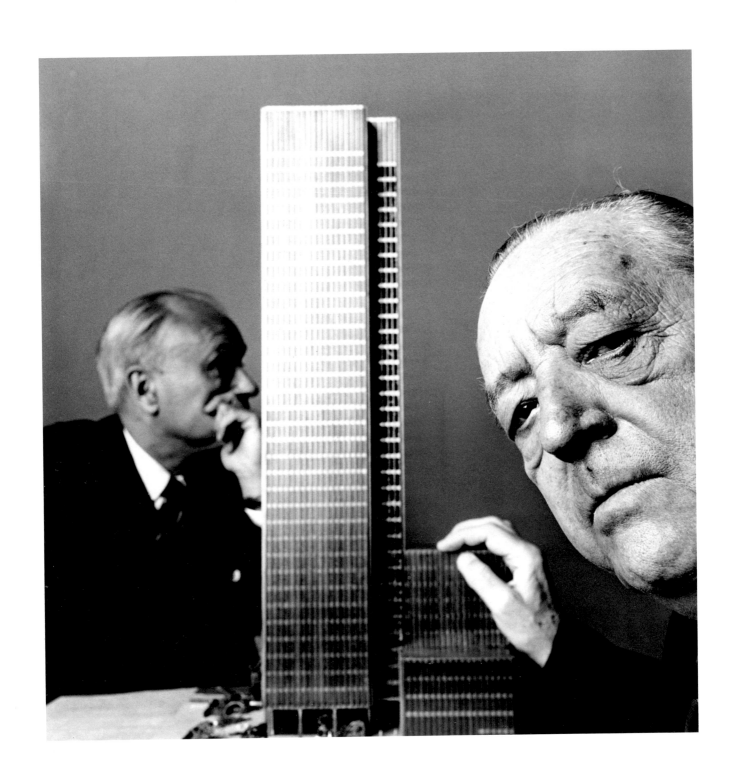

86. Philip Johnson and Ludwig Mies Van Der Rohe, *New York, May 11, 1955*

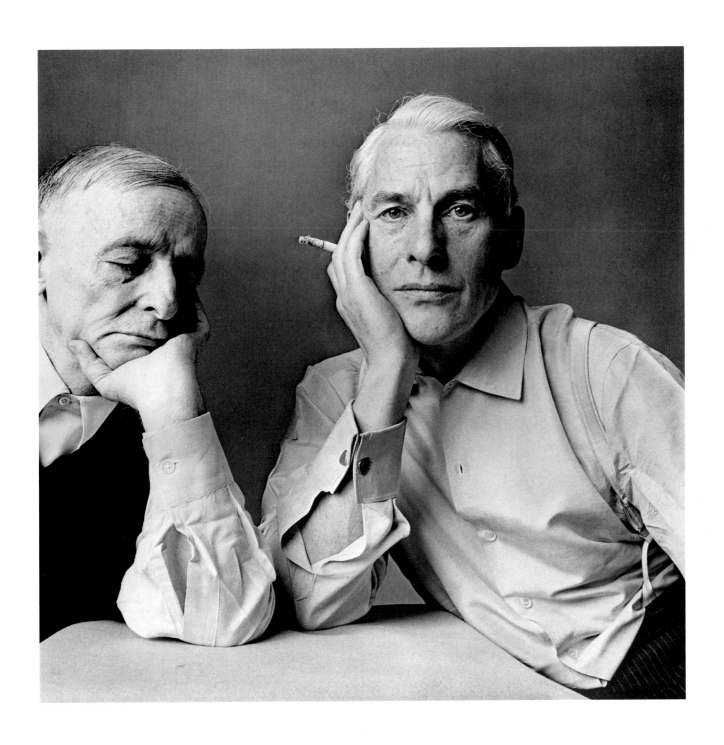

87. Frederick Kiesler and Willem de Kooning, *New York, 1960*

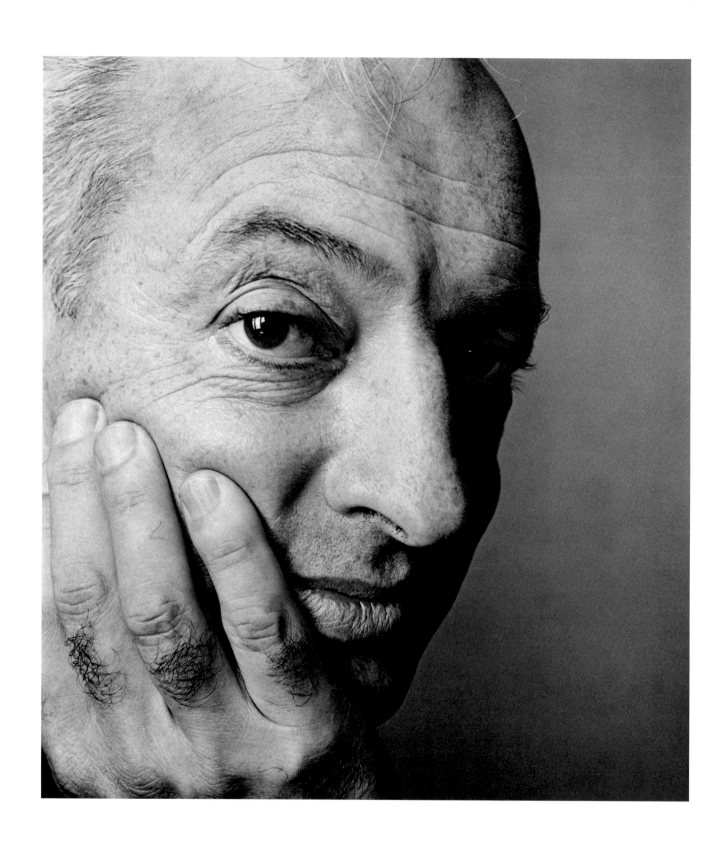

88. Saul Bellow, *New York, September 1964*

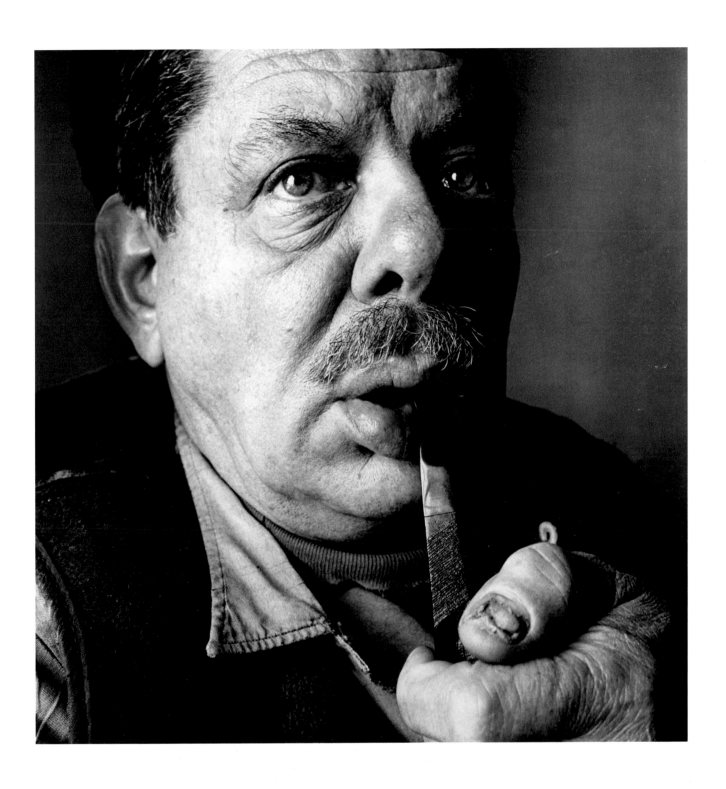

89. David Smith, *Bolton's Landing, N.Y., 1964*

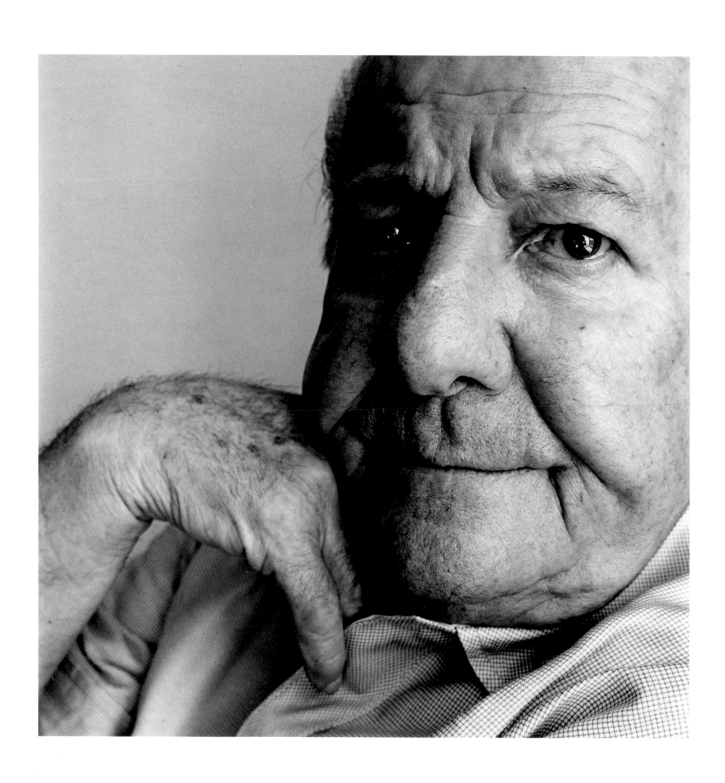

90. Hans Hofmann, *New York, January 1965*

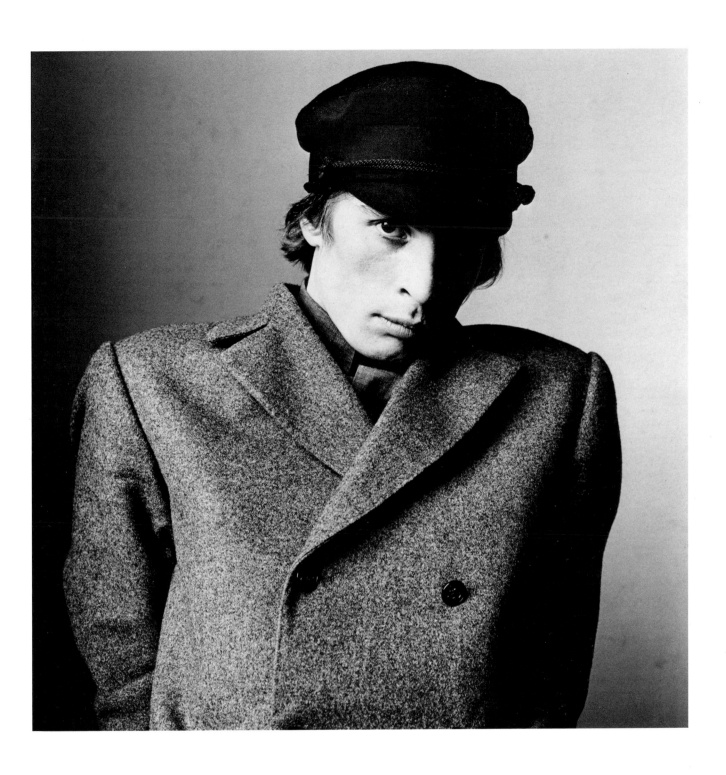

91. Rudolf Nureyev, *New York, May 1965*

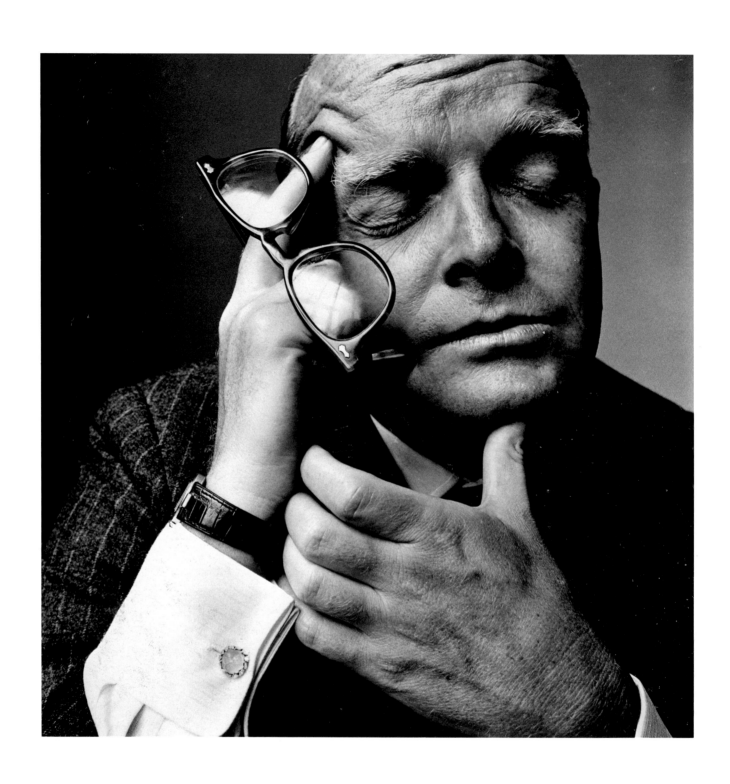

92. Truman Capote, *New York, 1965*

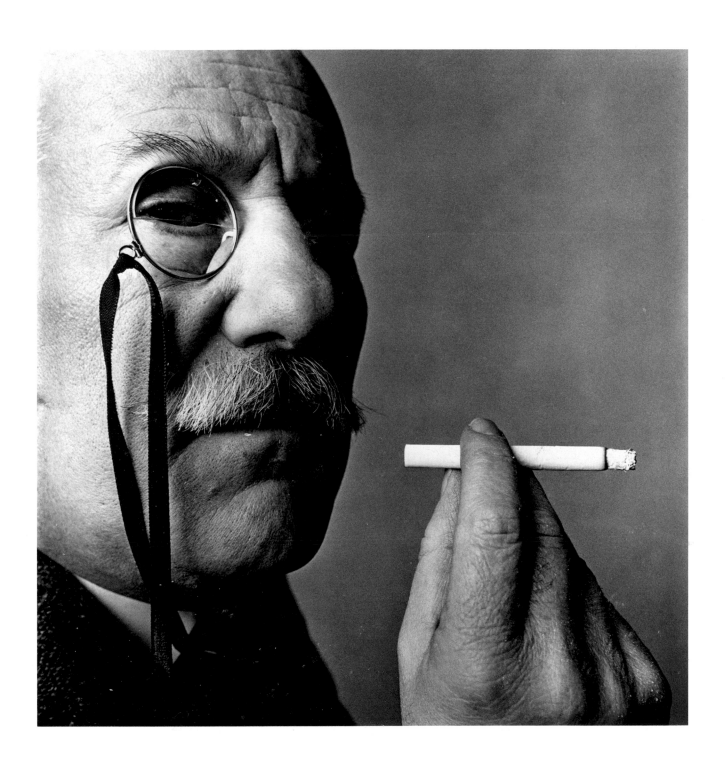

93. Barnett Newman, *New York, 1966*

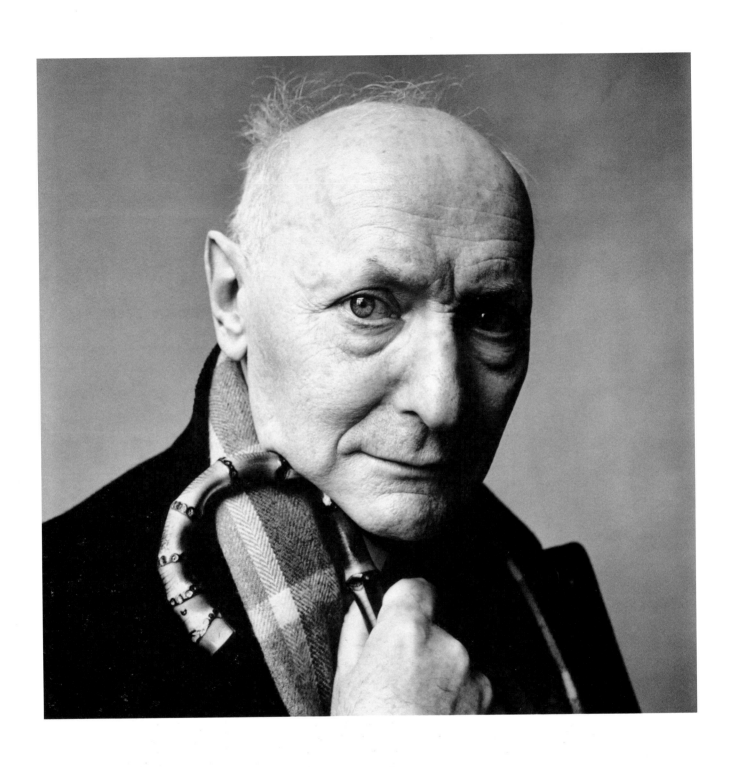

94. Isaac Bashevis Singer, *New York, 1966*

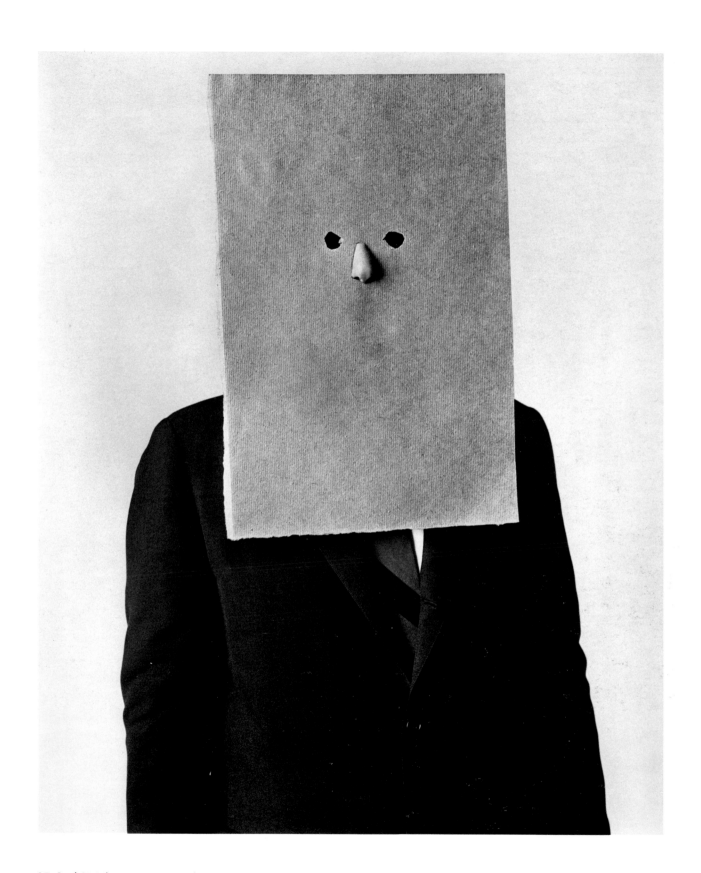

95. Saul Steinberg in Nose Mask, *New York, 1966*

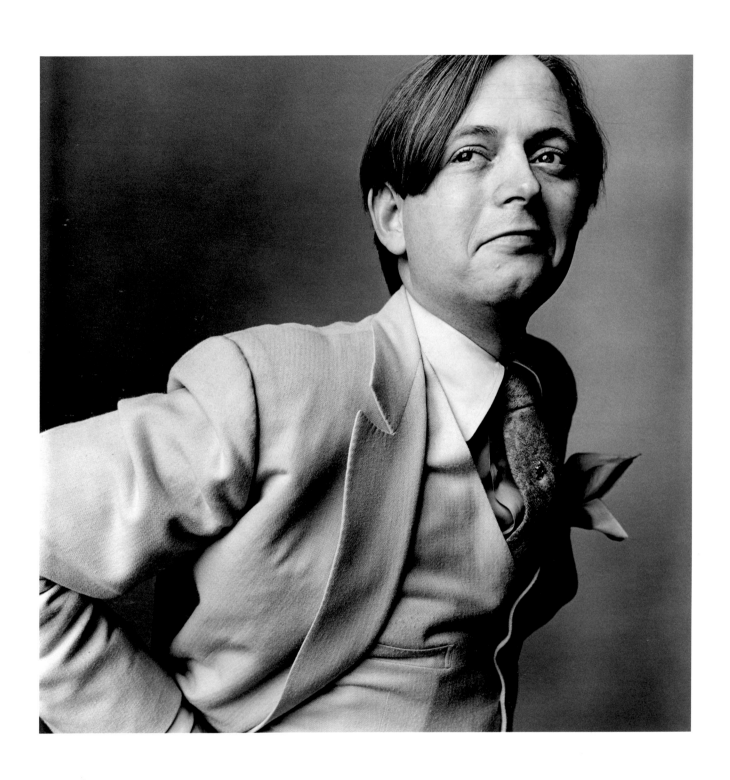

96. Tom Wolfe, *New York, 1966*

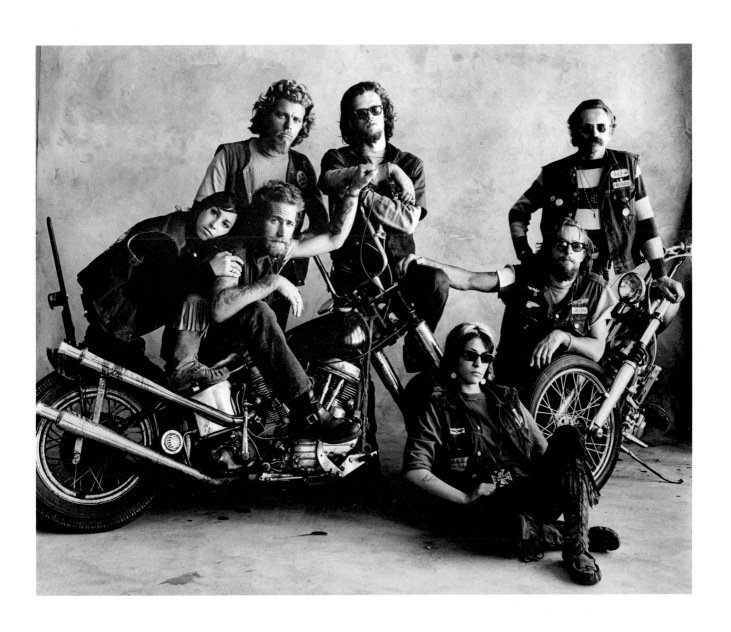

97. Hell's Angels, *San Francisco, 1967*

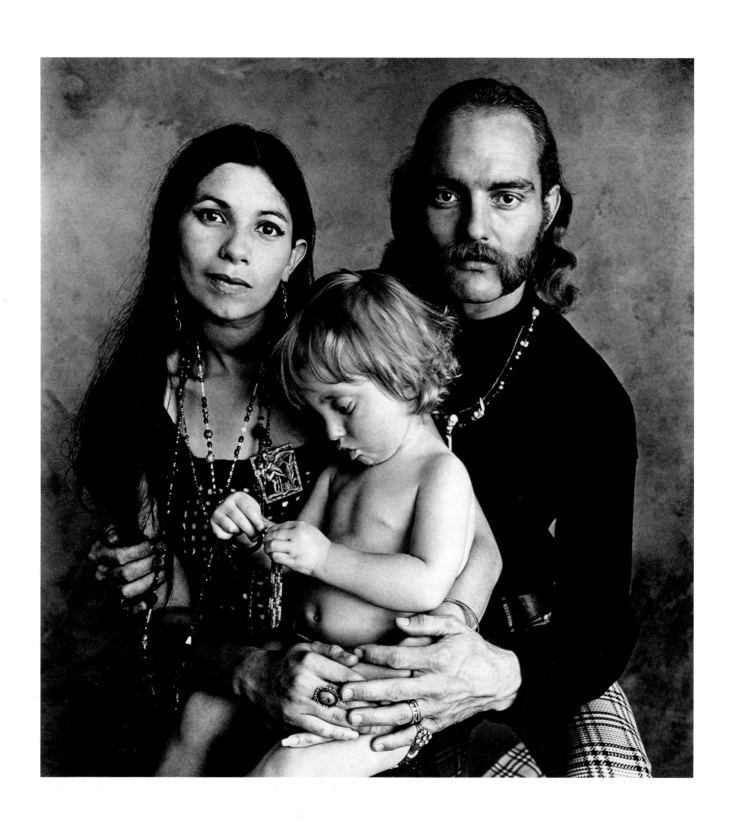

98. Hippie Family (F), *San Francisco, 1967*

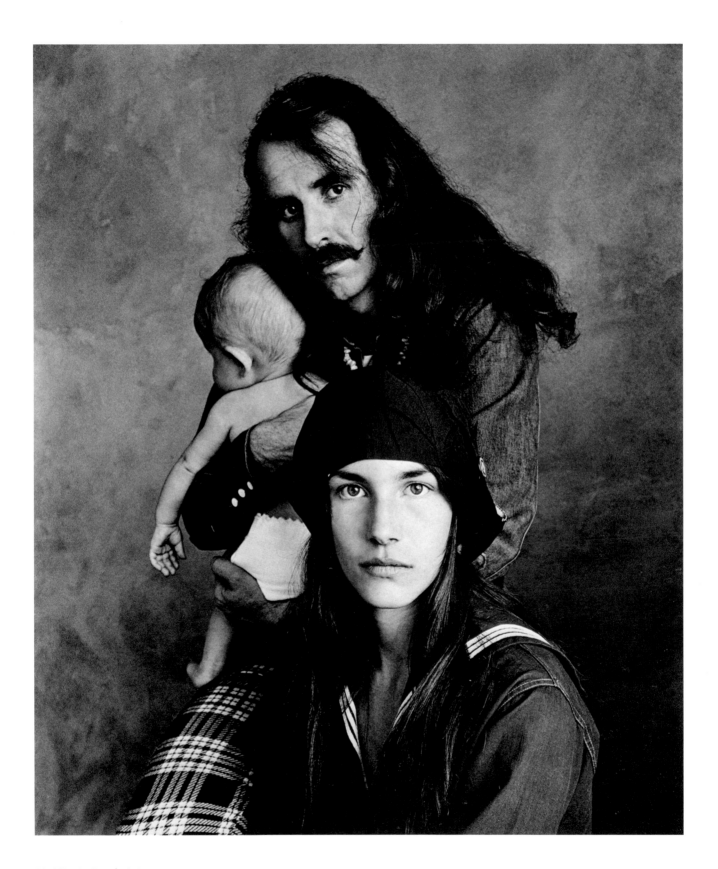

99. Hippie Family (K), *San Francisco, 1967*

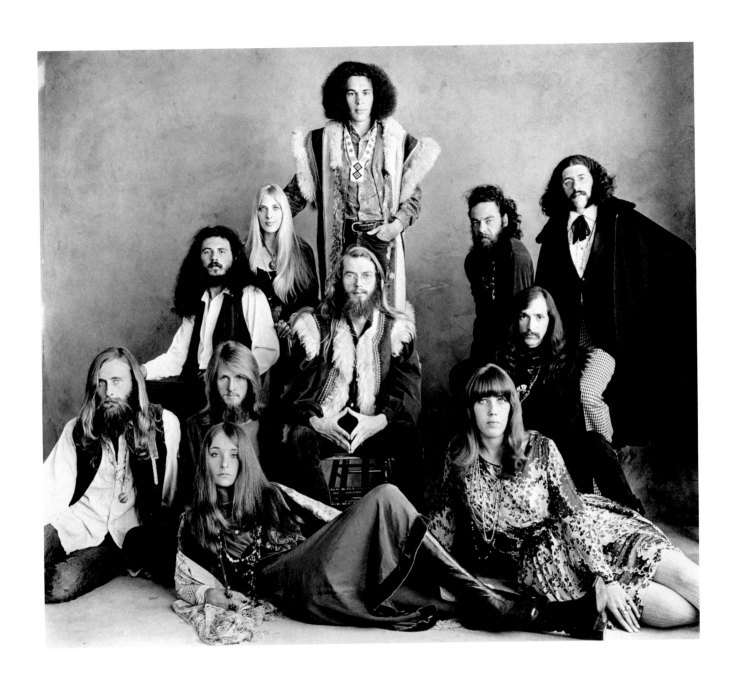

100. Hippie Group, *San Francisco, 1967*

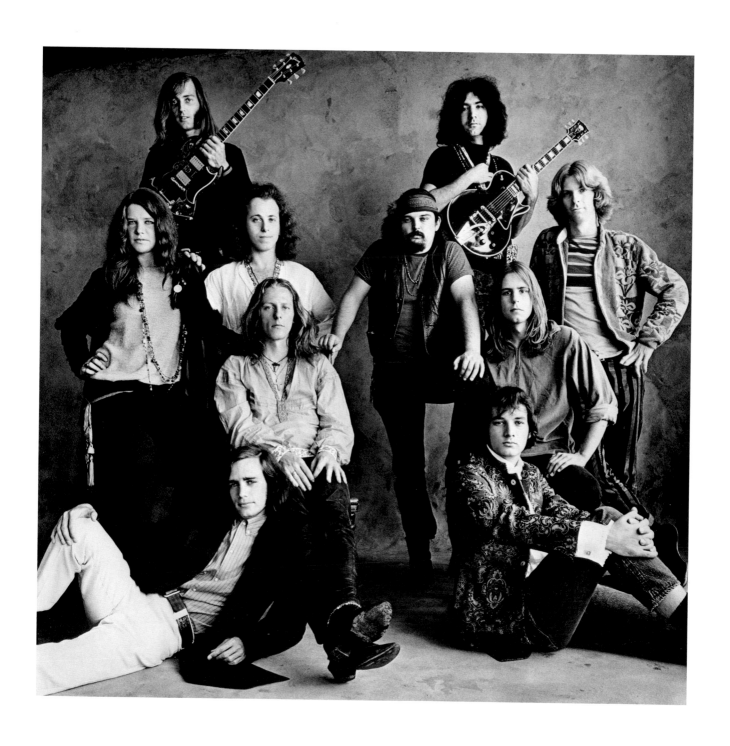

101. Rock Groups (Big Brother and the Holding Company and The Grateful Dead), *San Francisco, 1967*

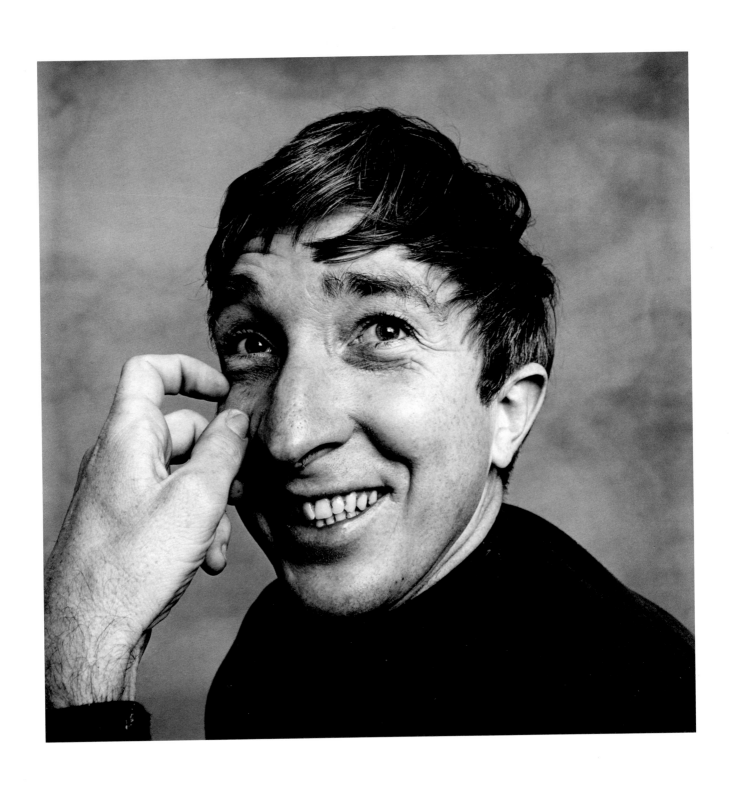

102. John Updike, *New York, 1970*

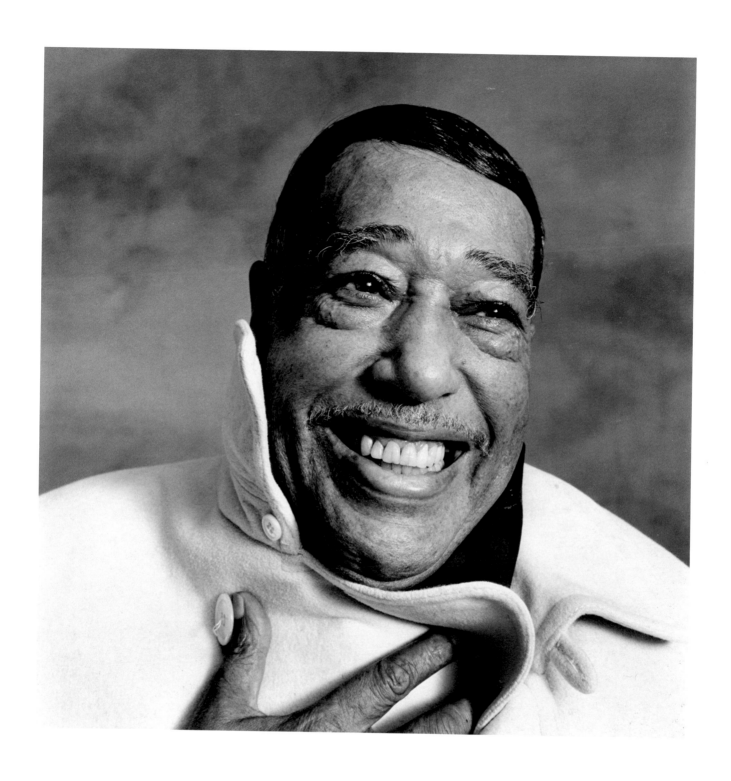

103. Duke Ellington, *New York, March 11, 1971*

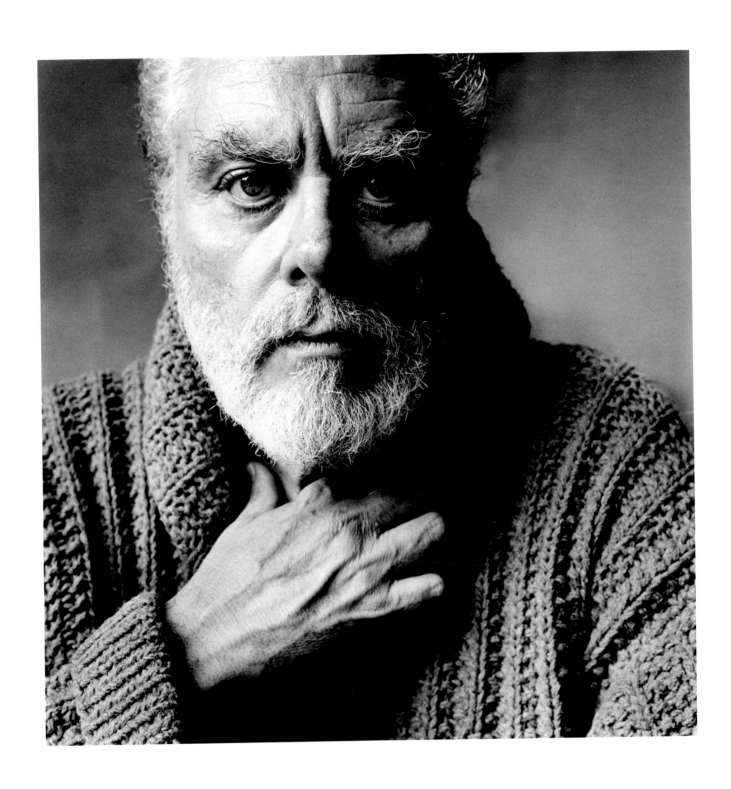

104. Tony Smith, *South Orange, N.J., July 19, 1971*

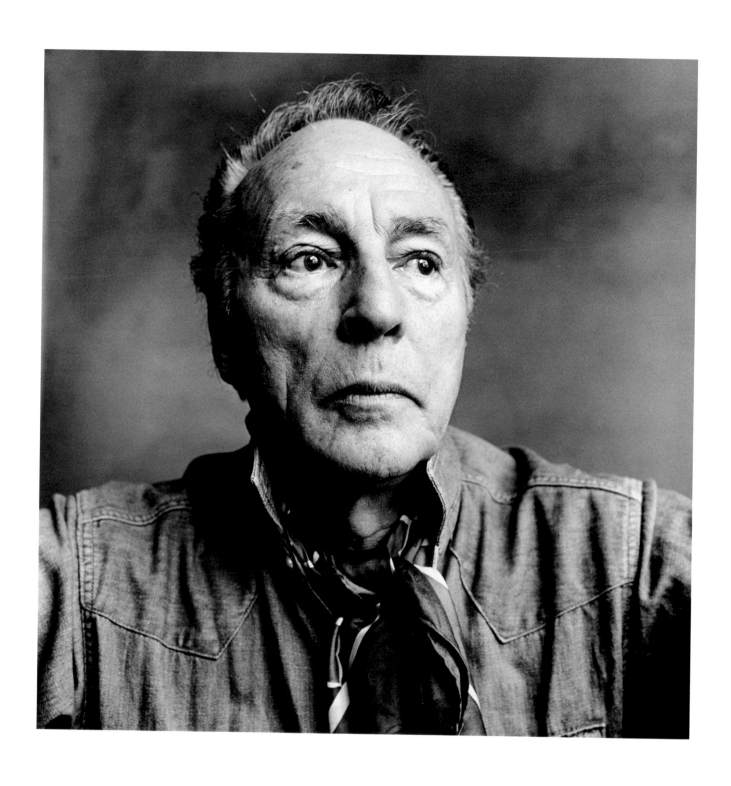

105. George Balanchine, *New York, October 14, 1971*

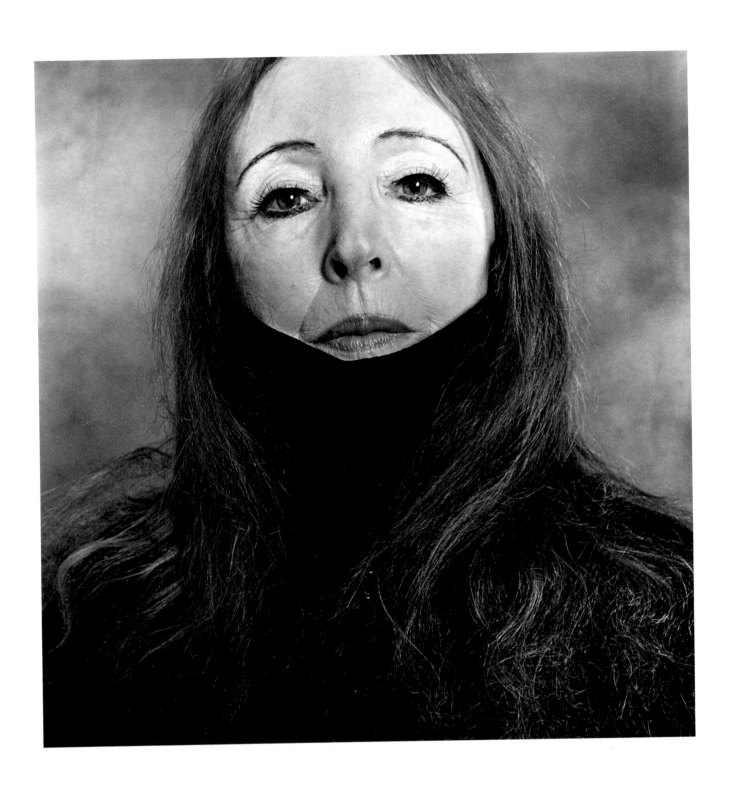

106. Anaïs Nin, *New York, 1971*

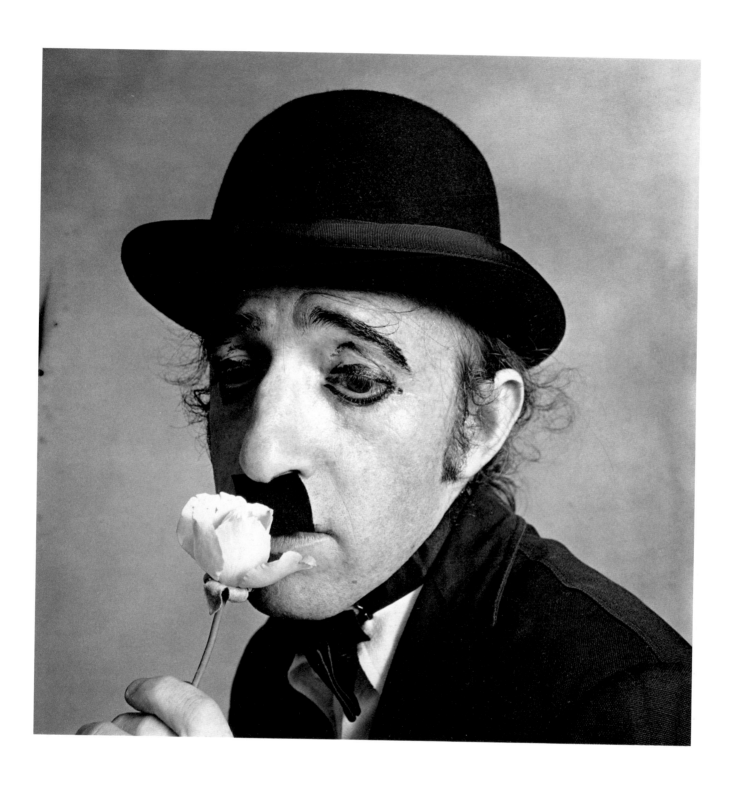

107. Woody Allen as Chaplin, *New York, 1972*

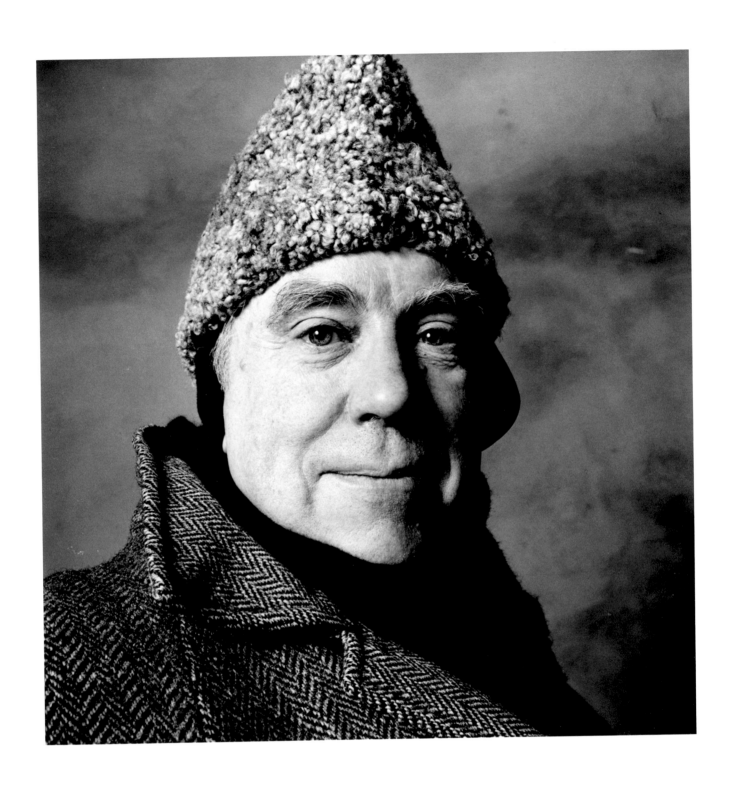

108. Elliott Carter, *New York, February 12, 1975*

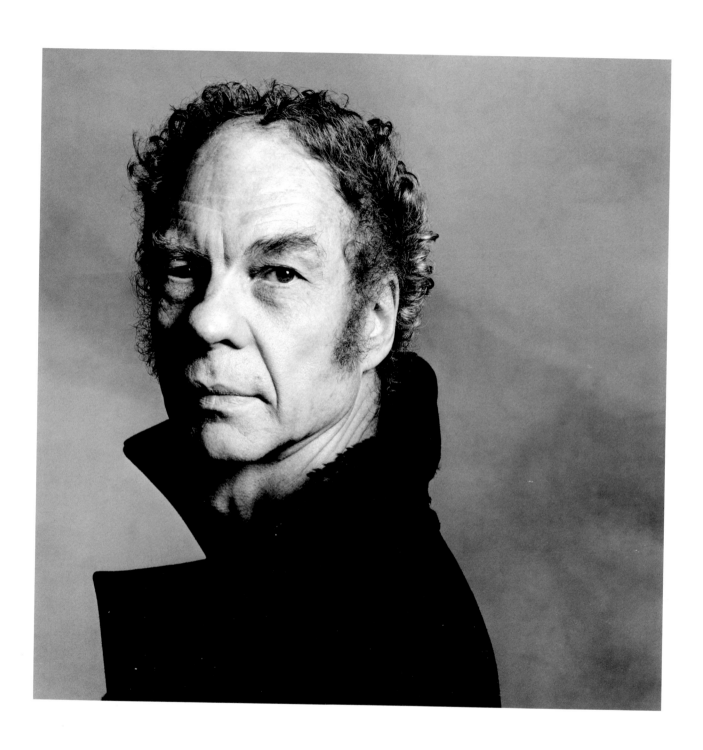

109. Merce Cunningham, *New York, 1978*

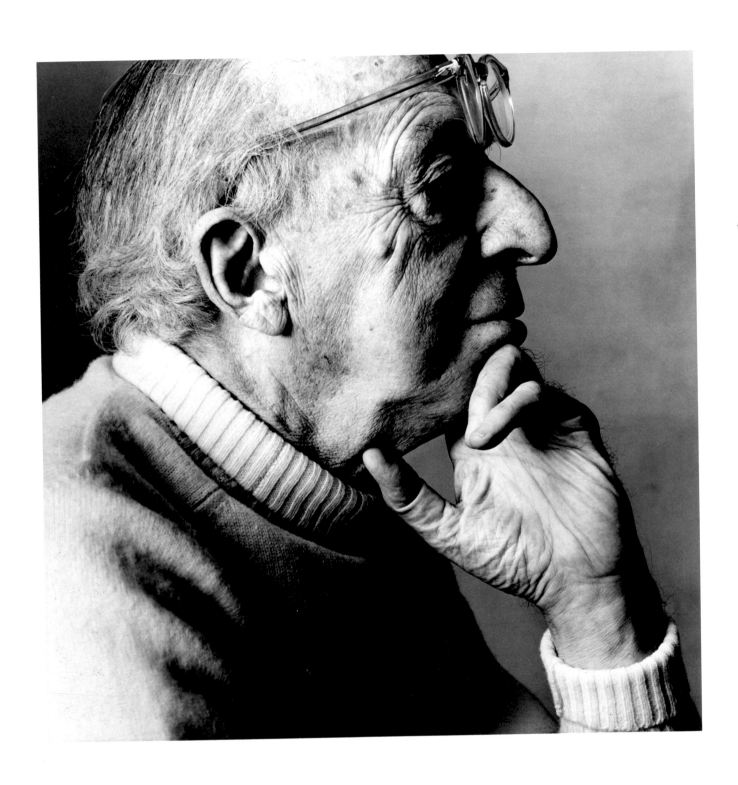

110. Aaron Copland, *New York, February 21, 1979*

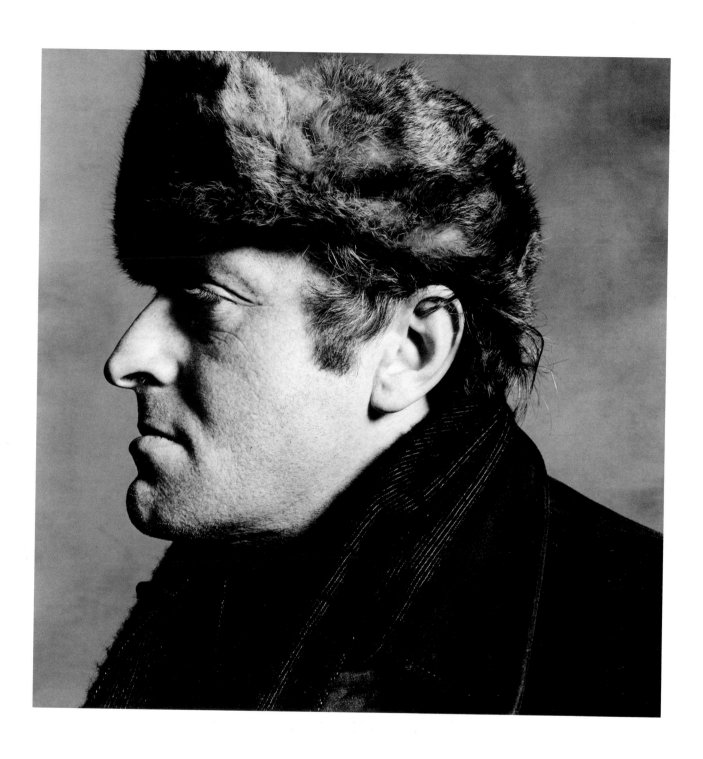

111. Joseph Brodsky, *New York, January 7, 1980*

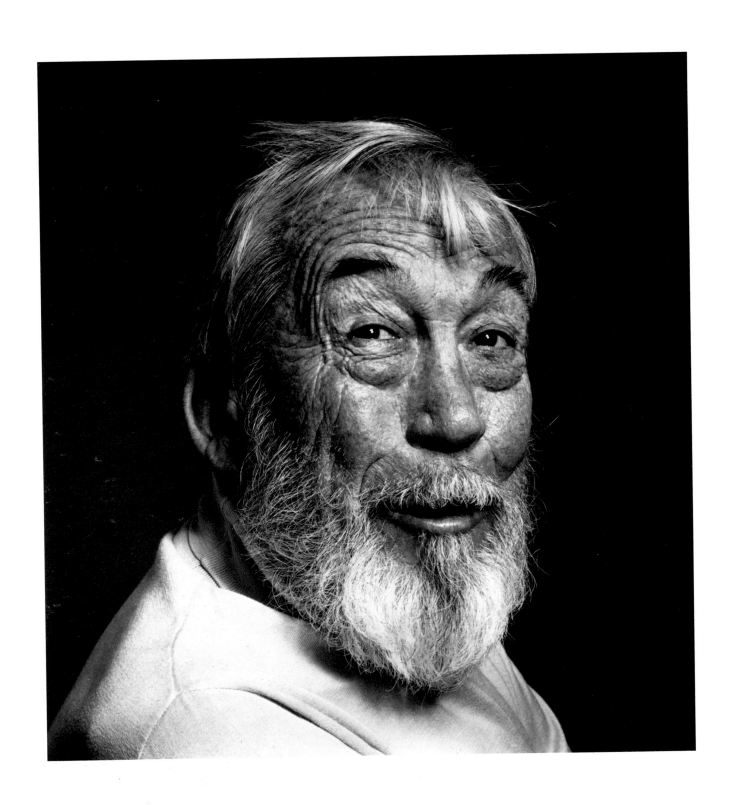

112. John Huston, *New York, February 7, 1980*

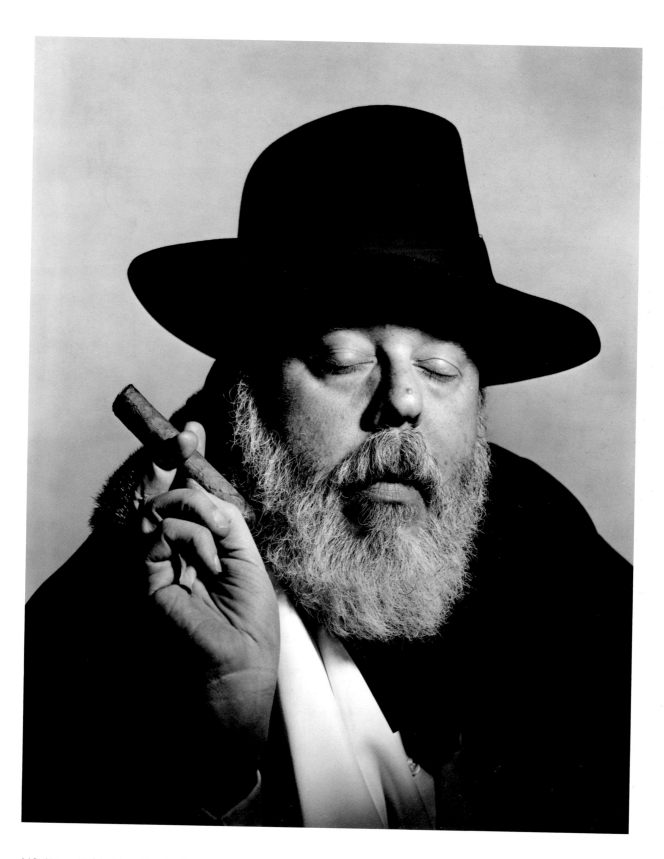

113. Henry Geldzahler, *New York, 1981*

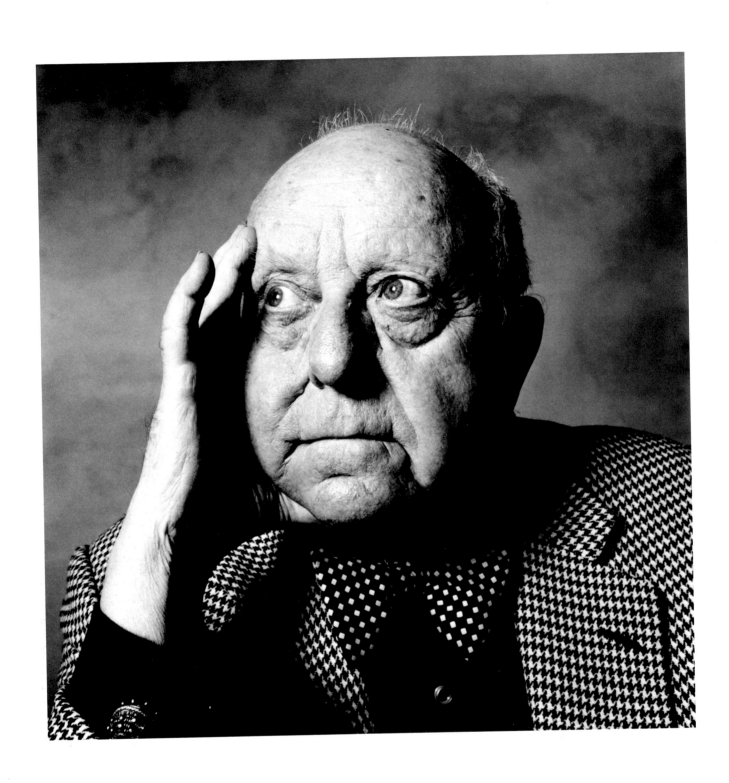

114. Virgil Thomson, *New York, December 28, 1982*

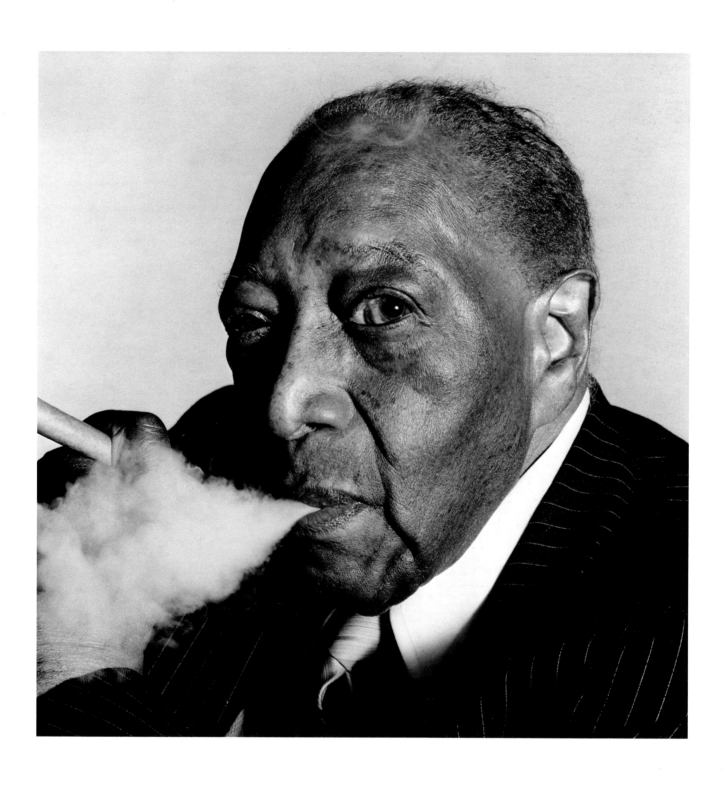

115. James Van Der Zee, *New York, February 11, 1983*

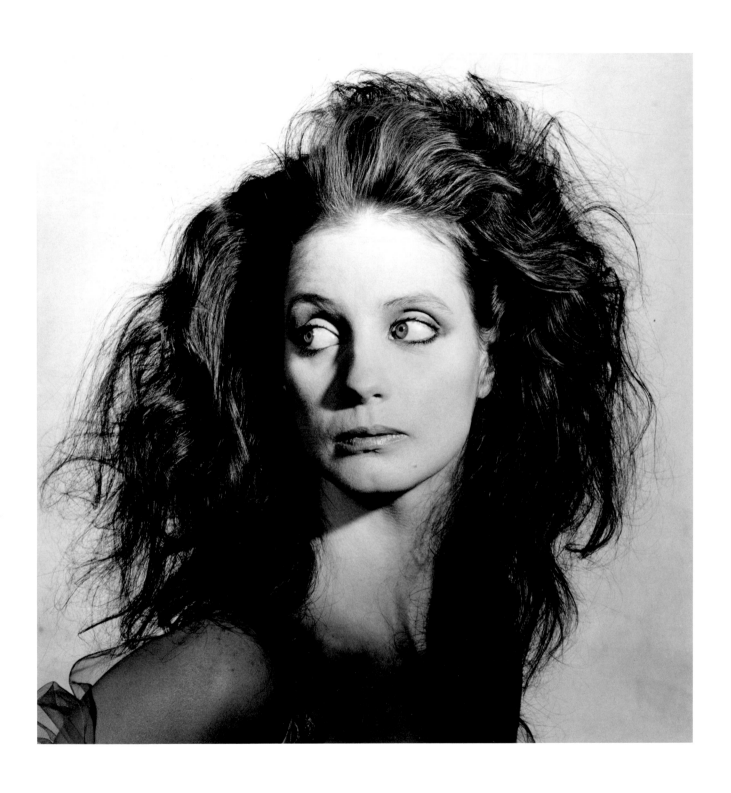

116. Suzanne Farrell, *New York, February 25, 1983*

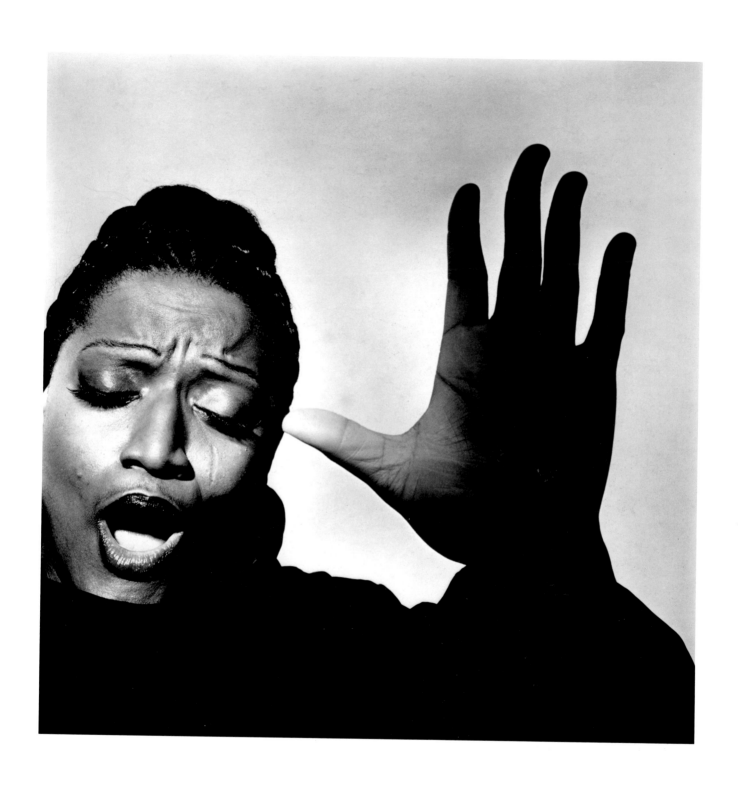

117. Jessye Norman, *New York, May 20, 1983*

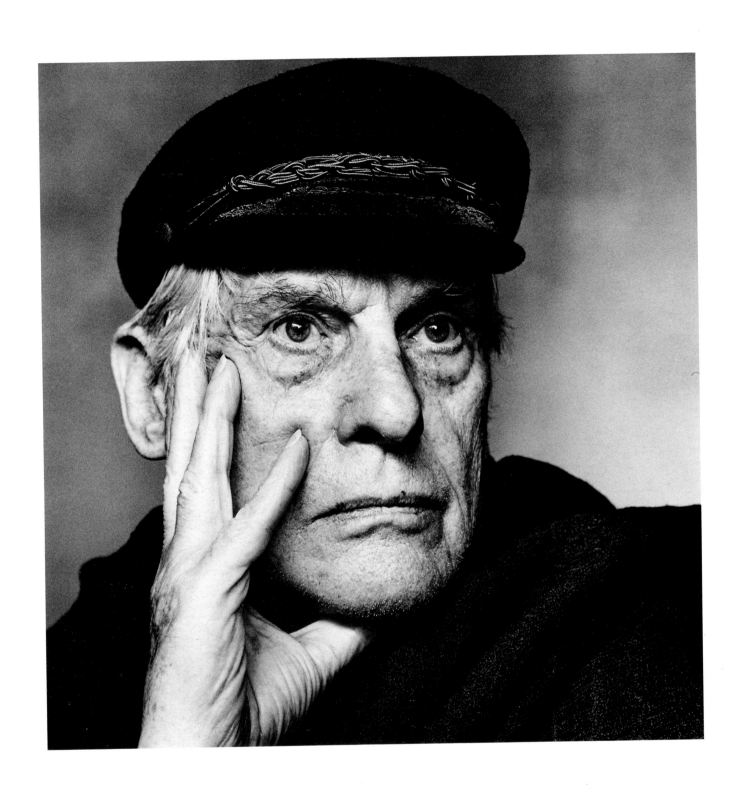

118. Willem de Kooning, *Long Island, N.Y., September 26, 1983*

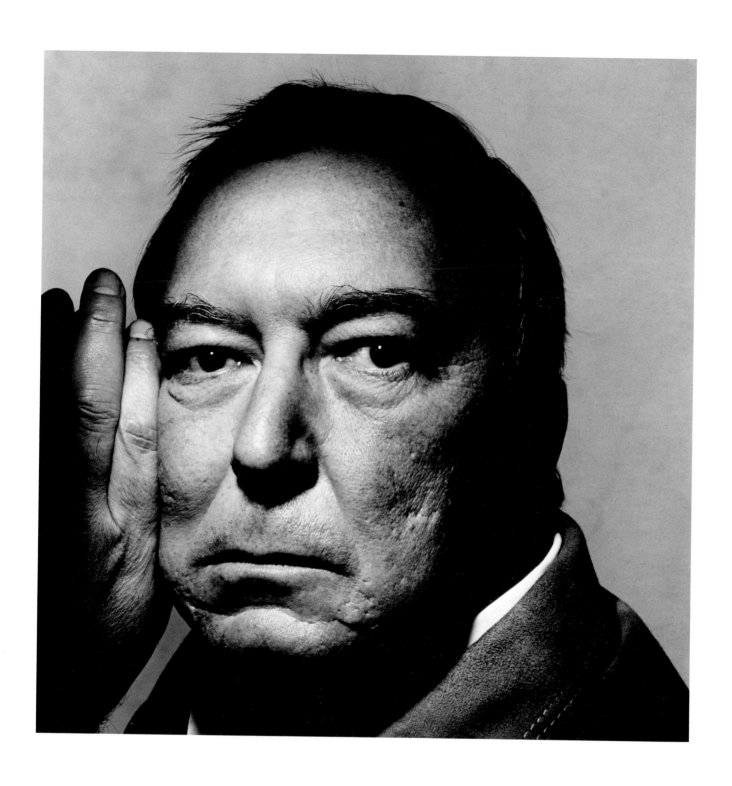

119. Jasper Johns, *New York, November 18, 1983*

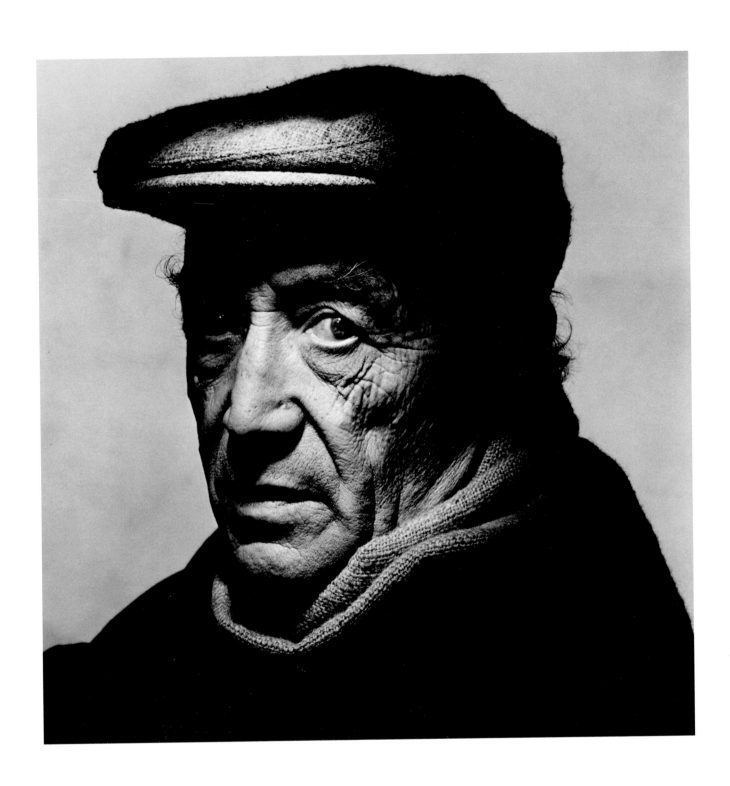

120. Isamu Noguchi, *New York, December 20, 1983*

61.

Group of *Vogue* Photographers, *Long Island, N.Y.*

LEFT TO RIGHT: Serge Balkin, Cecil Beaton, George Platt Lynes, Constantin Joffe, Dorian Leigh (model), Horst P. Horst, John Rawlings (rear), Irving Penn (front), Erwin Blumenfeld

DATE OF NEGATIVE: 1946

DATE OF PRINT: Circa 1946

PRINT MEDIUM: Gelatin silver

SUPPORT: Dry-mounted on board

DIMENSIONS

 IMAGE: 37.1 × 49.6 cm. ($14\frac{5}{8}$ × $19\frac{1}{2}$ in.)

 SHEET: 37.1 × 49.6 cm. ($14\frac{5}{8}$ × $19\frac{1}{2}$ in.)

 MOUNT: 43.2 × 58.5 cm. (17 × $23\frac{1}{16}$ in.)

NUMBER/SIZE OF EDITION: No more than fifty-six signed silver prints

ACCESSION NUMBER: T/NPG.88.70.57

PENN'S REFERENCE NUMBER: 8674

COPYRIGHT: 1946 by Irving Penn (renewed 1974)

FIRST PUBLISHED: Paris *Vogue* (1947), p. 82

REMARKS: The photograph was taken on Horst's estate on Long Island, at the first reunion of Vogue's leading photographers after the end of World War II.

62.

Max Ernst and Dorothea Tanning, *New York*

DATE OF NEGATIVE: March 20, 1947

DATE OF PRINT: 1947

PRINT MEDIUM: Gelatin silver

SUPPORT: Dry-mounted on board

DIMENSIONS

 IMAGE: 24.2 × 19.6 cm. ($9\frac{9}{16}$ × $7\frac{11}{16}$ in.)

 SHEET: 24.2 × 19.6 cm. ($9\frac{9}{16}$ × $7\frac{11}{16}$ in.)

 MOUNT: 35.6 × 28.1 cm. (14 × $11\frac{1}{16}$ in.)

NUMBER/SIZE OF EDITION: No more than twelve signed silver prints

ACCESSION NUMBER: NPG.88.70.18

PENN'S REFERENCE NUMBER: 10262

COPYRIGHT: 1983 by Irving Penn, courtesy of *Vogue*

FIRST PUBLISHED: John Szarkowski, *Irving Penn* (exhibition catalogue, Museum of Modern Art, New York, 1984), pl. 17

63.

Walter Lippmann, *New York*

DATE OF NEGATIVE: June 27, 1947

DATE OF PRINT: Circa 1947

PRINT MEDIUM: Gelatin silver

SUPPORT: Paper

DIMENSIONS

 IMAGE: 24.4 × 19.6 cm. ($9\frac{5}{8}$ × $7\frac{3}{4}$ in.)

 SHEET: 25.3 × 20.4 cm. ($9\frac{15}{16}$ × $8\frac{1}{16}$ in.)

 MOUNT: Unmounted

NUMBER/SIZE OF EDITION: No more than twenty-nine signed silver prints

ACCESSION NUMBER: NPG.88.70.33

PENN'S REFERENCE NUMBER: 2930

COPYRIGHT: 1948 by The Condé Nast Publications Inc. (renewed 1976)

FIRST PUBLISHED: "Influences," *Vogue* (February 1, 1948), p. 216

REMARKS: Inscribed in the negative: "1447a 8 9"

64.

George Jean Nathan and H. L. Mencken, *New York*

DATE OF NEGATIVE: 1947

DATE OF PRINT: 1985

PRINT MEDIUM: Platinum-palladium, single coating, multiple printing

SUPPORT: Rives paper on aluminum panel

DIMENSIONS

 IMAGE: 55.2 × 45.5 cm. ($21\frac{3}{4}$ × $17\frac{15}{16}$ in.)

 SHEET: 63.2 × 55.9 cm. ($24\frac{7}{8}$ × 22 in.)

 MOUNT: 66 × 55.9 cm. (26 × 22 in.)

NUMBER/SIZE OF EDITION: Number fourteen of an edition of seventeen in platinum metals

OTHER PRINTS: No more than sixty-five unnumbered, signed silver prints

ACCESSION NUMBER: NPG.88.70.31

PENN'S REFERENCE NUMBER: 679

COPYRIGHT: 1948 by The Condé Nast Publications Inc. (renewed 1976)

FIRST PUBLISHED: "Influences," *Vogue* (February 1, 1948), p. 217

REPRODUCED: Irving Penn, *Moments Preserved: Eight Essays in Photographs and Words* (New York, 1960), p. 135; Szarkowski, *Penn,* pl. 7

CAPTION: *George Jean Nathan and H. L. Mencken reputedly rocked God out of the boat because He had "no critical faculties." For this photograph they met after a coolness of many years and seemed to find pleasure in this simple truce* (Penn, *Moments Preserved,* p. 135).

65.

John Marin, *New York*

DATE OF NEGATIVE: 1947

DATE OF PRINT: August 1979

PRINT MEDIUM: Platinum-palladium, single coating, multiple printing

SUPPORT: Rives paper on aluminum panel

DIMENSIONS

IMAGE: 54.3 × 39.7 cm. ($21\frac{3}{8}$ × $15\frac{5}{8}$ in.)

SHEET: 63.3 × 56 cm. ($24\frac{15}{16}$ × $22\frac{1}{16}$ in.)

MOUNT: 66.1 × 56 cm. (26 × $22\frac{1}{16}$ in.)

NUMBER/SIZE OF EDITION: Number fourteen of an edition of forty in platinum metals

OTHER PRINTS: No more than forty-two unnumbered, signed silver prints

ACCESSION NUMBER: NPG.88.70.30

PENN'S REFERENCE NUMBER: 1006

COPYRIGHT: 1948 by The Condé Nast Publications Inc. (renewed 1976)

FIRST PUBLISHED: Penn, *Moments Preserved*, p. 134.

CAPTION: *John Marin posed on a rainy day with rubbers and umbrella. His brusque, nervous style of painting the sea's action, the pitch of a boat or the tilt of a Maine rock he compared to golf: "the fewer strokes I can take, the better the picture."*

REPRODUCED: Szarkowski, *Penn*, pl. 14

REMARKS: A variant pose from the same sitting was published in "Copyrighted," *Vogue* (April 1, 1948), p. 146

66.

Twelve Most Photographed Models, *New York*

Dana Jenney (front, left), Dorian Leigh (front, right), Marilyn Ambrose (second row, left), Andrea Johnson (second row, right), Meg Mundy, Helen Bennett, Lisa Fonssagrives, Lily Carlson, Kay Hernan (third row, left to right), Betty McLauchlen, Elizabeth Gibbons, Muriel Maxwell (back row, left to right)

DATE OF NEGATIVE: 1947

DATE OF PRINT: 1947

PRINT MEDIUM: Gelatin silver

SUPPORT: Dry-mounted on board

DIMENSIONS

IMAGE: 33.2 × 40.5 cm. ($13\frac{1}{16}$ × $15\frac{15}{16}$ in.)

SHEET: 33.2 × 40.5 cm. ($13\frac{1}{16}$ × $15\frac{15}{16}$ in.)

MOUNT: 40.5 × 50.9 cm. ($15\frac{15}{16}$ × $20\frac{1}{16}$ in.)

NUMBER/SIZE OF EDITION: No more than twenty-four signed silver prints

ACCESSION NUMBER: S/NPG.88.70.53

PENN'S REFERENCE NUMBER: 4319

COPYRIGHT: 1947 by The Condé Nast Publications Inc. (renewed 1975)

FIRST PUBLISHED: *Vogue* (May 1, 1947), pp. 130–31. The image was printed in a brown-toned ink.

REPRODUCED: Penn, *Moments Preserved*, pp. 144–45; Szarkowski, *Penn*, pl. 28

CAPTION: *When American women think of clothes, beauties like the twelve shown here are responsible for the way they think, the way they want to look, and the dollars they spend. These are the models whose elegant*

bones and immaculate heads appeared most often in the fashion photographs of the decade 1937–1947—subtle symbols of the clothing business, the third largest industry in America. Their faces are known to millions; their talents to the few who work closely with them. Each of these girls, professional to the finger tips, has besides looks a developed sense of the source of light and how to appraise her position in that light. For this picture, the group was loosely composed and each model fell instinctively into a characteristic attitude. Out of twenty-nine shots made in an atmosphere of polite jockeying, this one seemed the truest (Penn, *Moments Preserved*, p. 144).

67.

Ballet Theatre, *New York*

DATE OF NEGATIVE: 1947

DATE OF PRINT: May 1978

PRINT MEDIUM: Platinum-palladium, multiple coating and printing

SUPPORT: BF paper on aluminum panel

DIMENSIONS

IMAGE: 39.1 × 54.9 cm. ($15\frac{3}{8}$ × $21\frac{5}{8}$ in.)

SHEET: 56 × 63.4 cm. ($22\frac{1}{16}$ × 25 in.)

MOUNT: 56 × 66.1 cm. ($22\frac{1}{16}$ × 26 in.)

NUMBER/SIZE OF EDITION: Number twelve of an edition of twenty-five in platinum metals

OTHER PRINTS: No more than sixty unnumbered, signed silver prints

ACCESSION NUMBER: S/NPG.88.70.4

PENN'S REFERENCE NUMBER: 74

COPYRIGHT: 1948 by The Condé Nast Publications Inc. (renewed 1976)

FIRST PUBLISHED: *Vogue* (June 1948), pp. 126–27

REPRODUCED: Penn, *Moments Preserved*, p. 146; Szarkowski, *Penn*, pl. 15

CAPTION: *This first native-born ballet company appeared for two months at Covent Garden, with satisfying success, just a year before this photograph was taken. The nucleus of their triumph depended on these artists. Left to right: Muriel Bentley, character dancer; Alicia Alonso, classic ballerina; Antony Tudor, choreographer; Oliver Smith, designer and co-director; Dimitri Romanoff, regisseur and occasional dancer; Lucia Chase, co-director and dancer; Nora Kaye, dramatic ballerina; Max Goberman, then musical director; and, elevated on the scaffold, the three leading male dancers, Hugh Laing, John Kriza, Igor Youskevitch. Developed mainly with the carpet and clock fortune of Lucia Chase, Ballet Theatre, founded in 1940, was the first American dance troupe to go to Europe, the first to dare Russia* (Penn, *Moments Preserved*, p. 146).

68.

W. H. Auden, *New York*

DATE OF NEGATIVE: October 16, 1947

DATE OF PRINT: Before 1959

PRINT MEDIUM: Gelatin silver

SUPPORT: Dry-mounted on board

DIMENSIONS

 IMAGE: 30.7 × 26 cm. ($12\frac{1}{16}$ × $10\frac{1}{4}$ in.)

 SHEET: 30.7 × 26 cm. ($12\frac{1}{16}$ × $10\frac{1}{4}$ in.)

 MOUNT: 36.7 × 31.9 cm. ($14\frac{7}{16}$ × $12\frac{9}{16}$ in.)

NUMBER/SIZE OF EDITION: No more than fifteen signed silver prints

ACCESSION NUMBER: NPG.88.70.2

PENN'S REFERENCE NUMBER: 1920

COPYRIGHT: 1984 by Irving Penn, courtesy of *Vogue*

69.

Janet Flanner, *New York*

DATE OF NEGATIVE: 1948

DATE OF PRINT: Circa 1948

PRINT MEDIUM: Gelatin silver

SUPPORT: Dry-mounted on board

DIMENSIONS

 IMAGE: 24.1 × 19 cm. ($9\frac{1}{2}$ × $7\frac{1}{2}$ in.)

 SHEET: 24.1 × 19 cm. ($9\frac{1}{2}$ × $7\frac{1}{2}$ in.)

 MOUNT: 35.7 × 28.2 cm. ($14\frac{1}{16}$ × $11\frac{1}{8}$ in.)

NUMBER/SIZE OF EDITION: No more than fifteen signed silver prints

ACCESSION NUMBER: NPG.88.70.20

PENN'S REFERENCE NUMBER: 10291

COPYRIGHT: 1948 by The Condé Nast Publications Inc. (renewed 1976)

FIRST PUBLISHED: Penn, *Moments Preserved*, p. 36

CAPTION: *Janet Flanner, writing as The New Yorker's Genêt since 1925, has been for many Americans a lifeline to Paris. Born in Indiana, she manages to convey a feeling of home ties as well as devotion to France and the French. She describes herself as looking "like an eighteenth-century judge off the bench," characteristically wears elegant suits and handsome shoes.*

70.

Georgia O'Keeffe, *New York*

DATE OF NEGATIVE: January 31, 1948

DATE OF PRINT: May 1986

PRINT MEDIUM: Platinum-palladium, multiple coating and printing

SUPPORT: Rives paper on aluminum panel

DIMENSIONS

 IMAGE: 58.1 × 44 cm. ($22\frac{7}{8}$ × $17\frac{3}{8}$ in.)

 SHEET: 63.2 × 55.8 cm. ($24\frac{7}{8}$ × 22 in.)

 MOUNT: 66 × 55.8 cm. (26 × 22 in.)

NUMBER/SIZE OF EDITION: Number two of an edition of five in platinum metals

OTHER PRINTS: No more than ten unnumbered, signed silver prints

ACCESSION NUMBER: T/NPG.88.70.42

PENN'S REFERENCE NUMBER: 892

COPYRIGHT: 1984 by Irving Penn, courtesy of *Vogue*

71.

Charles Sheeler, *New York*

DATE OF NEGATIVE: February 13, 1948

DATE OF PRINT: 1948

PRINT MEDIUM: Gelatin silver

SUPPORT: Dry-mounted on board

DIMENSIONS

 IMAGE: 24.3 × 19 cm. ($9\frac{9}{16}$ × $7\frac{1}{2}$ in.)

 SHEET: 24.3 × 19 cm. ($9\frac{9}{16}$ × $7\frac{1}{2}$ in.)

 MOUNT: 35.5 × 27.9 cm. (14 × 11 in.)

NUMBER/SIZE OF EDITION: No more than twenty-two signed silver prints

ACCESSION NUMBER: NPG.88.70.46

PENN'S REFERENCE NUMBER: 4506

COPYRIGHT: 1984 by Irving Penn, courtesy of *Vogue*

72.

Joe Louis, *New York*

DATE OF NEGATIVE: February 15, 1948

DATE OF PRINT: July 9, 1948

PRINT MEDIUM: Gelatin silver

SUPPORT: Paper

DIMENSIONS

 IMAGE: 24.4 × 19.6 cm. ($9\frac{5}{8}$ × $7\frac{11}{16}$ in.)

 SHEET: 25.3 × 20.4 cm. ($9\frac{15}{16}$ × $8\frac{1}{16}$ in.)

 MOUNT: Unmounted

NUMBER/SIZE OF EDITION: No more than nineteen signed silver prints

ACCESSION NUMBER: T/NPG.88.70.34

PENN'S REFERENCE NUMBER: 3078

COPYRIGHT: 1948 by The Condé Nast Publications Inc. (renewed 1976)

FIRST PUBLISHED: "Inside N.Y.C.," *Vogue* (July 1, 1948), p. 60

REMARKS: Inscribed in the negative: "1447a 8 9"

73.

E. B. White, *New York*

DATE OF NEGATIVE: February 19, 1948

DATE OF PRINT: 1948

PRINT MEDIUM: Selenium toned gelatin silver

SUPPORT: Dry-mounted on board

she came to be photographed, the sitting turned into a one-act play—phones ringing, friends arriving with messages, unexpected packages being delivered. On paper there are no trappings at all; what she writes about the South is strong and touching, punctuated with humor and a kind of nagging realism. She lives and works in Nyack, New York (Penn, *Moments Preserved*, p. 136).

83.

T. S. Eliot, *London*

DATE OF NEGATIVE: 1950

DATE OF PRINT: 1984

PRINT MEDIUM: Selenium toned gelatin silver

SUPPORT: Paper

DIMENSIONS

IMAGE: 42.3 × 39.2 cm. (16$\frac{11}{16}$ × 15$\frac{7}{16}$ in.)

SHEET: 50.7 × 40.4 cm. (20 × 15$\frac{7}{8}$ in.)

MOUNT: Unmounted

NUMBER/SIZE OF EDITION: No more than twenty-eight signed silver prints

ACCESSION NUMBER: NPG.88.70.15

PENN'S REFERENCE NUMBER: 8780

COPYRIGHT: 1960 by Irving Penn, courtesy of *Vogue* (renewed 1988)

FIRST PUBLISHED: Penn, *Moments Preserved*, p. 81

CAPTION: *T. S. Eliot arrived at the studio early and sat on the steps until it was time to be photographed. His clothes were old and beautifully maintained. A grave, scholarly man, Eliot writes at home; in the afternoon he works in his office at Faber & Faber, the publishing firm of which he is a director. Among London publishers it is said that he writes the best blurbs in the business.*

84.

Sir Jacob Epstein, *London*

DATE OF NEGATIVE: 1950

DATE OF PRINT: Before 1959

PRINT MEDIUM: Gelatin silver

SUPPORT: Dry-mounted on board

DIMENSIONS

IMAGE: 35.1 × 33.6 cm. (13$\frac{13}{16}$ × 13$\frac{1}{4}$ in.)

SHEET: 35.1 × 33.6 cm. (13$\frac{13}{16}$ × 13$\frac{1}{4}$ in.)

MOUNT: 50.5 × 40.5 cm. (19$\frac{15}{16}$ × 16 in.)

NUMBER/SIZE OF EDITION: No more than fifteen signed silver prints

ACCESSION NUMBER: NPG.88.70.17

PENN'S REFERENCE NUMBER: 5024

COPYRIGHT: 1950 by The Condé Nast Publications Inc. (renewed 1978)

FIRST PUBLISHED: "Famous in British Arts," *Vogue* (May 1, 1951), p. 124

REPRODUCED: Penn, *Moments Preserved*, p. 87; Szarkowski, *Penn*, pl. 32

CAPTION: *Sir Jacob Epstein, a severe but rumpled prophet, wanted to be photographed in his workroom, but the mass of violent sculpture was overpowering. Covered with plaster dust, he was taxied to a photographic studio, protesting "I shouldn't leave," as though a break with his train of images might be catastrophic. Born on New York's lower East Side in the 1880s, Epstein went abroad young, became the friend of Brancusi in Paris, later settled in London. In 1925 when Prime Minister Stanley Baldwin unveiled an Epstein nude, he said spontaneously, "My God!"* (Penn, *Moments Preserved*, p. 87).

85.

Senator Tom Connally, *Washington*

DATE OF NEGATIVE: 1951

DATE OF PRINT: February 1973

PRINT MEDIUM: Palladium, single coating, multiple printing

SUPPORT: Wiggins-Teape paper on aluminum panel

DIMENSIONS

IMAGE: 38.9 × 38.9 cm. (15$\frac{5}{16}$ × 15$\frac{5}{16}$ in.)

SHEET: 60.7 × 50.9 cm. (23$\frac{7}{8}$ × 20$\frac{1}{16}$ in.)

MOUNT: 63.5 × 50.9 cm. (25 × 20$\frac{1}{16}$ in.)

NUMBER/SIZE OF EDITION: Number four of an edition of four in palladium

OTHER PRINTS: No more than eleven unnumbered, signed silver prints

ACCESSION NUMBER: NPG.88.70.9

PENN'S REFERENCE NUMBER: 1181

COPYRIGHT: 1951 by The Condé Nast Publications Inc. (renewed 1979)

FIRST PUBLISHED: "Famous in Washington," *Vogue* (August 15, 1951), p. 148

REMARKS: "Famous in Washington" comprised portraits by Penn of seventy-three prominent Washington personalities.

86.

Philip Johnson and Ludwig Mies Van Der Rohe, *New York*

DATE OF NEGATIVE: May 11, 1955

DATE OF PRINT: 1984

PRINT MEDIUM: Selenium toned gelatin silver

SUPPORT: Paper

DIMENSIONS

IMAGE: 27 × 26.7 cm. (10$\frac{5}{8}$ × 10$\frac{1}{2}$ in.)

SHEET: 35.5 × 27.7 cm. (14 × 10$\frac{15}{16}$ in.)

MOUNT: Unmounted

NUMBER/SIZE OF EDITION: No more than eight signed silver prints

ACCESSION NUMBER: T/NPG.88.70.55

PENN'S REFERENCE NUMBER: 12872

COPYRIGHT: 1984 by Irving Penn, courtesy of *Vogue*

REMARKS: A variant of this image from the same sitting was published in Penn, *Moments Preserved*, p. 128. The caption to the published variant reads: *Ludwig Mies Van Der Rohe and Philip Johnson flanking a model of the joint pinnacle, the Seagram Building; Mies, ruddy, dignified, massive in mind and structure; Johnson, spruce and mercurial, intent on embellishing the earth with architecture.*

87.
Frederick Kiesler and Willem de Kooning, *New York*

DATE OF NEGATIVE: 1960

DATE OF PRINT: June 1982

PRINT MEDIUM: Platinum-palladium, single coating, multiple printing

SUPPORT: Rives paper on aluminum panel

DIMENSIONS

IMAGE: 47 × 49.1 cm. ($18\frac{1}{2}$ × $19\frac{3}{8}$ in.)

SHEET: 55.9 × 63.3 cm. (22 × $24\frac{7}{8}$ in.)

MOUNT: 55.9 × 66 cm. (22 × 26 in.)

NUMBER/SIZE OF EDITION: Number twenty-six of an edition of twenty-eight in platinum metals

OTHER PRINTS: No more than ten unnumbered, signed silver prints

ACCESSION NUMBER: T/NPG.88.70.29

PENN'S REFERENCE NUMBER: 828

COPYRIGHT: 1960 by Irving Penn (renewed 1988)

REPRODUCED: Szarkowski, *Irving Penn*, pl. 38

88.
Saul Bellow, *New York*

DATE OF NEGATIVE: September 1964

DATE OF PRINT: February 1986

PRINT MEDIUM: Platinum-palladium, multiple coating and printing

SUPPORT: Rives paper on aluminum panel

DIMENSIONS

IMAGE: 42.8 × 39.1 cm. ($16\frac{7}{8}$ × $15\frac{3}{8}$ in.)

SHEET: 63.3 × 55.9 cm. (25 × 22 in.)

MOUNT: 66.2 × 55.9 cm. (26 × 22 in.)

NUMBER/SIZE OF EDITION: Number three of an edition of five in platinum metals

OTHER PRINTS: No more than twelve unnumbered, signed silver prints

ACCESSION NUMBER: S/NPG.88.70.5

PENN'S REFERENCE NUMBER: 981

COPYRIGHT: 1964 by The Condé Nast Publications Inc.

FIRST PUBLISHED: "Saul Bellow, Master Writer," *Vogue* (November 15, 1964), p. 110

89.
David Smith, *Bolton's Landing, N.Y.*

DATE OF NEGATIVE: 1964

DATE OF PRINT: June 1979

PRINT MEDIUM: Platinum-palladium, multiple coating and printing

SUPPORT: Rives paper on aluminum panel

DIMENSIONS

IMAGE: 40 × 39.2 cm. ($15\frac{3}{4}$ × $15\frac{7}{16}$ in.)

SHEET: 60.6 × 50.8 cm. ($23\frac{7}{8}$ × 20 in.)

MOUNT: 63.4 × 50.8 cm. (25 × 20 in.)

NUMBER/SIZE OF EDITION: Number five of an edition of sixteen in platinum metals

OTHER PRINTS: No more than fifteen unnumbered, signed silver prints

ACCESSION NUMBER: NPG.88.70.49

PENN'S REFERENCE NUMBER: 805

COPYRIGHT: 1965 by The Condé Nast Publications Inc.

FIRST PUBLISHED: Robert Motherwell, "A Major American Sculptor, David Smith," *Vogue* (February 1, 1965), p. 134

REPRODUCED: Szarkowski, *Irving Penn*, pl. 137

90.
Hans Hofmann, *New York*

DATE OF NEGATIVE: January 1965

DATE OF PRINT: 1965

PRINT MEDIUM: Selenium toned gelatin silver

SUPPORT: Dry-mounted on board

DIMENSIONS

IMAGE: 39.7 × 39.6 cm. ($15\frac{5}{8}$ × $15\frac{9}{16}$ in.)

SHEET: 39.7 × 39.6 cm. ($15\frac{5}{8}$ × $15\frac{9}{16}$ in.)

MOUNT: 50.5 × 45.8 cm. ($19\frac{7}{8}$ × 18 in.)

NUMBER/SIZE OF EDITION: No more than fifteen signed silver prints

ACCESSION NUMBER: NPG.88.70.27

PENN'S REFERENCE NUMBER: 7772

COPYRIGHT: 1965 by The Condé Nast Publications Inc.

FIRST PUBLISHED: Harold Rosenberg, "Hans Hofmann," *Vogue* (May 1965), p. 193

91.
Rudolf Nureyev, *New York*

DATE OF NEGATIVE: May 1965

DATE OF PRINT: 1965

PRINT MEDIUM: Gelatin silver

SUPPORT: Dry-mounted on board

DIMENSIONS

IMAGE: 35 × 34.4 cm. ($13\frac{13}{16}$ × $13\frac{9}{16}$ in.)

SHEET: 37.3 × 35.4 cm. ($14\frac{11}{16}$ × $13\frac{15}{16}$ in.)

MOUNT: 44.2 × 40.6 cm. ($17\frac{7}{16}$ × 16 in.)

NUMBER/SIZE OF EDITION: No more than six signed silver prints

ACCESSION NUMBER: S/NPG.88.70.40

PENN'S REFERENCE NUMBER: 34

COPYRIGHT: 1965 by The Condé Nast Publications Inc.

FIRST PUBLISHED: "People Are Talking About . . . Nure-yev," *Vogue* (July 1965), p. 81

92.

Truman Capote, *New York*

DATE OF NEGATIVE: 1965

DATE OF PRINT: March 1986

PRINT MEDIUM: Platinum-palladium

SUPPORT: Rives paper on aluminum panel

DIMENSIONS

IMAGE: 39.7 × 39.5 cm. ($15\frac{5}{8}$ × $15\frac{9}{16}$ in.)

SHEET: 63.1 × 55.9 cm. ($24\frac{15}{16}$ × 22 in.)

MOUNT: 66 × 55.9 cm. (26 × 22 in.)

NUMBER/SIZE OF EDITION: Number nineteen of an edition of twenty in platinum metals

REMARKS: Penn also photographed Capote in 1948 and 1979.

REPRODUCED: Szarkowski, *Irving Penn*, pls. 9 and 148.

OTHER PRINTS: No more than twelve unnumbered, signed silver prints

ACCESSION NUMBER: T/NPG.88.70.7

PENN'S REFERENCE NUMBER: 723

COPYRIGHT: 1965 by The Condé Nast Publications Inc.

FIRST PUBLISHED: "People Are Talking About . . . Truman Capote," *Vogue* (October 15, 1965), p. 95

REPRODUCED: Szarkowski, *Penn*, pl. 133

93.

Barnett Newman, *New York*

DATE OF NEGATIVE: 1966

DATE OF PRINT: April–May 1980

PRINT MEDIUM: Platinum-palladium, multiple coating and printing

SUPPORT: Rives paper on aluminum panel

DIMENSIONS

IMAGE: 39.4 × 39.4 cm. ($15\frac{1}{2}$ × $15\frac{1}{2}$ in.)

SHEET: 63.3 × 56.1 cm. ($24\frac{15}{16}$ × $22\frac{1}{16}$ in.)

MOUNT: 66 × 56.1 cm. (26 × $22\frac{1}{16}$ in.)

NUMBER/SIZE OF EDITION: Number six of an edition of twenty in platinum metals

OTHER PRINTS: No more than twelve unnumbered, signed silver prints

ACCESSION NUMBER: NPG.88.70.36

PENN'S REFERENCE NUMBER: 750

COPYRIGHT: 1966 by The Condé Nast Publications Inc.

FIRST PUBLISHED: "Barnett Newman," *Vogue* (April 15, 1966), p. 110

REPRODUCED: Szarkowski, *Penn*, pl. 145

94.

Isaac Bashevis Singer, *New York*

DATE OF NEGATIVE: 1966

DATE OF PRINT: February 1982

PRINT MEDIUM: Platinum-palladium, multiple coating and printing

SUPPORT: Rives paper on aluminum panel

DIMENSIONS

IMAGE: 38.4 × 39.5 cm. ($15\frac{1}{8}$ × $15\frac{9}{16}$ in.)

SHEET: 58.2 × 50.6 cm. ($22\frac{15}{16}$ × 20 in.)

MOUNT: 61 × 50.6 cm. (24 × 20 in.)

NUMBER/SIZE OF EDITION: Number ten of an edition of twenty-five in platinum metals

OTHER PRINTS: No more than fifteen unnumbered, signed silver prints

ACCESSION NUMBER: T/NPG.88.70.47

PENN'S REFERENCE NUMBER: 235

COPYRIGHT: 1966 by The Condé Nast Publications Inc.

FIRST PUBLISHED: "People Are Talking About . . . Isaac Bashevis Singer," *Vogue* (April 1, 1966), p. 146

REPRODUCED: Szarkowski, *Penn*, pl. 141

95.

Saul Steinberg in Nose Mask, *New York*

DATE OF NEGATIVE: 1966

DATE OF PRINT: July 1979

PRINT MEDIUM: Platinum-palladium, multiple coating and printing

SUPPORT: Rives paper on aluminum panel

DIMENSIONS

IMAGE: 55.8 × 45.7 cm. (22 × 18 in.)

SHEET: 63.1 × 56 cm. ($23\frac{7}{8}$ × 22 in.)

MOUNT: 66 × 56 cm. (26 × 22 in.)

NUMBER/SIZE OF EDITION: Number fifteen of an edition of thirty-six in platinum metals

OTHER PRINTS: No more than fifteen unnumbered, signed silver prints

ACCESSION NUMBER: S/NPG.88.70.50

PENN'S REFERENCE NUMBER: 2272

COPYRIGHT: 1966 by The Condé Nast Publications Inc.

REPRODUCED: Szarkowski, *Penn*, pl. 143

REMARKS: This photograph is a variant of the portrait illustrating Harold Rosenberg, "Steinberg," *Vogue* (January 1, 1967), p. 98. In the variant, Steinberg has drawn a face and half-length body on the mask.

96.

Tom Wolfe, *New York*

DATE OF NEGATIVE: 1966

DATE OF PRINT: 1983

PRINT MEDIUM: Selenium toned gelatin silver

SUPPORT: Paper

DIMENSIONS

 IMAGE: 38 × 37.9 cm. (15 × 14$\frac{15}{16}$ in.)

 SHEET: 50.5 × 40.4 cm. (19$\frac{7}{8}$ × 15$\frac{7}{8}$ in.)

 MOUNT: Unmounted

NUMBER/SIZE OF EDITION: No more than twenty signed silver prints

ACCESSION NUMBER: S/NPG.88.70.60

PENN'S REFERENCE NUMBER: 12398

COPYRIGHT: 1966 by The Condé Nast Publications Inc.

FIRST PUBLISHED: Elaine Dundy, "Tom Wolfe . . . But Exactly, Yes!," *Vogue* (April 15, 1966), pp. 124–25

REPRODUCED: Szarkowski, *Irving Penn*, pl. 135

97.

Hell's Angels, *San Francisco*

DATE OF NEGATIVE: 1967

DATE OF PRINT: March–April 1969

PRINT MEDIUM: Platinum-iridium/platinum-palladium, multiple coating and printing

SUPPORT: Wiggins-Teape paper on aluminum panel

DIMENSIONS

 IMAGE: 37.8 × 46.7 cm. (14$\frac{7}{8}$ × 18$\frac{3}{8}$ in.)

 SHEET: 50.7 × 60.8 cm. (20 × 23$\frac{15}{16}$ in.)

 MOUNT: 50.7 × 63.5 cm. (20 × 25 in.)

NUMBER/SIZE OF EDITION: Number twenty-four of an edition of thirty-five in platinum metals

OTHER PRINTS: No more than twenty unnumbered, signed silver prints

ACCESSION NUMBER: S/NPG.88.70.23

PENN'S REFERENCE NUMBER: 163

COPYRIGHT: 1967 by Irving Penn

FIRST PUBLISHED: Irving Penn, "The Incredibles," *Look* (January 9, 1968), pp. 56–57

CAPTION: *The Outrageous*—"There's only one thing that really matters to me and that's the Hell's Angels patch I wear. I can get me anything else—a new bike, a new old lady or money—but I can't get me another patch." "We've had a few deaths this year, but otherwise, it's been a good year. By that I mean we haven't had much police harassment. . . . It's like being brothers. Like, every man in the club's your brother." "Power. That's what it feels like when we ride in on a three-day weekend, we might have one-fifty, two-hundred bikes out on a run. People all get excited when they see us coming, and—I don't know—it's beautiful." ". . . You know what it is, it's a mind-blower. They come around with movie cameras. It's really beautiful." "If somebody messed up one of our brothers, it would be complete retaliation. An eye for an eye." ". . . My brothers—that's my whole life. My brothers. It's all I've got."

REPRODUCED: Szarkowski, *Penn*, pl. 142

98.

Hippie Family (F), *San Francisco*

DATE OF NEGATIVE: 1967

DATE OF PRINT: January 1982

PRINT MEDIUM: Platinum-palladium, single coating, multiple printing

SUPPORT: Rives paper on aluminum panel

DIMENSIONS

 IMAGE: 52.3 × 49.1 cm. (20$\frac{5}{8}$ × 19$\frac{3}{8}$ in.)

 SHEET: 63.4 × 55.8 cm. (24$\frac{7}{8}$ × 22 in.)

 MOUNT: 66 × 55.8 cm. (26 × 22 in.)

NUMBER/SIZE OF EDITION: Number thirty-two of an edition of forty-eight in platinum metals

OTHER PRINTS: No more than fifteen unnumbered, signed silver prints

ACCESSION NUMBER: S/NPG.88.70.24

PENN'S REFERENCE NUMBER: 2800

COPYRIGHT: 1967 by Irving Penn

FIRST PUBLISHED: Irving Penn, "The Incredibles," *Look* (January 9, 1968), p. 58

CAPTION: *The Families*—"What I'm really interested in now is, I have a son. That's all I'm working for now. I wish I knew just how to raise him. I can't say complete freedom. You have to decide what's right and wrong. Of course, I do a lot of wrong things myself." "We're not in that giant crowd of people they call hippies. We were doing these things—a lot of us were—before all this publicity came along, and I think we'll keep on doing them. Any art I do is something I feel right at the moment. Even dressing this way is art. When you're walking down the street like this, you don't have to have an exhibit of your paintings, or even say anything. Unfortunately, most people see only what they want to see. I feel we're clean and good and all those things the Boy Scouts are. We just get our enjoyment other ways. We like different kinds of music and different kinds of art. We don't have enough money. If we had more money, we'd really be outrageous." "It's really far out when you find you can do anything you want with your life. It would seem strange to me to pay an insurance company so that maybe later you'd get paid." "Yeah, those people out there are really insane. They spend half their life with paperwork. And then they say, 'Vote.' Vote for what? (If Reagan runs for President, he'll win.) I'll vote for him. It'll bring it all down quicker. When enough people get fed up with this civilization, this trip is going to fail. But I'm not hassling, not fighting it. I feel good. I've let my hair down."

99.

Hippie Family (K), *San Francisco*

DATE OF NEGATIVE: 1967

DATE OF PRINT: January 1981

PRINT MEDIUM: Platinum-palladium

SUPPORT: Rives paper on aluminum panel

DIMENSIONS

 IMAGE: 42.2 × 36.1 cm. (16⅝ × 14¼ in.)

 SHEET: 58.1 × 50.7 cm. (22⅞ × 20 in.)

 MOUNT: 61 × 50.7 cm. (24 × 20 in.)

NUMBER/SIZE OF EDITION: Number fifteen of an edition of twenty-five in platinum metals

OTHER PRINTS: No more than fifteen unnumbered, signed silver prints

ACCESSION NUMBER: S/NPG.88.70.25

PENN'S REFERENCE NUMBER: 348

COPYRIGHT: 1967 by Irving Penn and Cowles Publications Inc.

FIRST PUBLISHED: Penn, "The Incredibles," *Look* (January 9, 1968), p. 58

CAPTION: See entry for "Hippie Family (F), *San Francisco*"

REPRODUCED: Szarkowski, *Penn*, pl. 134

100.

Hippie Group, *San Francisco*

DATE OF NEGATIVE: 1967

DATE OF PRINT: February 1969

PRINT MEDIUM: Platinum-palladium, single coating, multiple printing

SUPPORT: Arches paper on aluminum panel

DIMENSIONS

 IMAGE: 49 × 55.6 cm. (19¼ × 21⅞ in.)

 SHEET: 55.8 × 63.2 cm. (22 × 24¹³⁄₁₆ in.)

 MOUNT: 55.8 × 66 cm. (22 × 26 in.)

NUMBER/SIZE OF EDITION: Number one of an edition of four in platinum metals

OTHER PRINTS: No more than fifteen unnumbered, signed silver prints

ACCESSION NUMBER: S/NPG.88.70.26

PENN'S REFERENCE NUMBER: 132

COPYRIGHT: 1967 by Irving Penn

FIRST PUBLISHED: Penn, "The Incredibles," *Look* (January 9, 1968), pp. 54–55

CAPTION: *The Originals*—"I believe that people live in terms of the images they see around them. If a person exists in a city of linear and rectilinear buildings and streets, with a sky shadowed by the loom of buildings, he begins to feel himself that way. He becomes square, so as to fit in with the background. He may even have a flattop haircut in an attempt to match his environment. I think the real background is the planet Earth. Things in nature flow in an organic manner—not force against

counterforce, game against game. We see more of an Art Nouveau universe, with curves and flux and flow. What we're trying to do is change man's image of himself by aesthetically altering the environment. We're doing it with poster art, light and sound shows, styles—and we want to get into TV and movies. In a sense, laissez-faire is still possible. A group of individuals can band together for both aesthetic and financial results without stepping on others." " . . . Love? It's not an easy word to talk about. I don't know if I can succeed in loving a large group of people who are not my relatives. But I know it's something worthy of attainment. It's like when Kazantzakis has St. Francis running to the people of Assisi after he has discovered the love of God and man, and shouting, 'Come one, come all! Come to hear the new madness!' "

101.

Rock Groups (Big Brother and the Holding Company and The Grateful Dead), *San Francisco*

LEFT: Big Brother and the Holding Company—top to bottom: Sam Andrew, Janis Joplin (left), David Getz (right), Jim Gurley, Peter Albin

RIGHT: The Grateful Dead—top to bottom: Jerome John ("Jerry") Garcia, Ronald ("Pigpen") McKernan (left), Philip ("Phil") Chapman Lesh (right), Robert ("Bob") Hall Weir, William ("Bill") Kreutzmann

DATE OF NEGATIVE: 1967

DATE OF PRINT: 1974

PRINT MEDIUM: Platinum-palladium, multiple coating and printing

SUPPORT: Rives paper on aluminum panel

DIMENSIONS

 IMAGE: 47.9 × 49.9 cm. (18⅞ × 19¹¹⁄₁₆ in.)

 SHEET: 56 × 63.2 cm. (22 × 24⅞ in.)

 MOUNT: 56 × 66 cm. (22 × 26 in.)

NUMBER/SIZE OF EDITION: Number two of an edition of fifty in platinum metals

OTHER PRINTS: No more than twelve unnumbered, signed silver prints

ACCESSION NUMBER: NPG.88.70.44

PENN'S REFERENCE NUMBER: 2408

COPYRIGHT: 1974 by Irving Penn

FIRST PUBLISHED: Penn, "The Incredibles," *Look* (January 9, 1968), pp. 52–53

CAPTION: *The Minstrels*—Big Brother and the Holding Company:

"I don't have any other life. Nobody in the band has any kind of secret life apart from our band. Nothing's separate—job, rehearsal, living, the way we dress." " . . . You make your own clothes, that's something for somebody to really appreciate. Just like when you make your own

music. But clothes are not really such a big thing with us. Somebody reading Look magazine in Montezuma, Iowa, might see the clothes and say, 'Wow,' and be more aware than we are. To us, it's just a life style, a total thing." "Life is primarily to live it, you know, and to get into it, to be able to do something so that if you're going to die, like everybody is, it'll be OK. You won't feel you're being burned. Like, for example, if I had to go to Vietnam and had to die, I'd feel I was being burned."

The Grateful Dead: "I don't know if you've ever had the experience—just by the sheer strength of being what you are, you're able to take people off the trip they're on and, you know, you have an audience. I don't know what trip I put them on. I wouldn't want to know, because then I'd have arcane powers. It's like when you can get four thousand people in an auditorium all to experience the same thing and then, when it's over, to look at each other and smile. The supreme time for me was one time we were playing so good that everybody was crying. That taught me something—that I can get good vibrations back from something I'm doing. That's where it's at—everybody has the ability to affect everything around them. Once we recognize this, that we can be a force on this planet, then we all may become more responsible. We'll realize that Western civilization has to have a spiritual reawakening to go along with technological advances. Drugs are not the ultimate answer. But they'll show you where you're at. In my case, I'm not taking drugs much anymore. It's not necessarily a bad thing. But ultimately, you have to go somewhere else to take care of something in your head. There's no easy way to get your head cool. Maybe it means work. Not just music. Having anything you love to do—installing telephones, digging ditches, cabinetmaking. The best thing I can do for this world is play my music, work on my head, get it straight. Anything else would just be adding static."

102.
John Updike, New York
DATE OF NEGATIVE: 1970
DATE OF PRINT: 1984
PRINT MEDIUM: Selenium toned gelatin silver
SUPPORT: Paper
DIMENSIONS
 IMAGE: 38 × 38 cm. (15 × 15 in.)
 SHEET: 50.7 × 40.4 cm. (20 × $15\frac{7}{8}$ in.)
 MOUNT: Unmounted
NUMBER/SIZE OF EDITION: No more than fifteen signed silver prints
ACCESSION NUMBER: S/NPG.88.70.54
PENN'S REFERENCE NUMBER: 14420

COPYRIGHT: 1971 by The Condé Nast Publications Inc.
FIRST PUBLISHED: Eric Rhode, "Grabbing Dilemmas," Vogue (February 1, 1971), p. 141

103.
Duke Ellington, New York
DATE OF NEGATIVE: March 11, 1971
DATE OF PRINT: 1984
PRINT MEDIUM: Selenium toned gelatin silver
SUPPORT: Paper
DIMENSIONS
 IMAGE: 38 × 37.8 cm. ($14\frac{15}{16}$ × $14\frac{7}{8}$ in.)
 SHEET: 50.6 × 40.4 cm. ($19\frac{15}{16}$ × $15\frac{15}{16}$ in.)
 MOUNT: Unmounted
NUMBER/SIZE OF EDITION: No more than eight signed silver prints
ACCESSION NUMBER: NPG.88.70.16
PENN'S REFERENCE NUMBER: 8930
COPYRIGHT: 1971 by The Condé Nast Publications Inc.
FIRST PUBLISHED: "American Greats: Ailey/Ellington," Vogue (September 1, 1971,) p. 255
REMARKS: Vogue also published a portrait of Alvin Ailey by Irving Penn in this article.

104.
Tony Smith, South Orange, N.J.
DATE OF NEGATIVE: July 19, 1971
DATE OF PRINT: 1983
PRINT MEDIUM: Selenium toned gelatin silver
SUPPORT: Paper
DIMENSIONS
 IMAGE: 27 × 26.8 cm. ($10\frac{5}{8}$ × $10\frac{9}{16}$ in.)
 SHEET: 35.4 × 27.7 cm. ($13\frac{15}{16}$ × $10\frac{7}{8}$ in.)
 MOUNT: Unmounted
NUMBER/SIZE OF EDITION: No more than twenty signed silver prints
ACCESSION NUMBER: S/NPG.88.70.48
PENN'S REFERENCE NUMBER: 347
COPYRIGHT: 1971 by Irving Penn, courtesy of Vogue

105.
George Balanchine, New York
DATE OF NEGATIVE: October 14, 1971
DATE OF PRINT: 1984
PRINT MEDIUM: Selenium toned gelatin silver
SUPPORT: Paper
DIMENSIONS
 IMAGE: 35.4 × 35.4 cm. ($13\frac{15}{16}$ × $13\frac{15}{16}$ in.)
 SHEET: 50.7 × 40.4 cm. ($19\frac{7}{8}$ × $15\frac{15}{16}$ in.)
 MOUNT: Unmounted

NUMBER/SIZE OF EDITION: No more than eighteen signed silver prints

ACCESSION NUMBER: T/NPG.88.70.3

PENN'S REFERENCE NUMBER: 8626

COPYRIGHT: 1972 by The Condé Nast Publications Inc.

FIRST PUBLISHED: John Gruen, "This Man Can Turn a Woman into a Star: George Balanchine," *Vogue* (March 1, 1972), p. 110

REPRODUCED: Szarkowski, *Penn*, pl. 147

106.
Anaïs Nin, *New York*

DATE OF NEGATIVE: 1971

DATE OF PRINT: February 1982

PRINT MEDIUM: Platinum-palladium, single coating, multiple printing

SUPPORT: Rives paper on aluminum panel

DIMENSIONS

 IMAGE: 49.8 × 49.5 cm. ($19\frac{5}{8}$ × $19\frac{1}{2}$ in.)

 SHEET: 63.2 × 55.9 cm. ($24\frac{7}{8}$ × 22 in.)

 MOUNT: 66 × 55.9 cm. (26 × 22 in.)

NUMBER/SIZE OF EDITION: Number two of an edition of twenty in platinum metals

OTHER PRINTS: No more than fifteen unnumbered, signed silver prints

ACCESSION NUMBER: NPG.88.70.37

PENN'S REFERENCE NUMBER: 1269

COPYRIGHT: 1971 by The Condé Nast Publications Inc.

FIRST PUBLISHED: "Anaïs Nin Talks about Being a Woman," *Vogue* (October 15, 1971), p. 98

REPRODUCED: Szarkowski, *Penn*, pl. 136

107.
Woody Allen as Chaplin, *New York*

DATE OF NEGATIVE: 1972

DATE OF PRINT: June 1980

PRINT MEDIUM: Platinum-palladium, single coating, multiple printing

SUPPORT: Rives paper on aluminum panel

DIMENSIONS

 IMAGE: 50 × 49.4 cm. ($19\frac{11}{16}$ × $19\frac{7}{16}$ in.)

 SHEET: 63.2 × 56 cm. ($24\frac{7}{8}$ × $22\frac{1}{16}$ in.)

 MOUNT: 66.1 × 56 cm. (26 × $22\frac{1}{16}$ in.)

NUMBER/SIZE OF EDITION: Number twenty of an edition of twenty-eight in platinum metals

OTHER PRINTS: No more than fifteen unnumbered, signed silver prints

ACCESSION NUMBER: S/NPG.88.70.1

PENN'S REFERENCE NUMBER: 2589

COPYRIGHT: 1972 by The Condé Nast Publications Inc.

FIRST PUBLISHED: Leo Lerman, "Woody the Great: The Funniest Man of the Year," *Vogue* (December 1972), p. 146

REMARKS: In the text, Woody Allen is quoted as saying: *I'm crazy about* [Charlie Chaplin.] *When I look at these photos of my impressions of him, I wish I had eyes like that in real life . . . deep sockets, dark.*

108.
Elliott Carter, *New York*

DATE OF NEGATIVE: February 12, 1975

DATE OF PRINT: 1984

PRINT MEDIUM: Selenium toned gelatin silver

SUPPORT: Paper

DIMENSIONS

 IMAGE: 27.5 × 27.1 cm. ($10\frac{7}{8}$ × $10\frac{11}{16}$ in.)

 SHEET: 35.5 × 27.8 cm. (14 × 11 in.)

 MOUNT: Unmounted

NUMBER/SIZE OF EDITION: No more than ten signed silver prints

ACCESSION NUMBER: S/NPG.88.70.8

PENN'S REFERENCE NUMBER: 13352

COPYRIGHT: 1984 by Irving Penn, courtesy of *Vogue*

109.
Merce Cunningham, *New York*

DATE OF NEGATIVE: 1978

DATE OF PRINT: 1986

PRINT MEDIUM: Selenium toned gelatin silver

SUPPORT: Paper

DIMENSIONS

 IMAGE: 26.2 × 26 cm. ($10\frac{5}{16}$ × $10\frac{11}{16}$ in.)

 SHEET: 35.5 × 27.8 cm. (14 × 11 in.)

 MOUNT: Unmounted

NUMBER/SIZE OF EDITION: No more than twelve signed silver prints

ACCESSION NUMBER: S/NPG.88.70.11

PENN'S REFERENCE NUMBER: 15285

COPYRIGHT: 1978 by Irving Penn

110.
Aaron Copland, *New York*

DATE OF NEGATIVE: February 21, 1979

DATE OF PRINT: 1983

PRINT MEDIUM: Selenium toned gelatin silver

SUPPORT: Paper

DIMENSIONS

 IMAGE: 26.9 × 26.8 cm. ($10\frac{5}{8}$ × $10\frac{9}{16}$ in.)

 SHEET: 35.4 × 27.9 cm. ($13\frac{15}{16}$ × 11 in.)

 MOUNT: Unmounted

NUMBER/SIZE OF EDITION: No more than fifteen signed silver prints
ACCESSION NUMBER: T/NPG.88.70.10
PENN'S REFERENCE NUMBER: 12672
COPYRIGHT: 1979 by CBS Inc.
REMARKS: The portrait was commissioned for an album cover.

111.
Joseph Brodsky, *New York*
DATE OF NEGATIVE: January 7, 1980
DATE OF PRINT: 1983
PRINT MEDIUM: Selenium toned gelatin silver
SUPPORT: Paper
DIMENSIONS
 IMAGE: 36.4 × 36 cm. ($14\frac{3}{8}$ × $14\frac{3}{16}$ in.)
 SHEET: 50.7 × 40.4 cm. ($19\frac{15}{16}$ × $15\frac{15}{16}$ in.)
 MOUNT: Unmounted
NUMBER/SIZE OF EDITION: No more than fourteen signed silver prints
ACCESSION NUMBER: S/NPG.88.70.6
PENN'S REFERENCE NUMBER: 8443
COPYRIGHT: 1980 by The Condé Nast Publications Inc.
FIRST PUBLISHED: "Brodsky," *Vogue* (May 1980), p. 259
REPRODUCED: Szarkowski, *Penn*, pl. 146

112.
John Huston, *New York*
DATE OF NEGATIVE: February 7, 1980
DATE OF PRINT: February 1984
PRINT MEDIUM: Platinum-palladium, multiple coating and printing
SUPPORT: Rives paper on aluminum panel
DIMENSIONS
 IMAGE: 40.9 × 39.6 cm. ($16\frac{1}{8}$ × $15\frac{5}{8}$ in.)
 SHEET: 60.5 × 50.7 cm. ($23\frac{13}{16}$ × 20 in.)
 MOUNT: 63.4 × 50.7 cm. (25 × 20 in.)
NUMBER/SIZE OF EDITION: Number six of an edition of eight in platinum metals
OTHER PRINTS: No more than ten unnumbered, signed silver prints
ACCESSION NUMBER: T/NPG.88.70.28
PENN'S REFERENCE NUMBER: 3128
COPYRIGHT: 1983 by The Condé Nast Publications Inc.
FIRST PUBLISHED: "Beating the Devil: John Huston," *Vanity Fair* (March 1983), pp. 76–77
REMARKS: The original image is in color.

113.
Henry Geldzahler, *New York*
DATE OF NEGATIVE: 1981
DATE OF PRINT: 1986
PRINT MEDIUM: Selenium toned gelatin silver
SUPPORT: Paper
DIMENSIONS
 IMAGE: 24.2 × 19.3 cm. ($9\frac{1}{2}$ × $7\frac{5}{8}$ in.)
 SHEET: 25.2 × 20.4 cm. ($9\frac{15}{16}$ × 8 in.)
 MOUNT: Unmounted
NUMBER/SIZE OF EDITION: No more than eleven signed silver prints
ACCESSION NUMBER: S/NPG.88.70.21
PENN'S REFERENCE NUMBER: 15407
COPYRIGHT: 1981 by Irving Penn

114.
Virgil Thomson, *New York*
DATE OF NEGATIVE: December 28, 1982
DATE OF PRINT: 1983
PRINT MEDIUM: Selenium toned gelatin silver
SUPPORT: Paper
DIMENSIONS
 IMAGE: 27 × 27.1 cm. ($10\frac{5}{8}$ × $10\frac{11}{16}$ in.)
 SHEET: 35.1 × 27.8 cm. ($13\frac{7}{8}$ × 11 in.)
 MOUNT: Unmounted
NUMBER/SIZE OF EDITION: No more than eleven signed silver prints
ACCESSION NUMBER: T/NPG.88.70.52
PENN'S REFERENCE NUMBER: 10113
COPYRIGHT: 1983 by The Condé Nast Publications Inc.
FIRST PUBLISHED: "Virgil Thomson: Encore," *Vanity Fair* (June 1983), pp. 40–41

115.
James Van Der Zee, *New York*
DATE OF NEGATIVE: February 11, 1983
DATE OF PRINT: 1984
PRINT MEDIUM: Selenium toned gelatin silver
SUPPORT: Paper
DIMENSIONS
 IMAGE: 37.8 × 37.4 cm. ($14\frac{7}{8}$ × $14\frac{3}{4}$ in.)
 SHEET: 50.6 × 40.7 cm. ($19\frac{15}{16}$ × 16 in.)
 MOUNT: Unmounted
NUMBER/SIZE OF EDITION: No more than thirteen signed silver prints
ACCESSION NUMBER: T/NPG.88.70.56
PENN'S REFERENCE NUMBER: 1081
COPYRIGHT: 1983 by The Condé Nast Publications Inc.
FIRST PUBLISHED: Carol Squiers, "James Van Der Zee: Harlem's Elegant Eye," *Vanity Fair* (August 1983), pp. 80–81

116.

Suzanne Farrell, *New York*

DATE OF NEGATIVE: February 25, 1983

DATE OF PRINT: 1983

PRINT MEDIUM: Gelatin silver

SUPPORT: Paper

DIMENSIONS

 IMAGE: 27.2 × 26.9 cm. (10¾ × 10⁹⁄₁₆ in.)

 SHEET: 35.4 × 27.7 cm. (13¹⁵⁄₁₆ × 10¹⁵⁄₁₆ in.)

 MOUNT: Unmounted

NUMBER/SIZE OF EDITION: No more than nine signed silver prints

ACCESSION NUMBER: S/NPG.88.70.19

PENN'S REFERENCE NUMBER: 6501

COPYRIGHT: 1983 by The Condé Nast Publications Inc.

FIRST PUBLISHED: David Kalstone, "Ballerina *Assoluta*: A Portrait of Suzanne Farrell," *Vanity Fair* (June 1983), pp. 80–81

REMARKS: The article includes two other portraits of Farrell by Penn from the same sitting.

117.

Jessye Norman, *New York*

DATE OF NEGATIVE: May 20, 1983

DATE OF PRINT: February–March 1985

PRINT MEDIUM: Platinum-palladium, multiple coating and printing

SUPPORT: Rives paper on aluminum panel

DIMENSIONS

 IMAGE: 49 × 47.9 cm. (19¼ × 18⅞ in.)

 SHEET: 63.2 × 55.8 cm. (24⅞ × 22 in.)

 MOUNT: 66 × 55.8 cm. (26 × 22 in.)

NUMBER/SIZE OF EDITION: Number three of an edition of five in platinum metals

OTHER PRINTS: No more than five unnumbered, signed silver prints

ACCESSION NUMBER: S/NPG.88.70.39

PENN'S REFERENCE NUMBER: 3227

COPYRIGHT: 1983 by The Condé Nast Publications Inc.

FIRST PUBLISHED: Peter Conrad, "Let the Grandeur Be Yours," *Vanity Fair* (September 1983), pp. 58–59

REMARKS: The original image is in color.

118.

Willem de Kooning, *Long Island, N.Y.*

DATE OF NEGATIVE: September 26, 1983

DATE OF PRINT: 1984

PRINT MEDIUM: Selenium toned gelatin silver

SUPPORT: Paper

DIMENSIONS

 IMAGE: 35.4 × 35.6 cm. (13¹⁵⁄₁₆ × 14 in.)

 SHEET: 50.5 × 40.5 cm. (19⅞ × 15¹⁵⁄₁₆ in.)

 MOUNT: Unmounted

NUMBER/SIZE OF EDITION: No more than nineteen signed silver prints

ACCESSION NUMBER: T/NPG.88.70.12

PENN'S REFERENCE NUMBER: 3411

COPYRIGHT: 1984 by The Condé Nast Publications Inc.

FIRST PUBLISHED: Peter Schjeldahl, "The Anti-Master Now," *Vanity Fair* (January 1984), pp. 66–67

119.

Jasper Johns, *New York*

DATE OF NEGATIVE: November 18, 1983

DATE OF PRINT: 1984

PRINT MEDIUM: Selenium toned gelatin silver

SUPPORT: Paper

DIMENSIONS

 IMAGE: 39.3 × 39 cm. (15½ × 15⅜ in.)

 SHEET: 50.7 × 40.4 cm. (20 × 15¹⁵⁄₁₆ in.)

 MOUNT: Unmounted

NUMBER/SIZE OF EDITION: No more than fifteen signed silver prints

ACCESSION NUMBER: S/NPG.88.70.32

PENN'S REFERENCE NUMBER: 4484

COPYRIGHT: 1984 by The Condé Nast Publications Inc.

FIRST PUBLISHED: Carter Ratcliff, "The Inscrutable Jasper Johns," *Vanity Fair* (February 1984), pp. 60–61

120.

Isamu Noguchi, *New York*

DATE OF NEGATIVE: December 20, 1983

DATE OF PRINT: 1984

PRINT MEDIUM: Selenium toned gelatin silver

SUPPORT: Dry-mounted on board

DIMENSIONS

 IMAGE: 38.6 × 38.3 cm. (15³⁄₁₆ × 15⅛ in.)

 SHEET: 38.6 × 38.3 cm. (15³⁄₁₆ × 15⅛ in.)

 MOUNT: 50.5 × 50.8 cm. (19¹⁵⁄₁₆ × 20 in.)

NUMBER/SIZE OF EDITION: No more than nineteen signed silver prints

ACCESSION NUMBER: T/NPG.88.70.38

PENN'S REFERENCE NUMBER: 13689

COPYRIGHT: 1984 by Irving Penn, courtesy of *Vanity Fair*

REMARKS: Penn first photographed Isamu Noguchi in 1948 ("Inside N.Y.C.," *Vogue* [April 1, 1948], p. 61).

Selected Bibliography

af Segerstad, Ulf Hård. "Vanity, Geniuses, and Cigarette Butts." *Svenska Dagbladet*, Stockholm, March 26, 1985.

Bailey, David, and Martin Harrison. *Shots of Style*. Victoria and Albert Museum, London, 1985.

Beaton, Cecil, and Gail Buckland. *The Magic Image*. London, 1975.

Blackmon, Rosemary. *Twen* (three issues). Cologne, Fall 1963.

Bourdon, David. "People of the World Materialize in the Ambulant Studio of a Famous Photographer." *Smithsonian Magazine*, Washington, D.C., October 1974.

Carluccio, Luigi, and Daniella Palazzoli. *I Platini di Irving Penn: 25 Anni di Fotografia*. Exhibition catalogue, Galleria Civica d'Arte Moderna, Turin, 1975.

Charles-Roux, Edmonde. *Penn Le Grand*. Exhibition catalogue essay, Printemps des Arts de Monte Carlo, 1986.

Edwards, Owen. "Perspectives of Penn." *New York Times Magazine*, September 4, 1977.

———. "Penn: The Power of Vision." *Vogue*, New York, September 1984.

Eisler, Colin. "Penn's Pensées: Camera Predicans," in *Irving Penn: Recent Still Life*. Exhibition catalogue, Marlborough Gallery, New York, 1982.

Gruber, L. Fritz. "Uber Irving Penn." *Photo Magazin*, Munich, September 1951.

———. *Grosse Photographen unseres Jahrhunderts*. Darmstadt, 1964.

Gysin, Brion. "Pas de Photo, Pas de Photo." *La Nouvelle Observateur*, Paris, June 1978.

Hall-Duncan, Nancy. *The History of Fashion Photography*. New York, 1979.

Hervé, Alain. "Pennmanship." *Réalités*, Paris, November 1962.

Hess, Thomas B. "Irving Penn." *Vogue*, New York, August 1975.

———. "Irving Penn: Time Is Luxury." *Vogue*, New York, September 1977.

"Homage to Penn." *Vogue*, New York, November 1, 1960.

Hopkinson, Tom. "Irving Penn." *The Daily Telegraph Magazine*, London, April 17, 1970.

Hughes, Robert. *Irving Penn: Photographs in Platinum Metals: Images 1947–1975*. Exhibition catalogue essay, Marlborough Fine Art (London) Ltd., 1981.

"Irving Penn: 9 Photographs." *Portfolio*, New York, 1950.

"Irving Penn: Ein Amerikanischer Modephotograph." *Gebrauchsgraphik*, Munich, 1952.

Kramer, Hilton. "Notes on Irving Penn." *The New Republic*, October 19, 1977.

Krauss, Rosalind E. *Earthly Bodies*. Exhibition catalogue essay, Marlborough Gallery, New York, September 1980.

———. "Irving Penn, Seeing Beyond the Shapes of Things." *Vogue*, New York, September 1982.

Liberman, Alexander. *The Art and Technique of Color Photography*. New York, 1951.

Maddow, Ben. *Faces*. Boston, 1977.

Malcolm, Janet. "Certainties and Possibilities." *The New Yorker*, August 4, 1975.

Martinez, R.E. "Irving Penn." *Camera*, Lucerne, November 1960.

Ostier, André. "Le Photographe Penn." *Vogue*, Paris, 1947.

Penn, Irving. *Moments Preserved: Eight Essays in Photographs and Words*. New York, 1960.

————. *Worlds in a Small Room*. New York, 1974.

————. *Inventive Paris Clothes, 1909–1939: A Photographic Essay*. Text by Diana Vreeland. New York, 1977.

Sobieszek, Robert A. *Masterpieces of Photography*. New York, 1985.

————. *Flowers*. New York, 1980.

Szarkowski, John. "Irving Penn: Recent Works." Exhibition text. Museum of Modern Art, New York, 1975.

————. *Irving Penn*. Exhibition catalogue, Museum of Modern Art, New York, 1984.

Talmey, Allene. "With Penn and Camera." *Vogue*, New York, November 1, 1960.

Thornton, Gene. "Irving Penn Out of Context." *New York Times*, September 11, 1977.

————. "Irving Penn—Dangers of the Painterly Approach." *New York Times*, September 5, 1982.

Tichenor, Jonathan. "Irving Penn." *Graphis #33*, Zurich, 1950.

————. "Irving Penn and Thirty-Six of His Photographs of Women." *U.S. Camera Annual*, New York, 1951.

Tiger, Lionel. "Duet with Silent Partner." *Camera Arts*, New York, September/October 1981.

Index

Italicized page numbers refer to illustrations.

Albin, Peter, *137*, 166
Allen, Woody, *143*, 168
Alonso, Alicia, *103*, 158
Ambrose, Marilyn, *ii*, *102*, 158
Andrew, Sam, *137*, 166
Atget, Eugène, 86
Auchincloss, Juliet, *25*, 75
Auden, W. H., xiv, 92, *104*, 159

Bacon, Francis, *48*, 80
Balanchine, George, *141*, 167–68
Balkin, Serge, 86, 88, *97*, 157
Ballet Theatre, 94–95, *103*, 158
Balthus (Baltusz Klossowski de Rola), xiv
Beaton, Cecil, xiv, 4, *39*, 78, 86, 88, *97*, 157
Beauvoir, Simone de, xiv
Bell, Kay, 86
Bellow, Saul, 93, *124*, 163
Bennett, Helen, *ii*, *102*, 158
Bentley, Muriel, *103*, 158
Big Brother and the Holding Company. *See Rock Groups*
Blumenfeld, Erwin, 4, 86, 88, *97*, 157
Bouché, René, 90
Bouet-Willaumez, René, 90
Brodovitch, Alexey, xiii, 2
Brodsky, Joseph, *147*, 169
Burnett, Ivy Compton, xiv, *45*, 79
Burrows, Abe, 89
Burton, Richard, xiv

Callot Swallow Tail Dress, *63*, 82
Calvino, Italo, xv
Camel Pack, 11, *64*, 82
Campigli, Massimo, xiv
Capote, Truman, xiv, 93, *128*, 164
Carlson, Lily, *ii*, *102*, 158
Carter, Elliott, *144*, 168
Cendrars, Blaise, xiv
Chagall, Marc, xiv
Chanel Sequined Suit, *61*, 82
Charbonnier, 8, *37*, 78
Charles-Roux, Edmonde, 7
Chase, Lucia, *103*, 158
Chevrier, 8, *36*, 77
Chimney Sweep, 8, *35*, 77
Cigarette No. 17, *58*, 81
Cigarette No. 37, 11, *59*, 81–82
Cigarette No. 42, *60*, 82
Cochran, Mrs. Drayton, 89
Cocteau, Jean, xiv, 2, 7, *20*, 75
Colette, Sidonie-Gabrielle, xiv, 7
Composition with Pitcher and Eau de Cologne, *67*, 83
Condé Nast Publications, 1, 85, 86, 88
Connally, Tom, 93, *121*, 162
Connolly, Cyril, xiv
Copland, Aaron, *146*, 168–69
Cornell, Joseph, 4
"Corner Portraits" series, 89–91, 92
Couturier, Père, xiv, 7, *21*, 75
Coward, Noel, xiv
Cretan Landscape, *49*, 80

Cunningham, Merce, *145*, 168
Cuzco Woman with High Shoes, 8, *24*, 75

Dali, Salvador, xiv, 2, 6, *17*, 74
De Chirico, Giorgio, 2, 3, *14*, 74, 88
De Kooning, Willem, xv, 93, *123*, *154*, 163, 170
Derain, André, xiv, 6, *22*, 75
Dietrich, Marlene, xiv, 93, *117*, 161
Duchamp, Marcel, xiv, 6, 91, *113*, 160

"Earthly Bodies" series, xiv, 9–10
Eliot, T. S., xiv, 93, *119*, 162
Ellington, Duke, 94, *139*, 167
Enesco, Georges, xiv, 7, *19*, 74
Epstein, Sir Jacob, xiv, 93, *120*, 162
Erickson, Carl, 90
Ernst, Max, 2, 6, 92, *98*, 157
Evans, Walker, 86

Farrell, Suzanne, *152*, 170
Fishmonger, 8, *34*, 77
Flanner, Janet, 92, *105*, 159
Fonssagrives-Penn, Lisa, *ii*, 5, *40*, *41*, *42*, *43*, 78–79, *102*, 158
Four Guedras, *57*, 81
Frissell, Toni, 86

Gabin, Jean, xiv
Garcia, Jerome John ("Jerry"), *137*, 166
Geldzahler, Henry, *149*, 169
Getz, David, *137*, 166
Giacometti, Alberto, xiv, *38*, 78
Gibbons, Elizabeth, *ii*, *102*, 158
Gill, Leslie, 4
Giono, Jean, xiv
Girl Behind Bottle, 12, *27*, 76
Girl Drinking, *26*, 76
Goberman, Max, *103*, 158
Goudeket, Maurice, 7
Grateful Dead. *See Rock Groups*
Graves, Robert, xv
Grosz, George, 90, *110*, 160
Group of Vogue *Photographers*, 88, 94, *97*, 157
Gurley, Jim, *137*, 166
Guttuso, Renato, xiv
Gypsy Family, 9, *50*, 80

Harlequin Dress, 5, *40*, 78
Harper's Bazaar, xiii, 2, 4, 88
Hayter, Stanley William, 6–7, *18*, 74
Hell's Angels, 95, *133*, 165
Hernan, Kay, *ii*, *102*, 158
Hippie Family (F), 95, *134*, 165

Hippie Family (K), 95, *135*, 166
Hippie Group, 95, *136*, 166
Hitchcock, Alfred, xiv
Hofmann, Hans, 93–94, *126*, 163
Hokinson, Helen, 87–88
Horst, Horst P., 85, 86, 88, *97*, 157
Huston, John, *148*, 169

Ionesco, Eugène, xiv, xv, *71*, 84

Jenney, Dana, *ii*, *102*, 158
Joffe, Constantin, 88, *97*, 157
Johns, Jasper, xv, 11, 94, *155*, 170
Johnson, Andrea, *ii*, *102*, 158
Johnson, Philip, *122*, 162–63
Joplin, Janis, *137*, 166

Kaye, Nora, *103*, 158
Kiesler, Frederick, 93, *123*, 163
Kreutzmann, William ("Bill"), *137*, 166
Kriza, John, *103*, 158

Laing, Hugh, *103*, 158
Le Corbusier, xiv, *16*, 74
Leigh, Dorian, *ii*, 6, 88, *97*, *102*, 157, 158
Lesh, Philip Chapman ("Phil"), *137*, 166
Liberman, Alexander, xiii, xiv, 2, 7, 85–86
Lion 3/4 View, 12, *72*, 84
Lippmann, Walter, 92, *99*, 157
Look, xiv, 95
Loren, Sophia, xv
Louis, Joe, 90–91, *108*, 159
Lynes, George Platt, 86, 88, *97*, 157

McCullers, Carson, 93, *118*, 161–62
McKernan, Ronald ("Pigpen"), *137*, 166
McLauchlen, Betty, *ii*, *102*, 158
McLaughlin, Frances, 86
Magnani, Anna, xiv
Malraux, André, *44*, 79
Man in White, Woman in Black, 9, *55*, 81
Man Ray, 4
Manzú, Giacomo, xiv
March, Frederic, 87
Marchand de Concombres, *33*, 77
Marin, John, xiv, 92, *101*, 157–58
Marini, Marino, xiv
Maugham, Somerset, xv
Maxwell, Muriel, *ii*, *102*, 158
Mencken, H. L., xiv, 92, *100*, 157
Mies Van Der Rohe, Ludwig, *122*, 162–63
Miller, Arthur, xv
Miller, Lee, 86

Miró, Dolores, *23*, 75
Miró, Joan, xiv, *23*, 75
Moore, Henry, xiv, xv, 10, *47*, 79
Mud Glove, 11, *65*, 83
Mundy, Meg, *ii*, *102*, 158

Nash, Ogden, 89
Nathan, George Jean, xiv, 92, *100*, 157
Newman, Barnett, 94, *129*, 164
New York Child, *25*, 75
Nin, Anaïs, 94, *142*, 168
Noguchi, Isamu, xv, 94, *156*, 170
Norman, Jessye, *153*, 170
Nubile Young Beauty of Diamaré, 9, *53*, 80–81
Nude No. 58, *29*, 76
Nude No. 147, *30*, 76
Nude No. 150, *31*, 76–77
Nureyev, Rudolf, *127*, 163–64

O'Hara, John, 91, *112*, 160
O'Keeffe, Georgia, xiv, 91, *106*, 159
Osborne, John, xiv, *46*, 79

Paper Cup with Shadow, *66*, 83
Patchett, Jean, *28*, 76
Pâtissiers, *32*, 77
Penn, Irving, *97*, 157. *See also* "Corner Portraits" series;
 "Earthly Bodies" series; "Small Trades" series;
 Worlds in a Small Room
Penn, Lisa. *See* Fonssagrives-Penn, Lisa
Perelman, S. J., 89
The Photographer: Penn, 90
Picasso, Pablo, xiv, 6, 10
Pollock, Jackson, 5
Price, George, 87

Rawlings, John, 85, 86, 88, *97*, 157
Reynolds, Quentin, 88
Reynolds, Virginia, 88
Richardson, Ralph, xiv
Rochas Mermaid Dress, 5, *41*, 78
Rock Groups, 95, *137*, 166–67
Romanoff, Dimitri, *103*, 158
Rose, Billy, 87
Rossellini, Roberto, xiv
Roth, Philip, xv
Rothko, Mark, 5
Rubinstein, Artur, 91, *111*, 160
Russell, Mary Jane, *26*, 76

St. Laurent, Yves, xiv
Seven Metal, Seven Bone, *68*, 83
Sheeler, Charles, 90, *107*, 159

Show, xv
Singer, Isaac Bashevis, 94, *130*, 164
Single Oriental Poppy, 11, *52*, 80
Sitting Enga Woman, 9, *54*, 81
"Small Trades" series, xiv, 7–8, 10, 93
Smith, David, 93–94, *125*, 163
Smith, Oliver, *103*, 158
Smith, Tony, 94, *140*, 167
The Spilled Cream, *70*, 83
Steichen, Edward, 4
Steinberg, Saul, 94, *131*, 164
Stewart, Mrs. William Rhinelander, 91, *114*, 160–61
Still Life with Food, 4, *15*, 74
Stravinsky, Igor, 91, *116*, 161
Sullavan, Margaret, 87
Sullivan, Frank, 89

Tabard, Maurice, 4
Tamayo, Rufino, 2
Tanning, Dorothea, 92, *98*, 157
The Tarot Reader, 4, *28*, 76
Tchelitchew, Pavel, 2
Thomson, Virgil, *150*, 169
Three Dahomey Girls, One Reclining, *51*, 80
Three Steel Blocks, *69*, 83
Thurber, James, 87, 88
Tichenor, Bridget, *28*, 76
Todd, Mike, 87
Tudor, Antony, *103*, 158
Twelve Most Photographed Models, *ii*, 94, 95, *102*, 158
Two Rissani Women in Black with Bread, *56*, 81

Updike, John, 94, *138*, 167

Van Der Zee, James, *151*, 169
Vanity Fair, xv, 85
Vionnet Harness Dress, *62*, 82
Visconti, Luchino, xiv
Vlaminck, Maurice de, xiv
Vogue, xiii, xiv, xv, 2–9, 85, 86, 87, 88–89, 90, 91, 92

Waugh, Evelyn, xiv
Weir, Robert Hall ("Bob"), *137*, 166
White, E. B., 90, *109*, 159–60
Windsor, Duchess of, 91, *115*, 161
Wolfe, Tom, *132*, 164–65
Woman in Dior Hat with Martini, *43*, 79
Woman in Moroccan Palace, *42*, 78–79
Worlds in a Small Room, xv, 9

Youskevitch, Igor, *103*, 158

Zebra, *73*, 84

This book was designed by Janice Wheeler for the Smithsonian Institution Press and typeset by G&S Typesetters, Inc., in Austin, Texas. The typefaces are Syntax Antiqua Roman and Bold and Univers 45. Both typefaces were born of the 1960s, conveying a tone of contemporary thought and style. This book was printed on Warren Lustro Dull White 80 lb. text by The Stinehour Press in Lunenburg, Vermont.